A PASSION FOR METAL

Reflections and Techniques of a Metal Sculptor

HENRY HARVEY

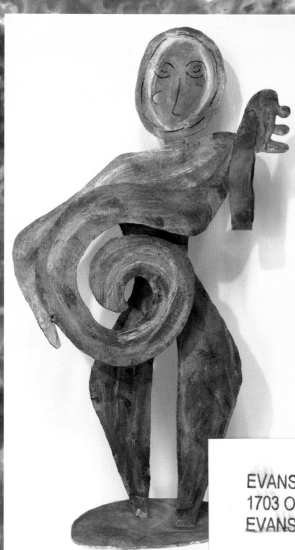

Schiffer Publishing Ltd

4880 Lower Valley Road, Atglen, PA 19310 USA

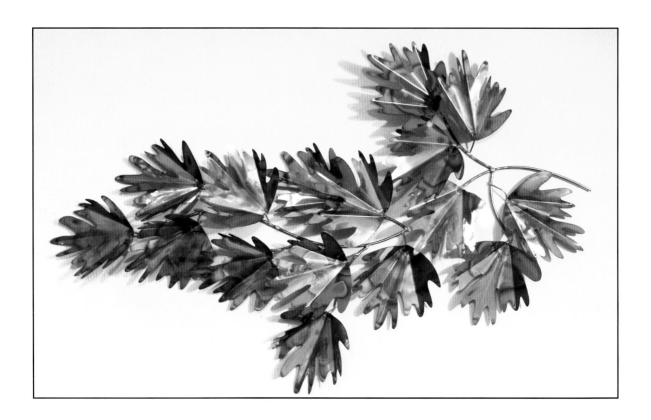

Library of Congress Cataloging-in-Publication Data

Harvey, Henry.
 A passion for metal: reflections and techniques of a metal sculptor/by Henry Harvey.
 p. cm.
 ISBN 0-7643-1840-3
 1. Harvey, Henry—Themes, motives. 2. Metal sculpture—Technique.
I. Title: Reflections and techniques of a metal sculptor. II. Title.
NB237.H35 A4 2004
730'.92—dc21
 2003010899

Designed by John P. Cheek
Type set in Busorama Md BT/Korinna BT

ISBN: 0-7643-1840-3
Printed in China

Published by Schiffer Publishing Ltd.
4880 Lower Valley Road
Atglen, PA 19310
Phone: (610) 593-1777; Fax: (610) 593-2002
E-mail: Info@schifferbooks.com
Please visit our web site catalog at **www.schifferbooks.com**
We are always looking for people to write books on new and related subjects. If you have an idea for a book please contact us at the above address.

This book may be purchased from the publisher.
Include $3.95 for shipping.
Please try your bookstore first.
You may write for a free catalog.

In Europe, Schiffer books are distributed by
Bushwood Books
6 Marksbury Ave.
Kew Gardens
Surrey TW9 4JF England
Phone: 44 (0) 20 8392-8585;
Fax: 44 (0) 20 8392-9876
E-mail: Bushwd@aol.com
Free postage in the U.K., Europe; air mail at cost.

Contents

DEDICATION

To my wife, Pamela, who has always been there, keeping it all glued together, supporting, nurturing, loving, keeping the business going, cutting out leaves, hammering geese, painting abstracts… A million verbs are not enough. A million pages would not explain. Pamela is the absolute hub of my universe, my mate, my friend, my lover. Without her there would be no book, no gallery, no world for me. Thank you, Pamela. I love you!

To my son, Cameron, who has been my sculptural right arm for the past five years. With Cameron's talent and initiative, we are continually branching into new territories and techniques. Virtually all of the castings in this book are by Cameron's hand, and thanks to Cameron we are now task-qualified in electroplating. He has contributed significantly to many of the sculptures viewed in these pages and if you look closely at the sketches sprinkled throughout, you will see his talent exhibited there as well. Thank you, Cameron, for all your help and support. I love you!

ACKNOWLEDGMENTS

To Peter and Nancy Schiffer. Without their vision, humor, and gracious support, this book would not have been possible. Thank you!

Thanks also to Doug Congdon-Martin, my editor, who tread the razor's edge between letting me fly and keeping me from crashing.

A Word About the Philosophy of A Passion for Metal

When I first met Peter and Nancy Schiffer to discuss the possibility of doing this book, Peter, with laser-like precision, came immediately to the point with the following question: "Henry, if you were going to create the ultimate book on metal sculpting, what would you have in it?"

A nervous second went by, and then I replied, "magic." More seconds went by and I realized it was time to explain in detail what has been in my mind these 30 years. I told Peter and Nancy that my intent would be to show the reader what a fantastic and exciting medium this is, and to inspire him to go out and try it for himself. It's that great.

After 30 years I still get sweaty palms when a new idea pops into mind. And I wanted to share that with you, the person standing there reading this paragraph. That's what it's all about, sharing something that's incredibly special. Hopefully, the result will be a slightly better, slightly happier planet.

I hope that you will go out and buy some wire, some copper, perhaps even a torch… and PLAY! Take a course at your local school…and then PLAY! If it begins to turn into work…you're doing it wrong. The secret to life is finding out what you love to do…and then doing it.

If in these pages, you come across something that is not clear to you, or if you have a question that I can answer, please feel free to contact me at my website, www.harveygallery.com.

FOREWORD

It's frustrating to stand in a bookstore reading about an artist, only to realize that most of what you're reading is purest speculation. Rarely are we invited behind the scenes to see what is or was actually going on in the mind of the artist.

Wouldn't it be exciting to really know what Alexander Calder was thinking when he created the first mobile, hung it above his work table, and witnessed a totally new art form?

Wouldn't it be fascinating to know what Michelangelo was muttering under his breath, having been conscripted to paint the ceiling of the Sistine Chapel? Was he swearing? Did his back hurt a lot? Did he even approve of the subject matter? There has even been significant debate as to the original brilliance of the colors he chose. Perhaps we'll never know.

What was in Rodin's mind when he conjured up his Gates of Hell? Critics speculate, but they don't know. They can only tell you approximately when it was created, where the artist was living, and perhaps a bit of history. The rest is conjecture.

It is only over time that sculptures, paintings, and books may take on a patina of God-like perfection. The reality is, many artists, upon reviewing their works years later, shudder at what they perceive to be mistakes, wishing that they could have one more chance to achieve that elusive perfection. The truth of the matter is, it's a never-ending process.

In the ensuing pages, it has been my goal to show you the evolution of one artist over three decades. There will be many candid glances behind the scenes. There will be opinions, and observations, and that's really all they are. No single artist has the market cornered on truth. There are myriad truths in the world of art. I have included a number of techniques, tips, and secrets so that you too, may become inspired to take the leap into this wondrously diverse art form of metal sculpture.

Henry Harvey

INTRODUCTION

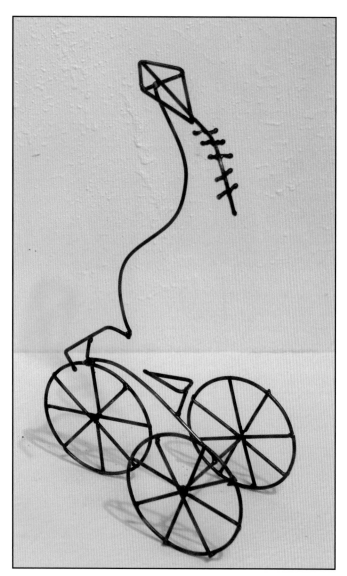

My first sculpture. Created from coat hangers, this crude piece is what started it all. 12" tall by 8"wide. 1972.

The first time I fell madly, passionately, hopelessly in love was when I met the girl who is now my wife. During a mixer at her school, she ran in front of my sorta hot sports car and yelled, "Take me! Take me!" She was joking, of course—but I wasn't. We've been married 30 years now and she's still my wild Hungarian.

The *second* time I fell hopelessly in love was when we walked into El Con Shopping Center in Tucson, Ari-zona. There was an art show going on and we came across a big cowboy type who was grizzled and gnarly like an over-the-hill Marlboro Man. No, this is not what you're thinking. The guy was making Harley hogs out of steel and spark plugs, naked women, bronze trees, pendants, *more* naked women, and he looked like he was having a ball! We got to talking and I told him I was *really* interested in getting into this. He said, "Get yourself a torch, son." "Anything else, Sir?" "Yep. Have fun."

My wife and I drove directly from El Con to the closest welding supply. We weren't exactly rolling in dough at the time, but we bought a small oxygen/acetylene setup and a striker (I didn't even know what a striker was, but the guy said I needed one) and away we went.

At home, I set the thing up on our patio table. I dragged out all the extra coat hangers in the house and then proceeded to read the matchbook-sized instructions on getting the torch lit. The first time I turned the acetylene knob and used the striker—I got a sooty plume of orange flame. I turned the torch off and my wife and I chuckled nervously. The second time, I tried to light just the oxygen. That didn't work at all. The third time I tried cranking in a little of both on at the same time. Nothing, nothing…and then it was like a .22 cartridge exploding, followed by a purring pencil-point of blue flame. Pamela, my wife, clapped with glee. Within half an hour, I had managed to create a small crude tricycle with a little stick figure peddling it and flying a kite. I turned the torch off, and twanged the long kite wire. The tricycle trembled. The kite fluttered back and forth. And I was smitten. It's been thirty years now and I still can't wait to get to work to see what's up for the day.

Six Bottles of Johnny Walker…and a Packing Crate

I had barely gotten my feet wet in Tucson, *beginning* to learn the personalities of the metals, *beginning* to learn that I'd have to come up with a better way of keeping track of which end of the rod was hot, when we got orders informing us that we were moving to Japan. That's how it is in the military. Just about the time you become competent at your job, they send you somewhere else.

I was a lowly lieutenant, my wife was pregnant, and my knowledge of Japanese was limited. I knew four words: *kamikaze, seppuku* (that's where you eviscerate

yourself with a sword), and *ichi ban*, which means "number one". The flight was long and when we arrived in Tokyo, the first thing I saw when I looked out the window, was a man in a business suit urinating against a fence. There was much to learn.

My first lesson came from my sponsor. The officials at Haneda International were holding my two dachshund puppies hostage. There was lots of red tape in Japan, and I learned that a bottle of Johnny Walker was the preferred means of bribery. Three bottles of scotch and we magically had our puppies back. I pinned the information away.

You'd think with everything that was going on, that the sculpting bug would have been placed on some distant back burner. It wasn't. I began to ask around to see what was available on base. I learned that there was nothing. I had brought my torch barrel and tips over with me in a suitcase, only to discover that everything in Japan was metric. Nothing would work; nothing would fit. The impossible dream began to appear well...impossible.

I began by driving around the back streets of Fussa and Tachikawa, looking for a welding supplier and a machine shop. Armed only with a notepad for drawing pictures, a wallet full of yen, and a bottle of Johnny Walker (black) to show how I was intending to bribe them, I walked into a tiny shop down a narrow alleyway and suddenly felt very much a stranger in this strange new land. I went to the counter and began drawing on my little pad. I drew two tanks, a welding hose, and a flame.

"Weldo," he said, "Hai" (that means yes. I had learned another word).

Then I pointed to myself, "Americano." I pointed to the threads inside the regulator. "Americano," I said. Then I pointed at him. "Japan—Metric." It took four or five tries, but soon the light bulbs began to twinkle on and we began doing charades.

Holding up the bottle, I asked him how many bottles of Johnny Walker it was going to take for two metric adapters.

He frowned and spread the fingers on one hand, then added a finger. "Six bottles," I said. "Hai." I wanted to ask him when, but I had no idea how to pantomime days going by. I pointed to his watch and swirled my finger like the hands were going around.

He nodded (thank God). "Next week," he said.

"Ah so," I replied. Apparently, this man knew substantially more English than I knew Japanese.

In the coming weeks, I *think* I ordered a tank of oxygen and acetylene. It was always hard to tell. In Japan, it's considered impolite to say *no*, and so even if they don't understand what you're saying, they say *hai* and nod their head. Then one day, biking home from work, I saw a tiny insect-like truck backed up to our World War II vintage housing. A crowd was forming in our front yard, mostly curious neighbors, mostly cheerful and supportive...mostly.

We dragged everything into the backyard, where I had set up a 6'x 9' wooden packing crate for my "studio." I ran to get my wallet and was given a pale yellow bill, the consistency of tissue paper. I couldn't understand anything, just the yen amount at the bottom.

After dinner, I tried everything out. The adapters were perfect; the torch purred to life with the first spark from the striker, and I discovered that the thin pencil of blue flame was like a magnet for my neighbors. In addition, they weren't all exactly enamored with the idea. "That gonna blow up?" my neighbor to the north asked.

"Nope. It's safer than our gas stoves," I replied. There was a stony silence as they were deciding whether they liked or hated the idea. "It's also good for making repairs," I said. "You got anything you need fixed?" It turned out that his son's bicycle had a crack in the frame. That was my first project in Japan.

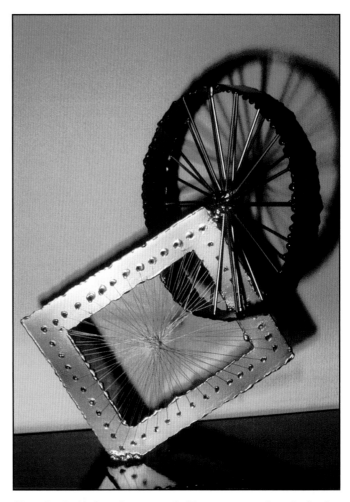

Class Crash. My first abstract work. This was created on the back step of base housing at Yokota AFB, Japan. It depicts a growing schism that I had, trying to be an officer and an artist at the same time. 1974.

CLASS CRASH

My very first abstract was also created in Japan. It was called Class Crash and it was a large square plate of metal with wires strung through it, colliding at a peculiar angle through a gear-shaped ring of steel, with rods emanating from it. Both plates had been drilled around the perimeter of their holes and then strung with brass wire. The effect was that they were fighting with each other, or perhaps they had been in a collision and become stuck together. Since then, the shape of a gear has come to symbolize technology for me. I use it often. Sometimes there is an ominous quality to the shape, but in the cases shown here, I was trying to achieve a sort of old-world comforting feeling…the feeling inside an old grist mill, staring at gears that have done their job without fail for centuries. There's something comforting in that.

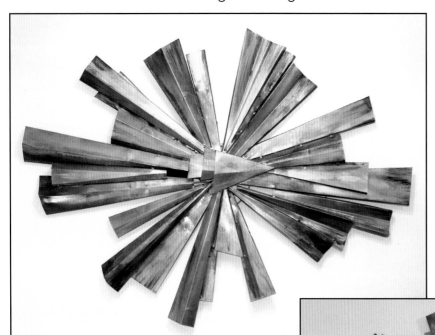

Starburst Triangles. This radial abstract is comprised of brass triangles formed with a sheet metal break. It is 6' 6" wide by 5' tall.

Docking at Babylon. This colorful abstract is comprised of chrome and brass triangles and circles, then painted and heat-treated. 60" by 60".

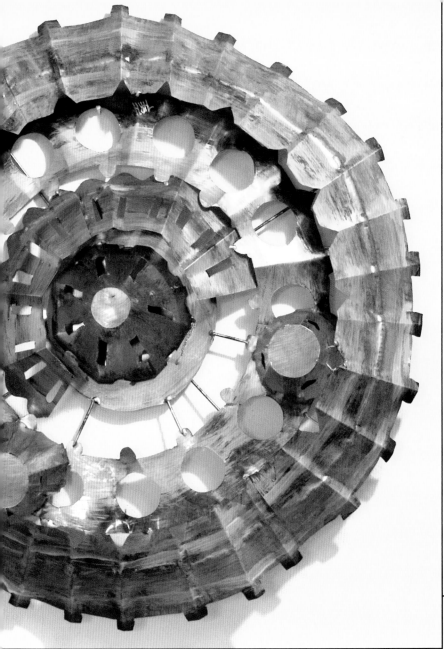

Ratchet. This two-piece gear abstract is composed of oxidized copper. It is 5' 10" long by 4' high.

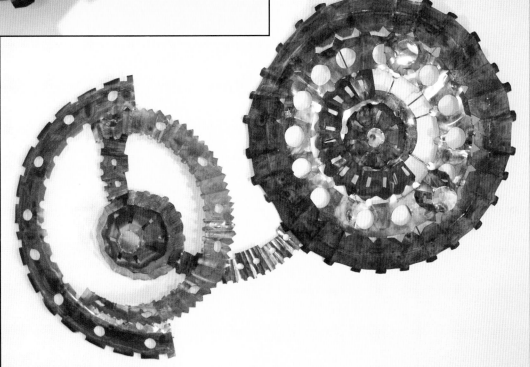

Hub. This circle abstract was cut with a plasma cutter. It is 36" in diameter and constructed of oxidized copper.

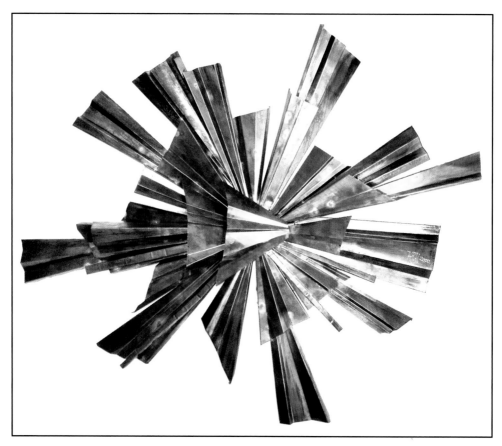

Pulsar. This is a variation on the Starburst theme. It is 4' high by 2' 8"wide and constructed of brass and copper.

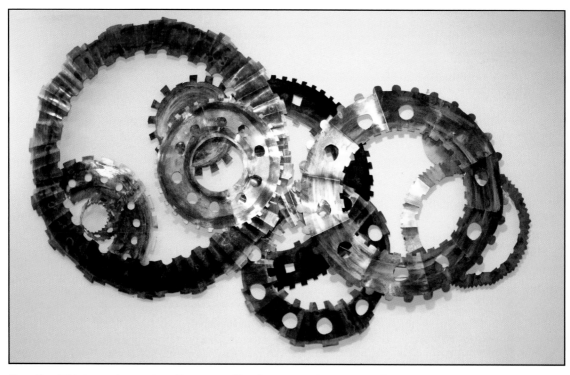

Gear Box. This is one in a series of large gear-like abstracts and a recurring theme over the decades.

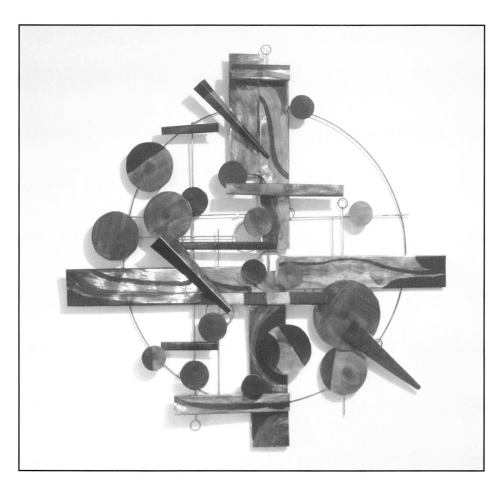

Focal Point. This work is comprised of painted steel. It is 36" square.

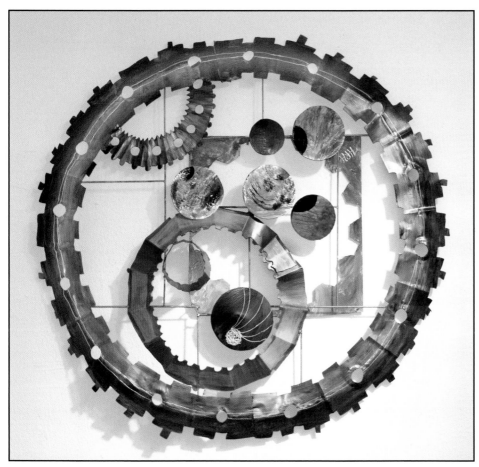

Cog. This wall piece is 45" in diameter. It was created with a plasma cutter, a sheet metal break, and is painted with acrylics. Steel and copper.

MARTIAN WARRIOR PRINCESS

Of all the sculptures I have done, this is probably in my top ten list of favorites. The genesis of this piece was an offhanded trip to Rice's Flea Market in Bucks County, Pennsylvania, to get some sour cream cheesecake and some of the best Canadian bacon in the world. On the way in, we passed a row of wooden tables with every kind of junk imaginable…old lawnmower parts, majolica bowls, cups and saucers, old toys from the thirties, and sticking out unceremoniously from a cardboard box were two women's legs. The head and torso were in another box, full of cobwebs, and looking rather pathetic. Even a mannequin deserves a better existence than that, and my wife and I decided to rescue her.

Back at the shop, I began putting her back together, and, maybe I've watched too many *Twilight Zones* in my time, but as she began to take shape, I noticed that this wasn't your typical mannequin. She was an adult, but very small, very art deco, and unusually pretty.

She reminded me of Deja Thoris in the John Carter books by Edgar Rice Burroughs…Deja, the princess of Mars. That was the mindset, but I didn't want to be limited to just that. This Deja had to have wings. This Deja is armed to the teeth. This Deja is dressed provocatively, yet at the same time it is the uniform of a warrior.

Because every part of her uniform is metal, and metal really hates being shaped into compound curves, I decided to bias-slit the pieces so that they could conform to her torso and then brazed them one-at-a-time. Her headdress is slightly reminiscent of the flapper era, her weaponry and quiver with glass spheres is pure fantasy. Designing her walking and wearing apparel, I wanted to divorce myself from the mundane styles on earth-folk, and her final pose was critical to the piece. She appears tranquil, yet lethal.

When it was finished, I felt as if I had royalty standing in my gallery. At night when I'd turn off the circuit breakers, it was always strange to see her standing in the darkness…waiting. One day someone came in and fell in love with her. She's living somewhere else now and I miss her.

Martian Warrior Princess. Front view of Martian Warrior Princess, composed of brass, bronze, wood, copper, glass, and acrylic. This work is 5'11" tall and 42" wide.

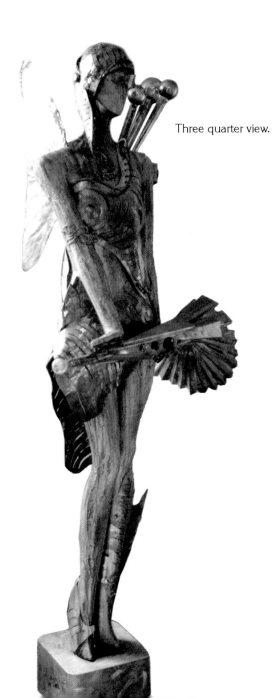

Three quarter view.

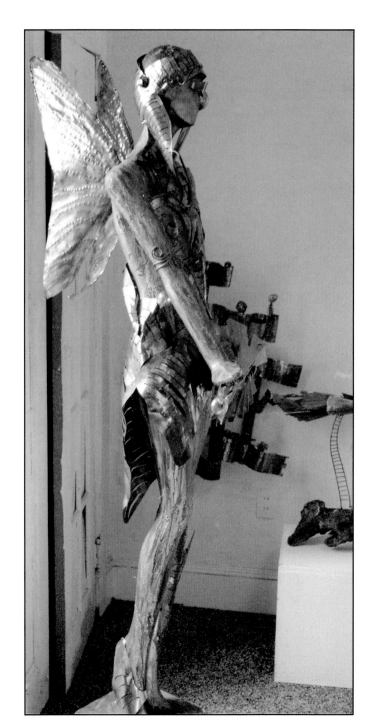

Side view of Martian Warrior Princess showing wings and attire.

CHAPTER 1
DID YOU KNOW THAT METALS HAVE DIFFERENT PERSONALITIES?

COPPER

Copper is an element. Its designation on the periodic table is CU. Copper is also a metal, though when most people think of copper, they think of the bottom of an expensive frying pan or the plumbing or the wiring in your house. Way back when, pennies used to be made out of copper, and as struggling artists we would make copper penny bracelets for people with arthritis. They say that copper has some magical ability to reduce the pain in arthritics, and who am I to argue?

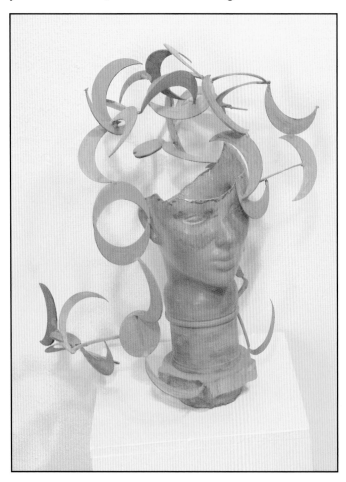

Moon Woman, courtesy of Robert Wiseman. This work is approximately 20" high and is composed of glass, bronze, and steel. It is a recurring theme of science fiction and fantasy.

But Copper Is So Much More!

My first lesson with copper was a valuable, though excruciating one. We were stationed over in Japan, and I was working on a secret project at Yokota Air Force Base. We were building a screen room, a room inside a room, made completely out of copper and copper mesh, to contain the signals from our then state-of-the-art top-secret communications devices. The copper shields all the emanations from being transmitted out to the bad guys (of which there were a bunch).

After the project was completed, several of my sergeants and airmen, knowing that I was a budding young sculptor as well as an Air Force lieutenant, put some scrap pieces of copper in the back of my car…a present if you will. In military parlance, it's called *scrounging*, and it's an old and accepted art form unto itself. Anyway, when I went home that night, I gobbled down dinner because I couldn't wait to dive in and see what I could make out of the copper.

The first piece I picked up was a heavy copper bar, approximately 2" wide, about an inch thick, and four-feet long. It was heavy and I guiltily imagined how many copper pennies had to give up their lives for this one hunk.

I was smart enough at the time to realize that since copper transmits heat, it was probably going to take a while to cut the bar down to a workable size. I went right to my "Big Bertha" cutting torch, capable of slicing through two-inch thick steel like it was butter. I lit the torch and began focusing the flame on one end of the bar. I waited, I waited, and I waited. Five minutes later, not only was the copper not in two pieces, it hadn't even discolored. It was sitting there smiling back at me, bright and shiny as ever. I thought to myself, "Boy these people who work with copper must be patient!" After ten minutes, I turned off the torch with a newfound respect for copper. I hadn't even put a dent in it. *That's* why they put it on the bottom of all those pots and pans.

Then I did a stupid thing and learned my first lesson. I knew that I had put ten minutes worth of heat into the bar. I knew that the far end was hot. And so, I slowly plunged the hot end of the bar into a bucket of water. A roar of steam, much hissing, and spitting, followed by—

excruciating pain. The heat energy, not wanting to become dissipated by the water, raced up the other end of the bar and right into my hand…something akin to giving a cat a bath. Who knew heat could travel that fast? Well I did…*now*, and it was a lesson that never required a refresher course.

That was my first sobering experience with copper. Taken in big massive hunks, it is a bear to work with. Anything else, however, and it is the sweetheart of metals.

Even in its most crude form, that of copper ore, it is beautiful to behold: azurite (blue), malachite (lacy forest green), turquoise (guess what color turquoise is), chrysocolla (green-blue green), and cuprite (a reddish brown crystal). If you go to a copper mine, you will most likely find a gaggle of silversmiths nearby, creating beautiful jewelry from the elegant ores of copper.

TIP

One easy way to track down copper is by buying copper flashing, available at most hardware stores. You can get several square feet of copper for a reasonable price, go home, and play with it. The corollary to this is: Never *ever* buy your copper at an arts and crafts store, particularly not one in a shopping mall. The sheets come in a blister pack, and with what they charge, the copper must have been stolen from King Tut's tomb. Figure on it being about ten times more than you should be paying. When you go home and start to play with it, you'll find that it is a wondrous and eager metal, and like a puppy, it's just waiting to please you.

Texturing and Forming

One thing I've learned is that no one has the complete handle on every form of sculpting, texturing, painting, and forming. Each of us has his own preferred way of doing things. And there are always new and high-tech ways to accomplish things. In the mid-twentieth century, gas and arc welding came into its own as a technique for metal sculpting. Now, plasma cutters are available as well as high-pressure water nozzles, lasers, and super glues. Who knows what will come next? But like anything else, owning expensive equipment won't guarantee that your artwork is good. That comes from between your ears. In the following pages, I will tell you about some of the tricks and techniques that I use. Another artist may have a different way of doing them and that's great. The goal, however, is for you to be able to recreate the images that are in your mind…in metal.

How you go about it is up to you.

Once, on a TV special, I watched an artist who used a shotgun to texture his copper. He'd hang a sheet of copper up against a tree and let her rip. The abstract patterns of the birdshot were interesting, if somewhat difficult to control.

Another artist chose as his paint brush the business end of a multimillion dollar business jet. He set the canvases up on a sturdy platform far behind the jet engines. Somewhere short of lift-off, the artist tossed pots of paint into the exhaust—and a microsecond later there were huge splats on the canvas. Still another artist chose to use high explosives to form his metal plates into interesting patterns. In the military, we used to call that shrapnel and I'd recommend steering clear. What we're going to be doing is probably less theatrical, but a lot more precise and the rewards will be greater.

I got a commission once to create thirty three-foot diameter copper lily pads. Not only were they large, they also had to float, and shoot water. Worse than that, the commission required that they be randomly textured. The first lily pad took me over an hour to hammer correctly. I wasn't opposed to hammering the others for 29 more hours, though if you've ever hammered…that's a lot of hammering. Then a possible solution occurred to me. I cut out a second lily pad and dragged it out into the graveled alley behind our shop, hopped into my little sports car, and began driving back and forth over the copper. Within five minutes, it was done…and indistinguishable from the original that had taken an hour. Next, I cut and dragged the other twenty-eight out into the driveway and proceeded to drive up and down the alley. Fifteen minutes later, all thirty were done. If you can, use your brain.

Coloring and Patinas

Color? You can play all day, just with heat patinas. Heat the back of the copper while watching the front and watch the fun begin. Coronas of color, delicate feathering…then (always carefully wearing gloves and holding the metal with pliers) move the flame around to the front and play it over the colorful oxides. Some colors will vanish, replaced by blues and greens. Then you can return to the backside and make ever more complicated heat patinas. Eventually, if you go too far, the whole thing begins to turn black. But if you wait a while until it cools down, it will go to deep burgundy. Well…some of it will. This is an art, not a science, and some of it will stay black. And if you screw up badly and your once pristine sheet looks like a piece of shrapnel, you can wipe it down with a little Sparex #2 which is a dry acid that you mix with water. There's nothing better for cleaning copper, and if your wife has a bunch of old cruddy copper pans, you can be her hero. The Sparex #2 is a

weak acid, but you really must use rubber gloves and goggles.

Within this last paragraph, whole worlds of patinas are possible. This is just the tip of the iceberg. For instance: (Carefully) place the torch flame parallel to the copper, rather than pointing at it. What you'll get looks like a comet with a tail…or a feather, or the eye of a peacock feather, it's all up to you. And we haven't even begun to talk about the chemical patinas that you can use on copper.

The chemical patinas of copper are just as wondrous as the heat patinas, but they are covered in depth in another section. It's safe to say, however, that with four easy-to-order chemicals, you can patina the copper to a malachite-green, turquoise, azure-blue, chestnut-brown, honey-brown, yellow, sage, black, robin's egg, and royal blue. This is a short section but possibly one worth book marking. It shows 15 different surface treatments for sculptures. If you're clever, you might want to cover up the captions and try to guess precisely how each treatment was created.

Since this is just an overview of copper, I will just touch on one more wondrous property of copper dealt with in more depth in another chapter. Copper is malleable, which is to say, it bends or works easily. When you order copper from a supplier, you can order it, soft, half-hard, or hard, as well as in a myriad of different thicknesses. 90 percent of the time I order soft, because it's easiest to work with, hammer, form, bend, or mold. The other 10 percent would be if you were building something on the order of a large window box and you wanted the sides to be strong and rigid. Other than projects like that, stick with the soft.

Gauges

The thickness of sheet metal can be measured four ways: gauge, decimal size, fractional inches, and weight per square foot. Is it a complicated system? Yes. Do you need to know them all? No. But you should have at least a working knowledge. If, for instance, you want to make a fountain for your back yard, 16-ounce soft copper is a good place to start. It's malleable, yet hardens quickly with a little pounding, and forms easily. Order 30-ounce hard copper, however, and you'll be there all day, just trying to make an ashtray. Or…make that fountain out of 8-ounce copper and you'd better keep your hamster away from it because he's going to bend the hell out of it.

A good starting point, if you have no idea what you're doing is to order a little sampling of this and that and experiment…take notes. I usually order 16-ounce copper for my fountains (24 gauge, .025, 1/40" they're all the same) and 28 gauge copper for the small stuff. It's a jumping-off point.

A close-up of a portion of a large wall fountain. It has been heat treated with the torch and then folded back unto itself by means of a sheet metal brake. Each fold provides an interesting challenge for the water that runs down.

A portion of what we call a ribbon abstract. The metal is chromium-plated steel. It has been cut with a plasma cutter, bent by hand, and then painted with acrylics. The over spray in pink and silver was by means of a commercial spray paint called Web Spray.

Heat-treated copper that has been hammered from the back with a welder's chipping hammer.

A close-up of an abstract incorporating hammered copper to which BBs have been attached with Epoxy glue to create texture. The sphere is a plastic Christmas ornament that has been washed with metallic powders.

One of my favorites … an old friend … chemically oxidized steel, if you're standing in a gallery in the Village … rusty iron, if you're standing in a barn in Pennsylvania.

A charming example of the wonderful patinas available just with cupric nitrate, calcium carbonate, and ammonium chloride, mixed in equal amounts and then added to warm water.

If you examine this photo closely and then flip through this book, you will *eventually* discover its origin. Think … castle walls. Oops, I gave it away. The coloring is by means of sulfurated potash, but the striations are by means of a plasma cutter set to "low" and then quickly dragged across the surface of the metal. From afar, it looks like stones and mortar.

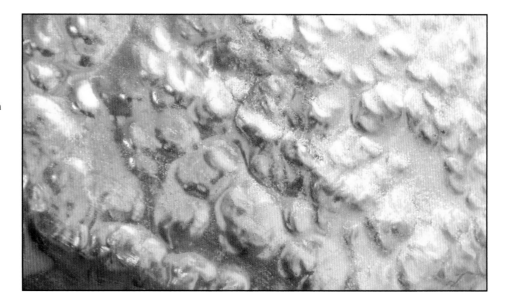

Shiny unadorned copper that has been hammered from the back with a ball peen hammer.

A close-up of a rectangle on an abstract. It has been coated with a base-coat of paint textured with sand, to which overwashes of metallic paint have been applied. Finally, the whole piece is sealed with a triple coating of polyurethane.

A close-up of a copper fountain basin, which has been pattern-hammered from the back and then spot-heated with a torch. The iridescent parts are where the heat was minimal.

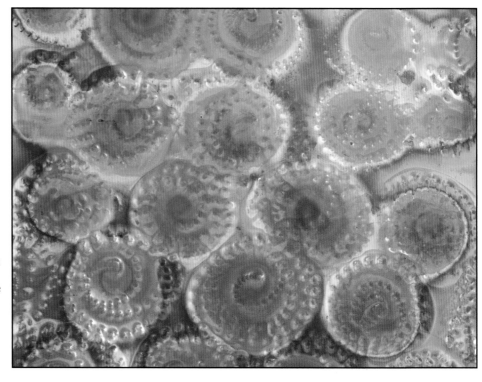

A real hodge-podge of finishes. First, the copper was chemically treated with potash. Next, hot glue was applied to the surface in strips to achieve texture. Following that, the piece was washed with metallic paint, allowed to dry and then scribbled on with pastels. Finally, puff-paint was used to achieve an extra layer of texture and depth.

20

If you look closely at this photo, you'll see that the material is clear acrylic. The paint has been applied from the back to achieve a slightly surreal effect.

Straight copper, slowly but heavily heated from behind, and then allowed to cool slowly.

This answers the question of what happens if you fold and pound a piece of copper long enough. Afterwards it was rubbed with metallic powders and treated with pastels.

Pure copper that has been over-patinated with potash until it is black, and then scraped with a steel wire brush.

IRON AND STEEL

If copper is the magical pretty-boy of the metals, then iron is the construction worker, or perhaps a prize-fighter. Iron and steel are tough. How many copper bulldozers do you see chugging around? And like copper, iron too is an element. Its sign on the periodic table is Fe (for ferrous which refers to anything made of iron. See? There is logic). Steel, however, is an alloy, which is to say they have intimately combined other elements and/or substances to create different properties.

For our purposes, however, we are not going to cover every permutation of iron and steel that ever existed. This would entail a book unto itself. Instead, I'm going to clue you in on the things you need to kickoff with in the sculpting world. After all, we're not making pistons or knives or parts for a nuclear power plant; we're making sculpture.

You need to know about mild steel, (both cold and hot-rolled) iron, Cor-Ten steel, and have at least a working knowledge of stainless steel and cast iron, if only to stay away from it until you have the proper equipment.

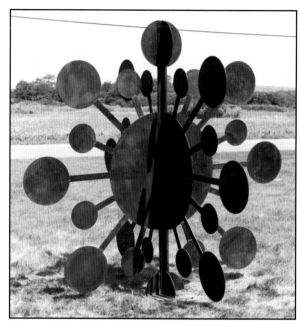

Circle. 8' x 8' x 8'.

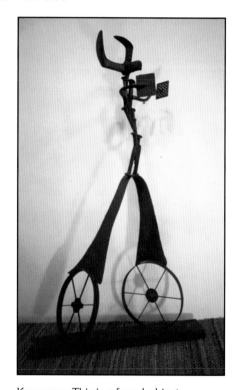

Kangaroo. This is a found-object sculpture, composed of cast iron, steel, and iron. It is approximately 60" tall.

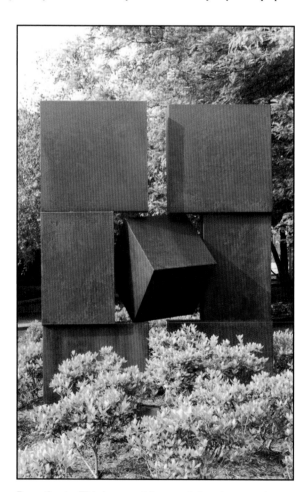

Parenthesis. This large outdoor sculpture is approximately 8-feet wide and is composed of Cor-Ten steel. It was a commission for Korman Corporation in the early eighties.

Like copper, steel can be hardened or annealed. Basically, it can be hardened two ways: by heating, then quenching quickly, or by work hardening. A quick example of work hardening at its most basic level: Take a metal coat hanger out of your closet and fold it sharply in half. Pretty easy wasn't it? That's because the metal is mild steel and it has been annealed. Now—try to bend that same coat hanger straight again. You'll find that at the point where the bend took place, it has suddenly

gotten an attitude. "You think you're going to bend me straight again? Guess again." That is work hardening and you can do it a hundred different ways.

One of the nice things about steel is that you can cut it, drill it, form it, and connect it in many easy straightforward ways. For our purposes, we use a lot of mild steel rod, called gas wire RG-45 in the industry. It comes in three-foot lengths and in 1/16" increments of diameter from 1/16" to 1/4" being the most common. For a little more money, they come plated with copper. This reduces rusting and it makes for a nice finish on certain projects. You can weld it just by heating two rods so that they melt together. This sounds easier than it is. With gas welding, you can count on lots of sparks, and the occasional pop of the torch. We prefer brazing, which is a bit less exciting, but it is quicker and won't leave little burn holes in your shirt. This involves melting brazing rod as the filler metal between the two pieces of steel.

The other common method of attaching larger pieces of metal together is with an electric arc welder. You can go with a good ole stick welder, affectionately called a "buzz box." It's cheap and effective and uses a wide variety of welding rods. Or you can go a little more high-tech and get a small MIG welder. These are sweet and the price has come way down. They even have a 110-volt version for smaller jobs, that's just great for the budding backyard sculptor.

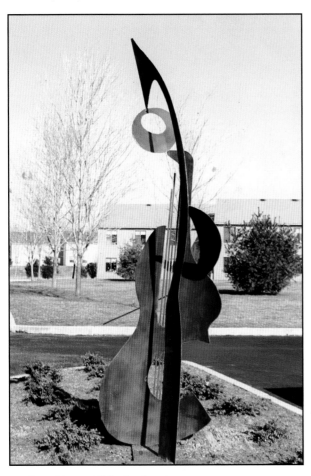

Big Bass Player. 16' high, 4' wide.

BRASS AND BRONZE

When you go hunting around on the periodic table of elements for brass and bronze, you're going to be disappointed. That's because they're alloys, not elements. Brass consists of copper + zinc (the percentage of zinc varies, usually from 10 to 40 percent). Bronze, on the other hand, consists of copper + tin.

A Bronze Banana

I'm going to give you a half tongue-in-cheek example of the importance of scale as well as the word *bronze* as factors in determining the seriousness of a work of art. Right now, I'm about to eat a banana that my wife packed for lunch today. If, however, instead of eating it, I were to spray it with copper powder and then plunge it in my electroplater, in a few hours, I would have a copper-plated banana. I might even be able to sell it for a few bucks as a novelty to someone who really likes bananas. Now, however, let's say I scale that banana up so that it's six-feet high and bronze. In the right gallery, this is the stuff of "serious" art, the assumption being, if somebody went to all that trouble, it has to be profound. Think of a price tag for that six-foot bronze banana. Depending on where the gallery is, we're talking thousands to tens of thousands of dollars. Now, however, scale that same banana up so that it's bronze and fifty-feet tall. We're talking hundreds of thousands of dollars and something very serious and important. Now we must think of all the subtexts, nuances, and metaphors for that fifty-foot banana. That's one of the realities of the art world. Deal with it.

TO CAST OR NOT TO CAST... *THAT* IS THE QUESTION

Having spent a good deal of time explaining to my customers and family how I wasn't really "in" to casting, as they say, my son, Cameron, finally asked, "Why?" I paused, reflected for a moment, then looked him in the eye and replied, "What was the question again?" He countered with his usual, "C'mon, Dad, give me a straight answer." More furtive glances at the sky and then I said, "I think I forgot why I'm not in to it. ...There must have been a good reason, though." In addition, that launched a small ripple of activity. Cameron did the homework on the computer and explained that it wouldn't be very difficult to build our own furnace. Soon we were ordering special high temperature kiln cement and fabricating our own tools. To be candid, yes, you can build your own furnace, but it's not nearly as simple or straightforward as it is explained and it's a steep learning curve, trying to trouble shoot a new device about which you know noth-

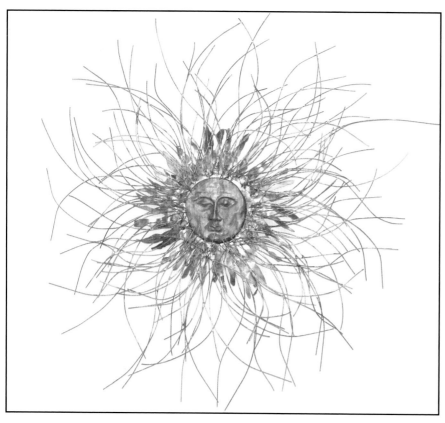

ing. It also roars like a jet engine when lit, and if improperly lit, creates large fiery *WHUMPS*…that can be heard from a good distance. In short, it's not for the faint of heart…and that's not even addressing the pouring of large and heavy crucibles of molten metal.

Suffice it to say, we have adopted strict safety procedures…and Cameron looks like Nanuck of the North when he is pouring. So far, Cameron is championing the casting and the castings in the sculptures in this section are all Cameron's. Only time will tell whether I am bitten by the casting bug. So far, I'm still *really* enjoying and appreciating having all my fingers and toes, my eyes and ears, and my beard intact…the little things in life.

Nested Sun. This sculpture is constructed with bronze rod and an aluminum casting. It is approximately 40" in diameter.

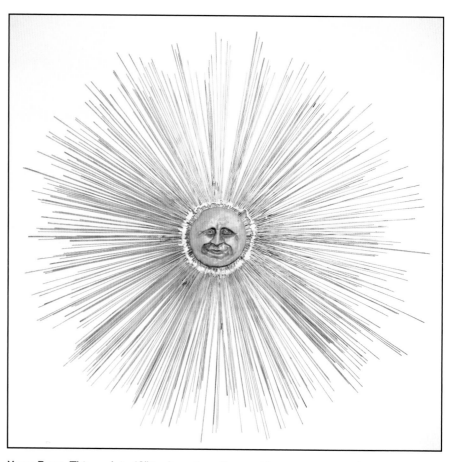

Moon Burst. This work is 48" in diameter with a cast bronze center portion.

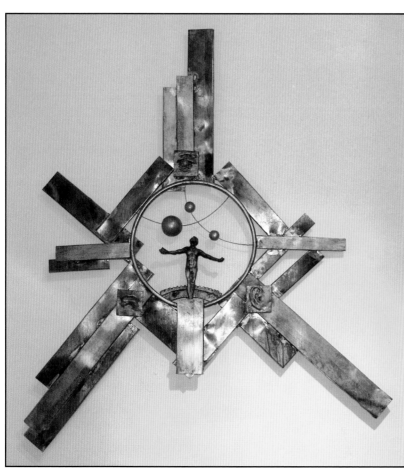

Triumvirate. This work was created in 2002 and is constructed of a cast bronze center portion with copper and brass panels radiating outward. It is approx. 5' by 5'.

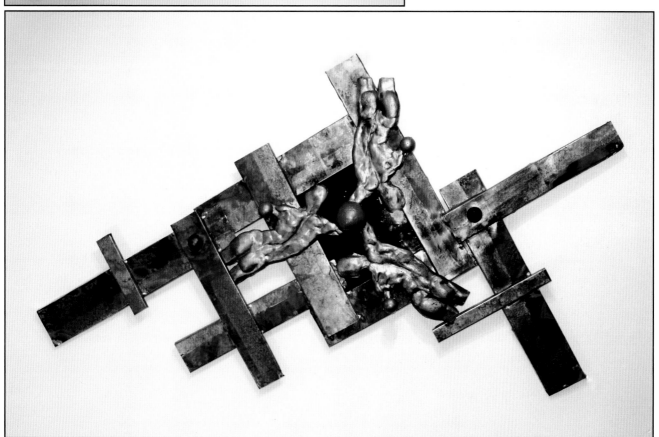

Triad with three bronze castings. This abstract incorporates three bronze castings, stained glass, copper panels, and is 4'6" long by 2'6" high.

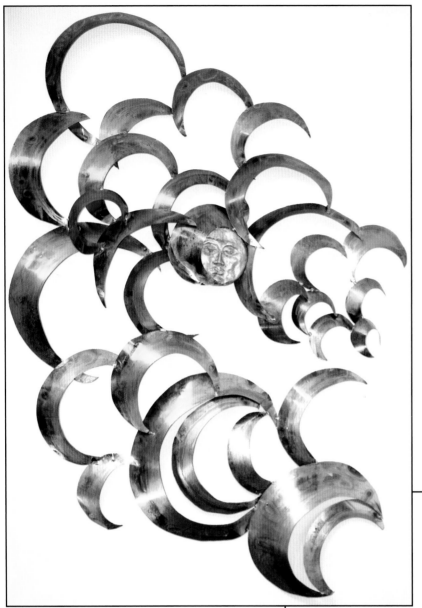

Man in Moon with Crescents. This is an example of traditional casting techniques mated to modern direct-metal sculpting techniques. 60" high by 42" wide.

Wise Men. This abstract was constructed in modules to facilitate shipping. It contains three cast faces backed by a stained acrylic circle. It is 7' tall by 5' wide.

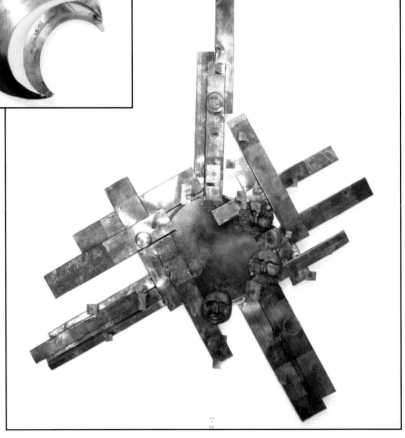

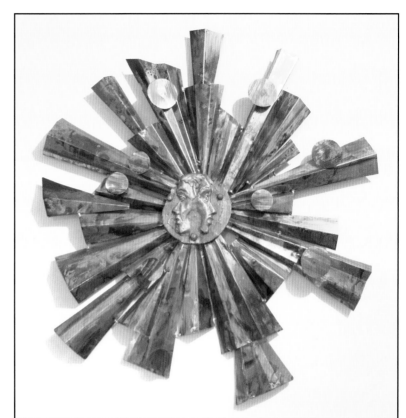

John & David, courtesy of John Sandy and David Lello. This was a commission created for two close friends. With the cast center disk, the effect is reminiscent of a Roman coin. It is 44" in diameter. Oxidized copper and bronze.

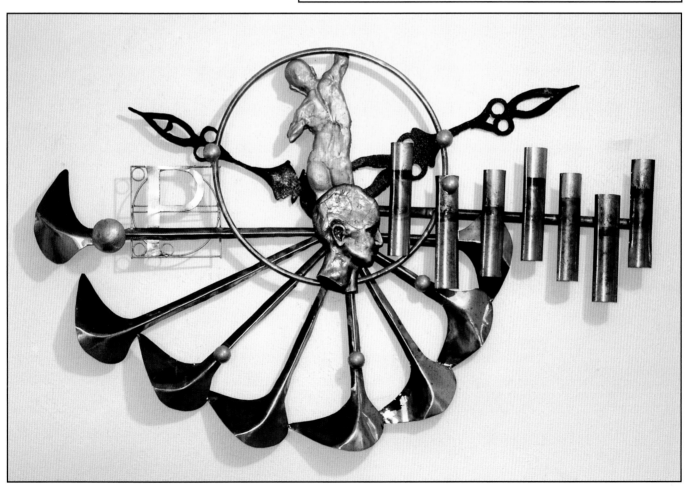

Precious Time. This abstract is 5' 6" long by 3' high and is composed of two bronze castings. The hands of the clock were cut with a plasma cutter out of plate steel.

POLYMER CLAY

Odd Folks…or…Absconding with Pamela's Pasta Machine

There are loads of very good how-to books on the market dedicated to the wonders of polymer clay. In point of fact, this is a medium that we at Harvey Galleries have only just begun to play with. So far, we're just having fun, integrating it into abstracts, freestanding pieces, mobiles and whatever we can think of to apply it to. And that's very much in keeping with our philosophy, that the best artwork comes out of curiosity mixed with a generous dose of play.

Don't be fooled by polymer's seemingly commercial or artsy-craftsy heritage. It's clay, and clay is clay. If Michelangelo had had access to it, I bet you a dollar he would have been one of the first to experiment with it.

The figures pictured here were sculpted over a matrix of copper tubing and then wrapped tightly with metal foil to create bulk. If like most people, you're hardening the clay in the same oven that you cook with, you'll soon discover that it produces an unmistakable odor as it's baking. I'd recommend good ventilation and I'd also recommend that you keep the thickness of the clay to a minimum…hence wrapping the armature with foil to reduce the volume of clay required.

One thing that becomes immediately apparent when working with clay, is that you want to be able to make uniform sheets. You can do this with a rolling pin, which I did for about a day, stealing Pam's gourmet Italian marble rolling pin. Or…you can dig around in the kitchen cabinets, and if your spouse has a pasta machine, you can steal that. Keep in mind, however, that once stolen, there are no "backsies." The clay gets into the cutting tines and, well, it gets ugly very quickly. I ended up running out to our local kitchenware shop and buying Pam a new (and improved) pasta maker. Peace was returned to the Harvey kitchen.

After the pasta maker debacle, Pamela's interest was piqued. She *really* wanted to know what was causing the horrible smells in the oven and why I had felt it necessary to borrow many of her cooking tools. I'm happy to say that there's a happy ending, or should I say, beginning to all this. Most of the pieces pictured in this section come directly from Pamela. Her charm and sense of humor are apparent.

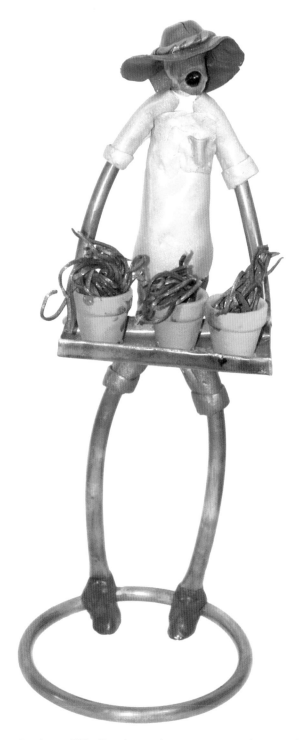

Gardener. 15" tall, polymer clay over a copper framework.

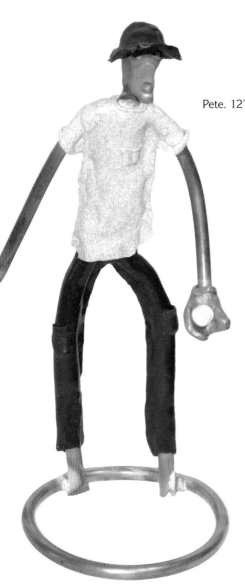

Pete. 12" tall, polymer clay.

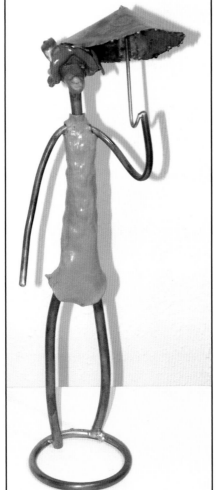

Matilda. 14" tall, polymer clay.

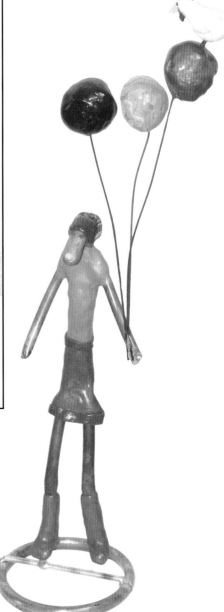

Chicken Balloons. 19" tall, polymer clay.

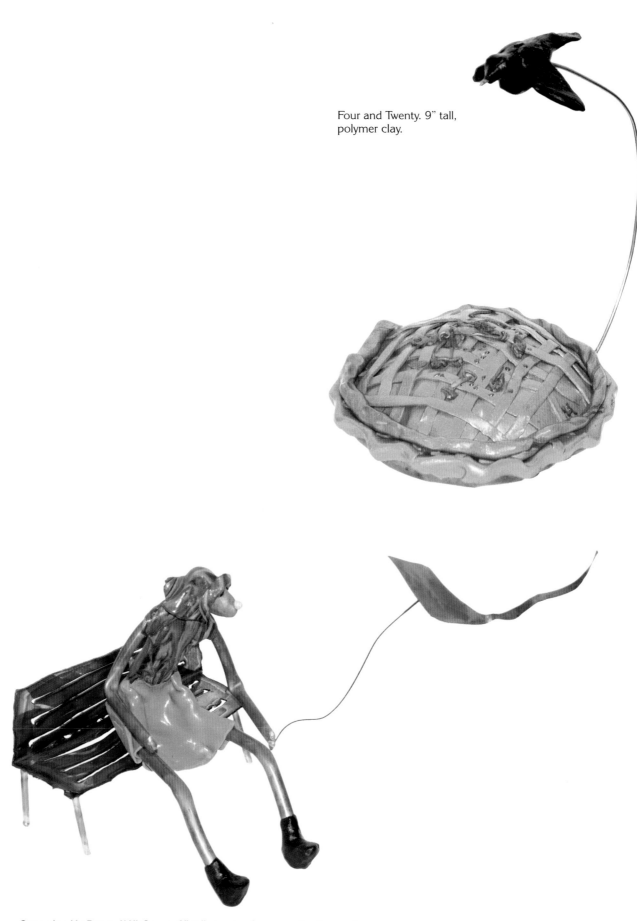

Four and Twenty. 9" tall, polymer clay.

Someday My Prince Will Come. 9" tall, copper, brass, and polymer clay.

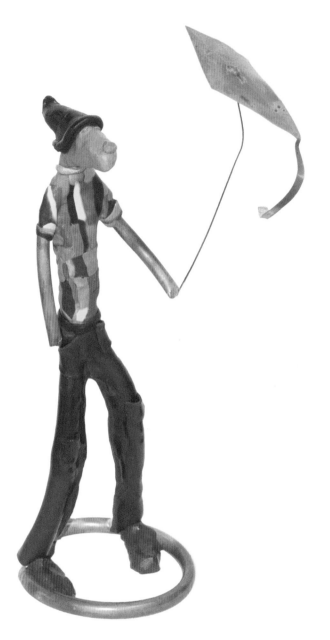

Go Fly a Kite. 14" tall, copper, brass, and polymer clay.

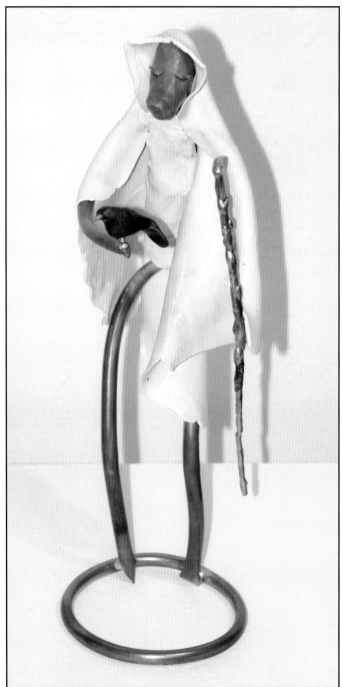

Two Friends. 14" copper and polymer clay.

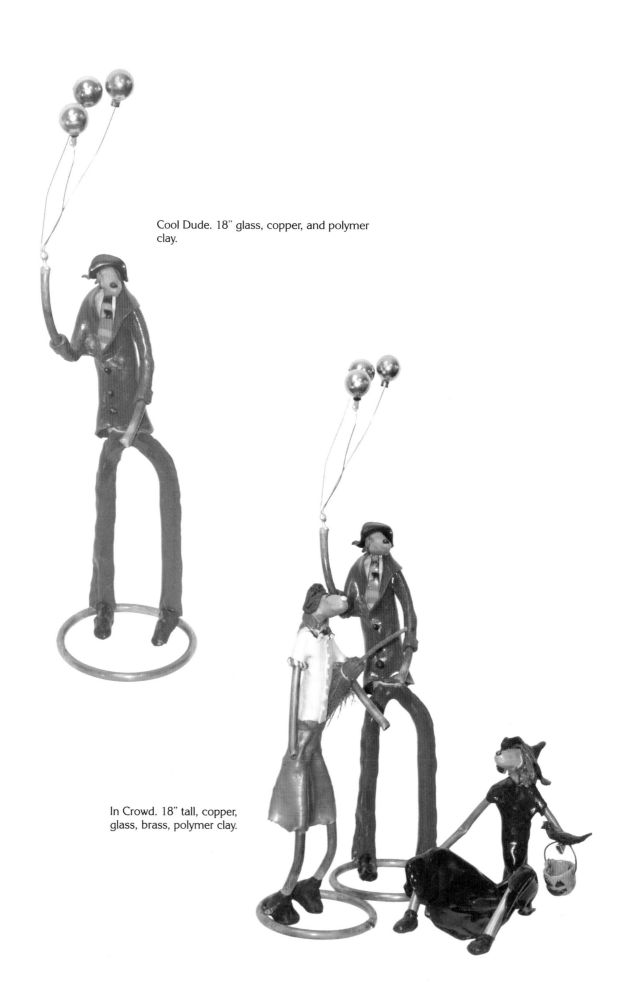

Cool Dude. 18" glass, copper, and polymer clay.

In Crowd. 18" tall, copper, glass, brass, polymer clay.

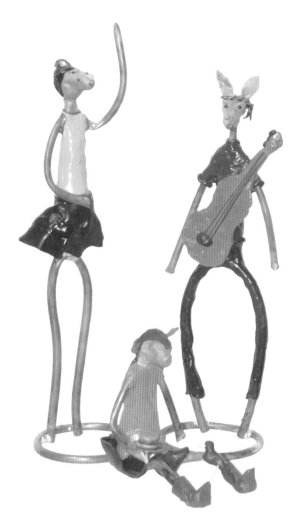

Arty Group. 17" tall,
copper and polymer clay.

Armatures for Odd Folks.
The understructure of our
Odd Folks sculptures
consist of copper tubing
brazed to form an
armature.

CHAPTER 2
THE ARTIST AND ART

The Million Dollar Spit-In-The-Wind

The most important character trait you will need if you're going to survive as a sculptor is perseverance.

Quite frankly, if you are looking to get into serious sculpting as a way of life and supporting yourself, you should plan on dropping terms like, "Well, I'll give it a shot," or "I'll give it the ole college try," right out of your vocabulary. The only way to win is to clamp down bulldog-like to your goal, and say to yourself…and the world, "*nothing* is going to shake me." This is probably true in many fields, but it is particularly true in this one.

In one particularly gloomy period of our lives, we had just made the jump out of the safety of the military, and into civilian life. And not just civilian life, but arty civilian life. The term, *starving artist*, didn't come out of thin air. With a wife and a tiny baby and no visible means of support, no gallery, no website…no history, we began doing every art show we could find. At one particular show at an Army Base at Fort Huachuca in Arizona, we hit bottom. We were down to our last couple of hundred bucks, it was hot enough to grill chicken on the roof of our hippie van, the baby was screaming, and Pamela's face seemed to be freezing into an expression of perpetual grimness.

The night before the art show, we were going to get a taco somewhere to make the last few bucks stretch as long as possible. But then, Pamela took my hand and said, "What the hell. If we're gonna bomb, let's go out with a bang, not a whimper!" That night we dined on surf and turf…not one, but two of them, and we ordered

Wind God. This wire caricature is reminiscent of tales of Odysseus and the early gods controlling our fates.

a nice bottle of wine (it had a cork). The next morning we awoke refreshed and satisfied and it was time to strap on the battle gear.

That morning we engaged every customer as if we were millionaires without a care in the world. (Never show fear. Never complain to a customer about how lousy things are.) Half an hour into the show, Pamela sold a huge copper sailing ship, a pricey thing back then, but it covered the mortgage for a month. Then I sold a steel money tree, and then things started popping. By the end of the day, we were financially back in the land of the living. This scenario has played itself over a number of times. Parenthetically, once we actually had a couple of bucks, we went right back to frugally eating hamburgers and hot dogs. You must be cocky. But you must not be stupid.

Critique

TRADITIONAL PEOPLE

The three photos shown on this page represent a progression. The question is: From what to what? Actually, the very first iteration of this series was too coarse to show. He was more desperate hobo, than lyrical musician.

The second iteration, was the guitar player, nice but somewhat bland. *Serenade* is getting closer to where I wanted to go. And then after *Serenade*, I created an accordion player with roller blades and with dachshunds.

The *Fish Guitarist* may not be as cute as the other figures, but he's a more curious creature. I feel that he would be right at home in an Aesop's Fable, or perhaps a Grimm's Fairytale. He's interesting, but there's a dark quality about him that I find intriguing. He's just a bit dangerous. I get the strange feeling one of those fish is going to be in a frying pan before long. And that's all I know about this piece. See? Another myth about artists is dispelled. We usually know, just a *tiny* bit more than the viewer. Once in a while, we know less.

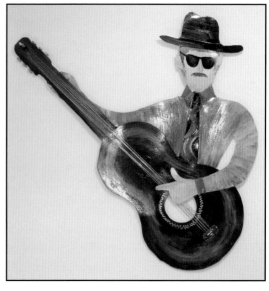

Floyd. This wall sculpture is 4' tall by 3'8" wide and is composed of painted sheet metal.

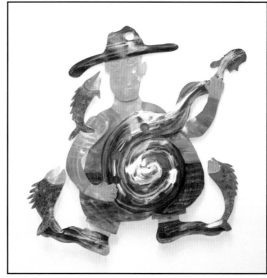

Fish Guitarist. This whimsical sculpture is 4' by 4'. It was cut with a plasma cutter and then brazed and painted.

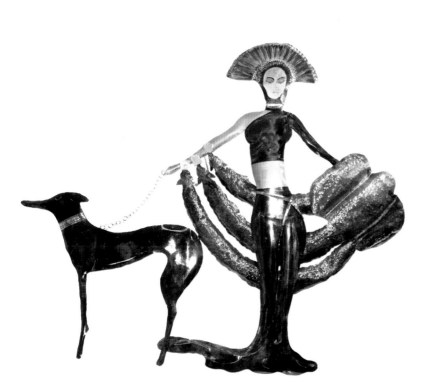

Zelda. Zelda is 5'4" tall and is a tribute to Erte. Oxidized copper and steel.

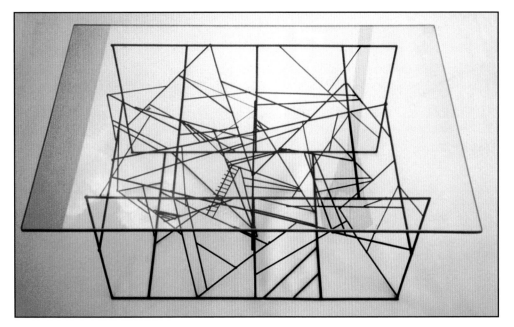

Wire Table. This table was constructed entirely from copper coated welding rod. It is surprisingly sturdy and the negative space is interesting when viewed through the glass top.

What is Art?

In thirty years of sculpting, I have arm-wrestled with many fellow artists and agreed with an equal number on the subject of "What is Art?" The conclusion I've come to is that it's much less important knowing the answer, than continually examining the question. Cop-out? Nope, I'm actually going to commit, here, but I wanted to state the ground rules. Let's go for the obvious stuff first. Is a rainbow beautiful? Yes! Is a mossy tree by a stream glorious to behold? Absolutely! Is it art? ...Nope. Or...if it is, then absolutely everything is art, and if everything is art, then the definition is useless.

When it comes to beauty, Mother Nature wins hands-down. In my opinion, there is *nothing* on the planet more beautiful than a beautiful girl or woman. If we are sloppy in our metaphors, we may say that this woman is a work of art. Let's let that slide, but what we're really saying is, "that woman is just plain gorgeous." No argument, but she's not art, and neither is the rainbow nor the mossy tree.

To follow this argument *reductio ad absurdum* (reduced to an absurdity), let's say in my utter tastelessness, I find a dead mouse and I decide to tie it to a helium balloon and set it free as a sort of sick Beat Generation commentary about our all being dead rats floating around the world. Is this good art? Doubtful. Is it beautiful? No way. Does it make me feel all warm and fuzzy when I look at it? No. ...Is it art? ...Yup.

As much as I hate to admit it, the moment that the perpetrator of this awful piece began thinking of the dead mouse and balloon as a commentary about life, the piece jumped over into the category of art. (We're not talking good art, just the bare-bones requirement for it *being* art.) And that, my friend, is why there's so much weird stuff out there. Everyone has the right to

The mouse and the balloon. Sketch by Cameron Harvey.

interpret the world however they please. As with music, and good food, the ultimate test of whether it is good or not, is whether it stands the test of generation upon generation seeing merit in it.

THE TORCH

"HOW DO I LIGHT THIS THING? *OKAY, NOW HOW DO I TURN IT OFF?*"

Some things are hard to learn, but easy to do. Adjusting the flame on an oxygen/acetylene torch is in that category. If you ever had to learn to use a clutch, you understand. Or sink a three-foot putt, or catch a softball. In these actions, there are a hundred micro-decisions that have to be made, more or less at the same time. Adjusting the flame is easy. Acquiring the experience to know at what level the flame should be adjusted takes time.

The welding/brazing torch that you use, whatever brand you buy, is going to have several things in common with every other torch. It has a barrel, which is the part that you hold. It will have interchangeable blowpipes (tips) that screw into the barrel and the major difference is in the size of the orifice. Very coarsely: Big orifice equals big flame. Little orifice equals little flame...and everything in between. Experiment. If you want to work with jewelry, tiny is good. If you want to repair the muffler on your brother-in-law's Alfa Romeo, however, you'll need a big tip.

TIP FOR BEGINNERS

Lick the end of the blowpipe (torch tip) before inserting it in the torch. "Yuck, I don't want to do that." "...Tough. Just do it."

Lastly, your torch will have two adjusting knobs, one for the gas and one for the oxygen. And no, you won't blow up if you do it wrong. If you try to light the oxygen first, you'll learn a fundamental fact about oxygen. It's an oxidizer. It makes things hotter, though by itself, you can try to light it till the cows come home and nothing will happen. Next is the acetylene...or Mapp, or propane, they're all okay and they all have their points. (For pro-

duction, Mapp is much cheaper, though it burns a bit cooler. Acetylene is great, but it costs more.) If you're going to piddle around in your garage, use acetylene. If you're going to get major-league serious about it, get Mapp.

Now, let's prepare to light the gas and only the gas. We're going to be opening the gas knob, just a crack, (about an eighth of a turn). Before you light anything, always remember to point the flame away from you, from your cat, your husband, wife, your next-door neighbor. Make sure you are in a safe, well-ventilated area with no combustibles whatsoever around. When you're learning...outside is a great place to start and make sure you have proper welding goggles, gauntlet gloves, boots, and old clothes. If it sounds like I'm going ultra safety conscious here, I am. The flame you're going to achieve is going to be running near 5000 to 6000 degrees. It's hot. Don't be frightened. Rather...be respectful.

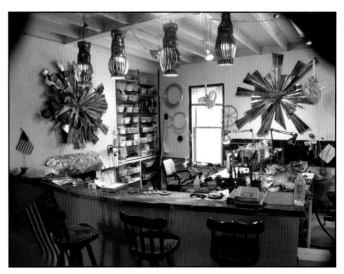

Counter area. We wanted the work area to be inviting so that customers would be able to watch. The counter top is black walnut and this is the nerve center of our gallery.

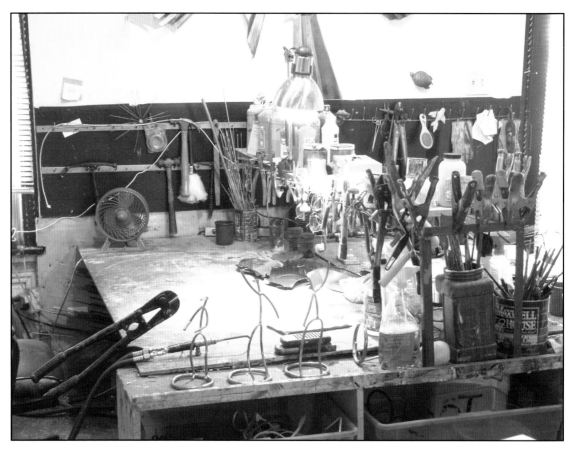

Workbench side. If you look closely, you'll see that there isn't a lot of exotic equipment, mostly hammers, pliers, bolt cutters, and assorted hand tools.

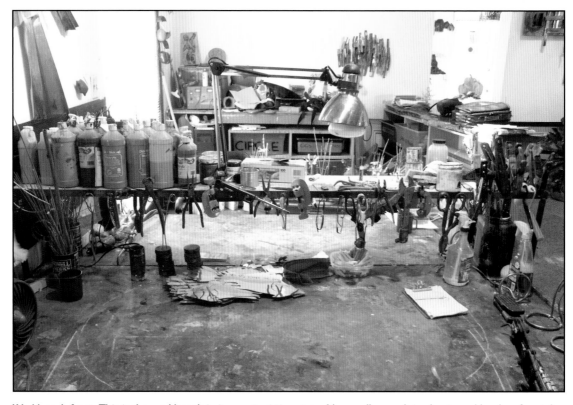

Workbench front. This is the workbench in its most pristine state. It's usually awash in sheets and hunks of metal. The table itself is constructed of 1/2" plate steel to which a 2" angle iron is welded at the bottom. Over time, even the small flame of the torch is capable of warping most table surfaces. Don't skimp on the plate thickness, or you'll be buying twice. The floor beneath our work area is wooden. Consequently, we laid down 1/8" steel plate wherever there was a possibility of sparks landing. And always keep flammables away from your table and keep a fire extinguisher close by.

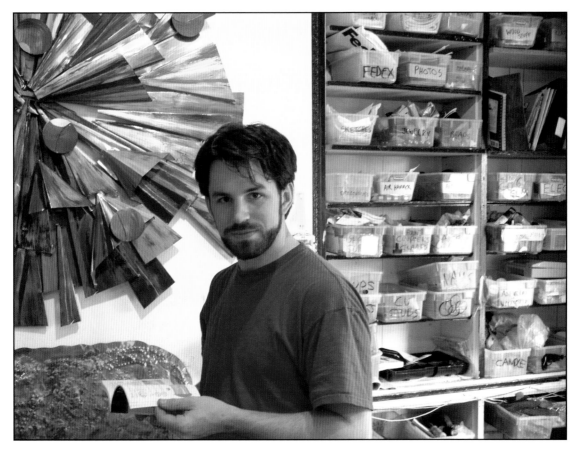

Cameron. This is Pam's and my greatest creation of all! Cameron is 5'10" 20" wide, is comprised of 90% water, 5% sweat, and 5% hot air. Cameron is our beacon to the future.

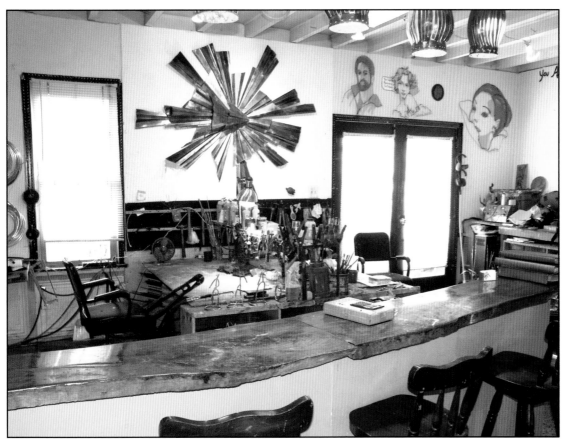

Long view of work area. In this view, you can see caricatures on the wall which we make to order.

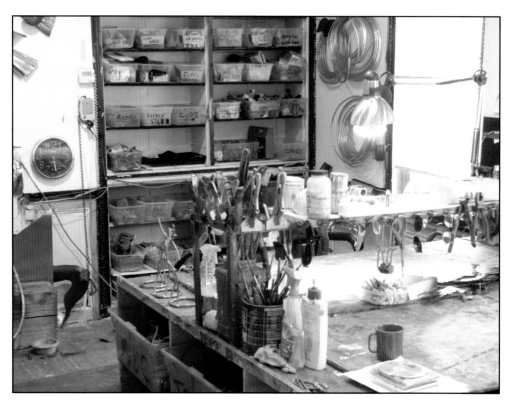

Work area from other side.

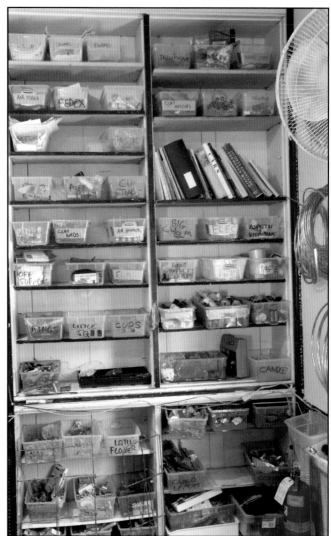

Weird storage. If the containers look familiar, they are plastic shoeboxes from K-Mart, perfect for holding the myriad little bits and pieces that go into our sculptures.

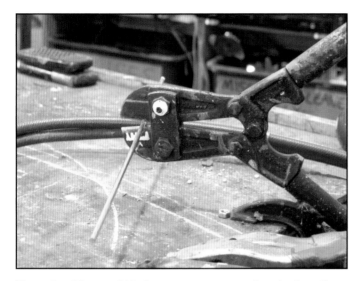

Nippy. Our 30 year-old bolt cutter, grew eyes and teeth about 5 years ago.

I use a Smith aircraft-type torch, primarily because it's lightweight. Victor is an excellent brand as well, but it's a little heavier in general, and there are tiny micro torches available now that do an excellent job for small stuff.

Just oxygen. This is a bit of dry humor. There is no flame with just oxygen.

Okay, now that you're dressed like Nanuck of the North and your heart is pounding, light the end of the torch with a striker. If you bought the torch new, it comes with a striker. If not, any hardware store sells them. The striker is essentially a device for making sparks…and it takes a little getting used to. Practice. Once you've lit the torch, you'll see an orange flame coming out the end. Hey, that's not so bad! Now it's time to get a feel for the adjusting knob. Slowly open the knob a little more. Bigger flame, a little more hissing, and if the initial flame was sooty, that sootiness will begin to go away. Open it a bit more…bigger flame, more hissing. Open it a bit more…Wow! If this is the flame, I'm going to be using— count me out!

Well, it isn't. This is just to give you a feel for adjusting. Now turn the torch off, (crank the gas knob completely off) just to prove to yourself that you really can, and start over. Crack the acetylene open, about a quarter turn this time, and light it. If you gauged it right, you have a purring orange flame and no soot. Adjust it until you have that. Now, verrrrry slowly crack the oxygen knob open. Immediately the flame will become quieter and less turbulent. It's also going to change color. The orange will turn to white, and then as you add more oxygen, it'll go blue. This means it's getting hotter.

In the section below, there's a photo of a neutral flame, which is our goal at this point. Neutral means there's just the right amount of oxygen and acetylene. What you're going to see very quickly is that the big long feathery flame (that everyone else can see) is not the flame you actually use. There is an inner cone of fire that emanates out a fraction of an inch from the end of your blowpipe. It's a brilliant blue-white and this tiny cone is what does all the work. It's your scalpel and where and how you point that tiny cone, is the difference between a rank amateur and a seasoned pro. Practice, practice, practice. What's nice is it's fun learning.

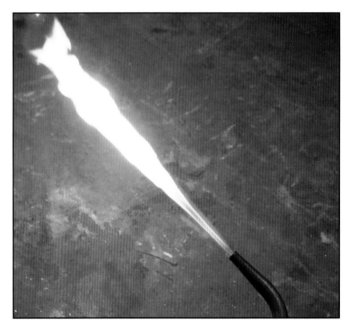

Just acetylene.

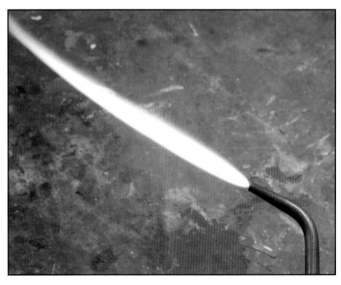

A neutral flame with Jet Flux.

THE THREE KEYS

ADJUSTING THE FLAME
HOW TO POINT
HOW TO PREHEAT

Square-cut Nails. Watch Out! They Can Drive You Slowly Insane!

A lot of people get square-cut nails and horseshoe nails mixed up. The horses don't. You won't either once you've seen them.

Back in the good ole days, we did so many cut-nail sculptures that we bought our nails in wooden kegs and we spent many hours meticulously laying out designs in nails and then brazing them together. Cut nails are great for learning the basics, first because they're cheap and *really* hard to destroy. Second, because even at this most basic level, all of the rules of brazing and gas welding come into play.

Assuming you've gone down to your local hardware store and befriended the manager (*always* make friends of your suppliers. It's good form, it's good karma, and they usually have a wealth of knowledge and advice) you should now have a row of small brown paper sacks sitting on your welding table, each filled with a different size of cut nail. Grab some nails and begin laying out the name of your significant other, or a snowflake, or well…anything. But because we're just learning here, you needn't do a rendering of *The Last Supper* with four thousand cut nails, primarily because those first brazes you make are probably going to be crude.

If you're using a Smith torch, a good all-round tip is a 201. Moisten the end that screws into the blowpipe. This is not capricious and malevolent; it's to lubricate the rubber O-ring to insure a good seal. Plus it's the "in thing" to do if you ever hang around some scroungy welders. Again…safety. No combustibles, proper attire, safety goggles…common sense.

Light your torch (it's okay too if you want to give your torch a name. If you get into this heavily, your torch will be like Lucille is to B.B. King). You want to adjust your flame so that it's not hissing loudly, just a nice robust flame.

Now, we're going to braze our first two square-cut nails together. Here's where the preheating comes into play, and to get serious for a moment, this is it. This is the nitty gritty. The goal here is to make both pieces of metal *equally hot at the same time*. Some people have an instinctive feel for this. Most don't. Logic and the laws of physics dictate, however, that if you're heating a big thing, it takes longer than heating a little thing. So train the tip of your flame (the tiny inner cone) at the larger of the two nails at the point where you intend to braze them. Again, the trick is to heat them both equally, so you're going to be waving it around, but biasing it more toward the larger nail. A little advice: Don't focus the flame in a zombie-like trance at one nail until it is glowing orange. That's too much heat and a good rule of thumb is that if you see color in the nail, it's too hot. Back off and wait for ten seconds or more.

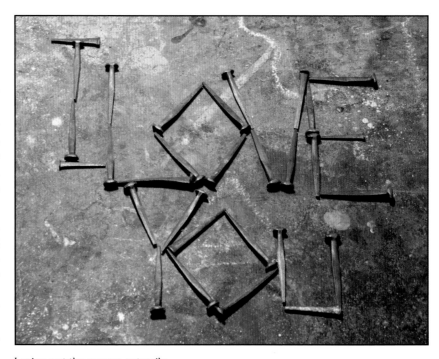

Laying out the square-cut nails.

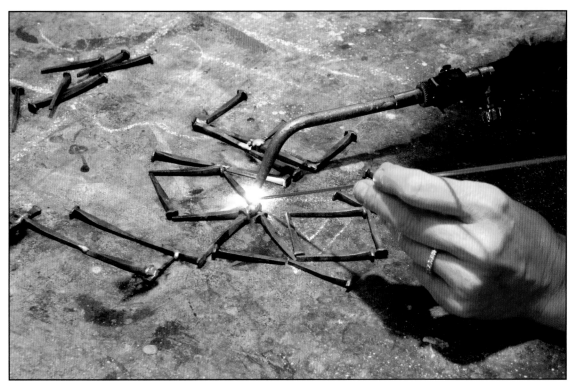

Brazing the nails.

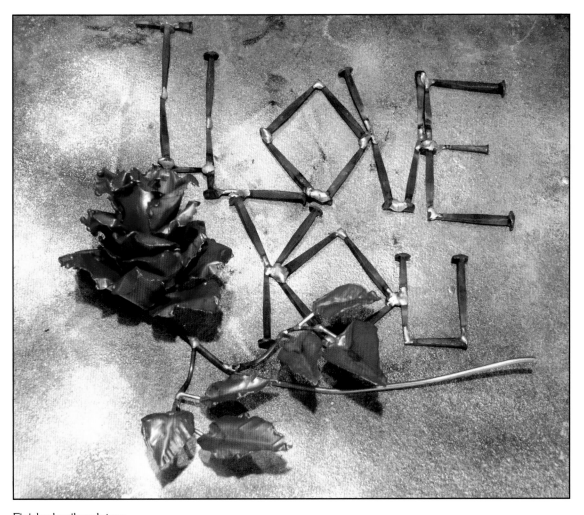

Finished nail sculpture.

SAFETY/TECHNIQUE TIP:

Beginning sculptors all tend to make the same mistake. In a zombie-like trance, they point their torch at the joint they want to braze and then they sit there, as the steel or copper in the joint gets hotter and hotter. Soon it's glowing, like a reactor core on the Starship Enterprise, and a moment later, the brazing rod that has been patiently trying to do its job…gives up. Actually, it gives up its zinc in a tiny explosion of gray smoke. You can't miss the tiny cloud of smoke rising over your now lousy joint. The zinc cloud is an irritating gas, which should be avoided and, of course, your studio should AL-WAYS be well ventilated.

So how do I avoid this mess? A couple of pointers, but it's going to take practice. First, as soon as you see any glowing metal—back off and wait until it cools. Second, and here's where experience comes in, you need to preheat the metal you intend to braze for a few moments to a minute or more for something large. When you finally bring the brazing rod in to melt into the joints, point your flame at the brazing rod, not the copper or steel of your sculpture. Think of the brass as a pat of butter that you have to melt into the joint. That way, the brass will melt first and not overheat…unless, of course, you become transfixed zombie-like *again* and keep pointing the torch at the joint. Once the brass has melted, get the flame out of the way. It's simple to do, and lengthy to explain…and it's key.

Okay, you've preheated, nothing is glowing orange, and we're almost ready to rock. If you're using flux-coated rod, or a Jet Fluxer, you can just go to it now. If not, then dip the end of your brazing rod in flux and then bring the tip of the brazing rod in right on top of the joint you want to fill, and focus the flame at the brass, not the nail. If you can, melt a little blob of brass on top of the joint and then wave the flame over the brass until it melts in and begins to flow. You'll know it when you see it, the joint will suddenly look like it's brass plated. Congratulations! You've made your first braze…hopefully the first of many thousands!

After you've finished brazing all the joints of your project, turn off the torch, and then *think* for a moment. If you're going to burn yourself, this is usually the time…right after you've accomplished something neat. You lose focus and grab onto that sucker…but not for long. A much better way is to turn the torch off, keep your gloves on, and then, with a pliers, grasp the object and quench it in a bucket of water. Keep in mind too, that the welding table may be getting hot, and the tip of your brazing rod is still hot. Make a habit now of ALWAYS placing the brazing rod on the table with the hot end facing away from you. This is a simple but important lesson. It doesn't take any longer to be safe.

Pam and Nail Stabile. This is an early photo of Pam in Tucson, posing with a southwestern stabile.

I always tell my students once they've lit the torch and attached two pieces of metal together that they now have the capability of doing EVERYTHING they see in our gallery. In a Zen kind of way, it's true. To be a great golfer, all you have to do is knock a little white ball in a hole.

Nail Abstract with turquoise. Circa 1977.

44

SECRET WEAPONS

THE JET FLUXER & THE PLASMA CUTTER

Unicorn of Welding Equipment— A Green Flame?

This piece of equipment is so rare, it'll take you fifteen minutes to convince your local welding shop that it even exists.

Way back when, I was leafing through one of my art books and I happened to glance at a small caption beneath a photo. It said something to the effect, "Because of the extensive amount of brazing required on this piece, a Jet Fluxer was used." *Huh?* That's all they said…no explanation, no clue as to where to get one or what it even was.

I called my buddies at Consolidated Welding in Tucson and I could almost see them scratching their heads on the other end of the line. "Are you sure you didn't read it wrong?" they kept asking. "Yes, yes," I kept replying in growing frustration. To make a long story a lot shorter, they finally came across a reference to Jet Fluxers buried deep in their files. No one had ever ordered one. No one even knew what it looked like. "I want one," I told Don on the other end. "Hokay."

Two weeks later it arrived. When I opened the box I thought, *scuba gear?* It was a heavy-duty orange and blue tank, about the size of a scuba tank, a length of hose, and a gallon of jet flux. Following the instructions religiously, I set the system up, connecting one side of it to the acetylene line, and the other to my torch. I pressure-tested the whole thing with Windex, the

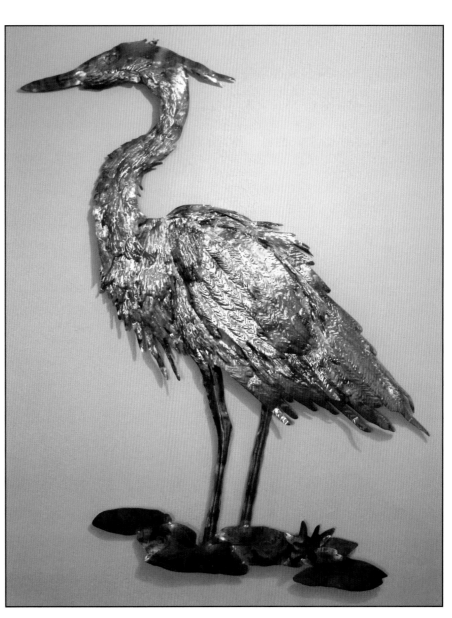

Heron. This copper and bronze work is 6'4" tall and was a commission on the west coast.

accepted method of checking all oxygen/acetylene lines. (Turn everything on, spray all the connections with Windex, and watch for bubbles. If there are bubbles, it's probably not tight enough. Tighten it until there are no bubbles.)

First impression: the sound of someone blowing bubbles with a soda straw in water. This stopped after a

minute or so. Next impression: lighting the torch. It lit without incident. It seemed as if nothing had happened at all. But that was just the residual gas in the acetylene hose. Once that had burned off (about 5 seconds) the flame went brilliant green and then it went out. I was sure I had screwed up somehow. I reread the instructions. There just weren't that many places to make a mistake. There were only two connections. Then for the next minute or so, I just kept lighting it and having it go out. Very frustrating. On about the sixth try, I lit it and it stayed lit...a gorgeous and extremely bright emerald-green flame. I learned that every time you refill the jet flux, this phenomenon happens. It has to do with the jet flux doing all that bubbling at one time and putting too much flux in the flame. In short, it goes away, and from there on out, the torch lit easily.

According to the pamphlet, with this amazing Jet Flux device, my days of buying expensive flux-coated rod, or dipping the brazing rod in flux every minute or two...those days were over. In a word—*they were right!* If you've never brazed anything or suffered the annoyance of having brazed something the regular way and then having fluffy white residue on every single joint, then this sounds like a really ho-hum topic. But if you intend to be a sculptor, then 90 percent of the time you're going to be brazing, and this machine is a godsend. You just touch the brass together and it melts beautifully.

What they don't tell you, is that there are extra advantages to the jet flux that the makers probably don't even know about. It has to do with the patinas of copper. With a green flame heating one side of the copper, the opposite side will give you the richest patinas in pink and red that you've ever seen.

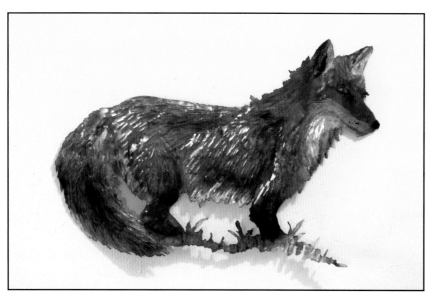

Fox. Painted and hammered copper, 24" by 18".

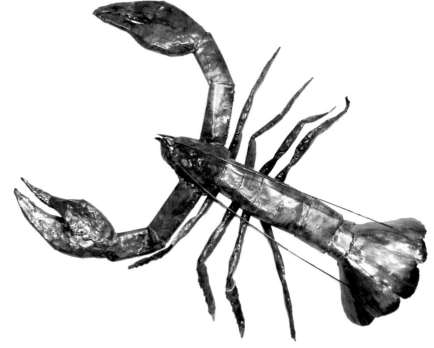

Lobster. Comprised of hammered copper sheet, copper tubing and bronze. Approximately 36" by 18".

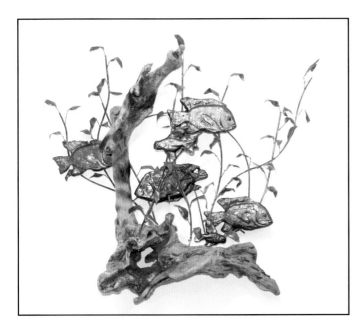

The Reef, cast bronze fish, driftwood, copper and bronze.

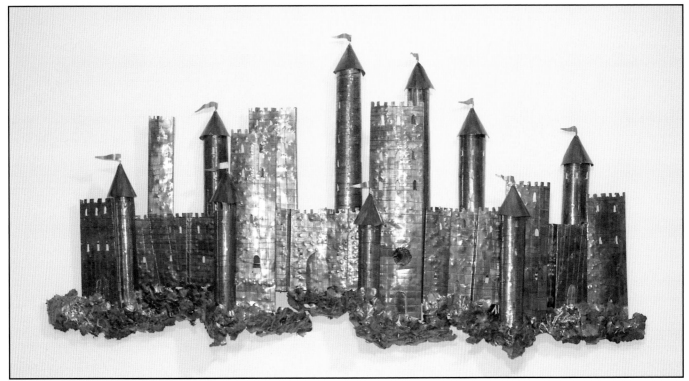

Camelot. This piece was cut with a plasma cutter and then etched with the same, set at a low setting. Copper-plated steel, it is 6' by approx. 32".

The Plasma Cutter

In the big scheme of things, the plasma cutter is a relative newcomer to the art world. And while it's true that some of the old timers, who have suffered through decades of torch cutting their sculptures might sneer, or say it was cheating having a plasma cutter, these are the same people who probably sneered at the newfangled gas-powered lawnmowers. The truth is, for almost all of the cutting a sculptor might do, the plasma cutter is superior. It's quicker, it's more precise, and the biggest advantage of all is there's little or no grinding afterwards. And from a safety standpoint, the edges when using a plasma cutter are much duller than if they were cut with a tin snips or a machine.

With a heavy-duty plasma cutter, you can quickly and easily slice inch-thick plate steel…or turn down the power and engrave micro-thin lines in the thinnest sheet metal. A good example is in the castle photo above. Virtually all of the cutting and engraving was done with a plasma cutter.

PROJECT 1
HOW TO MAKE A LEAF SPRAY

(Beginning Project)

There's an easy way to do this project…and there's a hard way. And since *you're* doing the work, let's take the hard way, because the end result is going to be prettier.

We're making a leaf spray, and the thing that's going to make the project easy or difficult is in the complexity of the leaf you choose. If it's summer or fall and you live near some vegetation, you can go outside, snoop around a bit, and come back with a really neat leaf and trace-out fifty or sixty. Or if you live in the city, you can log-on to your computer and do a leaf search, download a virtual leaf and make a printout. It's not as much fun, but it's viable. Or, if you're daring, you can come up with your own leaf design and have something unique.

Once you have your leaf pattern, you'll need to trace it out. A felt-tip pen is okay, though it tends to leave marks that are difficult to remove. A sharp object like an awl is preferable. If you've decided to make small leaves, thin copper, preferably .010-.015 or thereabouts is available at any good hardware store. Ask for copper flashing.

In the photos in this section, the material of choice was .015 copper-plated steel, which is harder than copper, but has more rigidity, necessary for the larger leaves. Depending on the size of your leaves, you'll need a few square feet to ten or more square feet.

Once the leaves are cut, you will want to stem them so they can be attached to the branch. For small leaves, 1/16" brass rod is fine for the stem. For larger leaves, 3/32" or 1/8" is preferable. Simply braze the end of the rod to the base of the leaf, give it a small curve to make it look natural, and then nip it off with the torch.

After you've finished stemming, it's time to provide a little detail. This can be accomplished with a little judicious hammering, either with a chipping hammer to provide veins, or with a plannishing hammer to provide shape and texture. With the copper-coated steel leaves shown here, I opted for a third technique and just bent them with a duckbill Vise Grips to provide veins and a bit of visual interest.

The next step is to make your branch, which will be the skeleton that holds everything together. Again, the size of the leaf spray, and the type of leaves you choose will dictate the scale of your branch. The one pictured is approximately 36" long by 22" wide. The central spine is a shallowly bent S-curve of 3/16" steel rod, with smaller curved branches of 1/8" steel radiating outward.

Next comes the fun! Though there are no rules written in stone, you might want to consider attaching the leaves at something other than a right angle. An acute angle (less than 90 degrees) is pleasing to the eye and provides a nice natural look. Also, as you attach the leaves, keep in mind that you are working in three dimensions, not two. Leaves can overlap and they can be bent at many angles and heights, just as in nature.

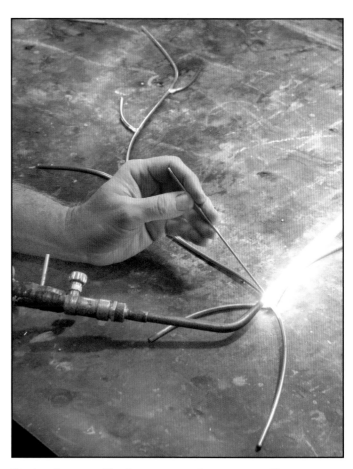

Brazing the spray. The first step in making a spray of leaves is forming the branch.

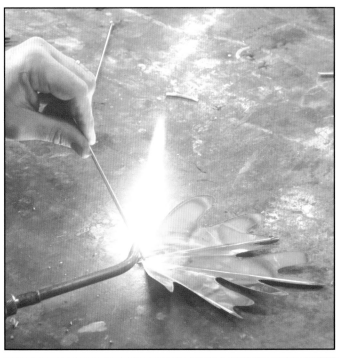

Brazing the leaf stem. The second step in the leaf spray consists of forming and stemming the leaves.

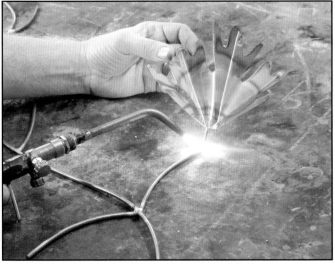

Brazing a leaf. Notice the detail on the individual leaves. They have been heat-treated and then formed with duck-bill Vise Grips.

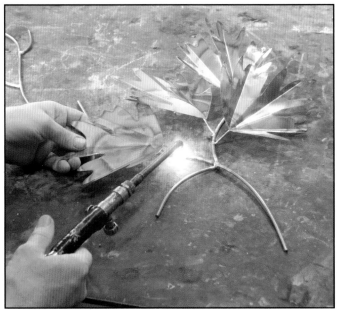

Brazing the leaves. Here is where the artistry comes in. Be sure to overlap and randomize the angles of your leaves to make them more natural-looking.

Once you have your spray roughed-out, you can do a little final bending to make sure the spray looks fluid, then finish off with a little heat applied to the back of some of the leaves to provide a little coloration. You can also introduce a wash of color if you're making your leaves to go with a certain décor. The final step is to take it outside and give it a coat of spray polyurethane. This protects the finish and gives a nice shine to the leaves.

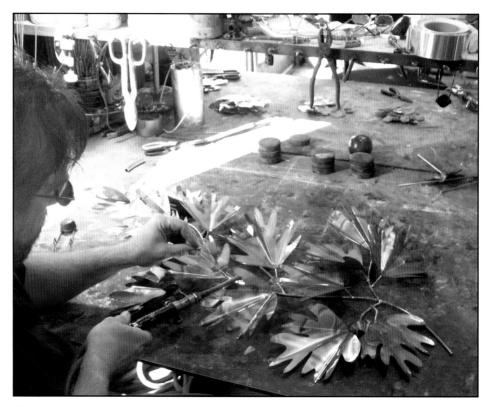

Finishing the leaves.

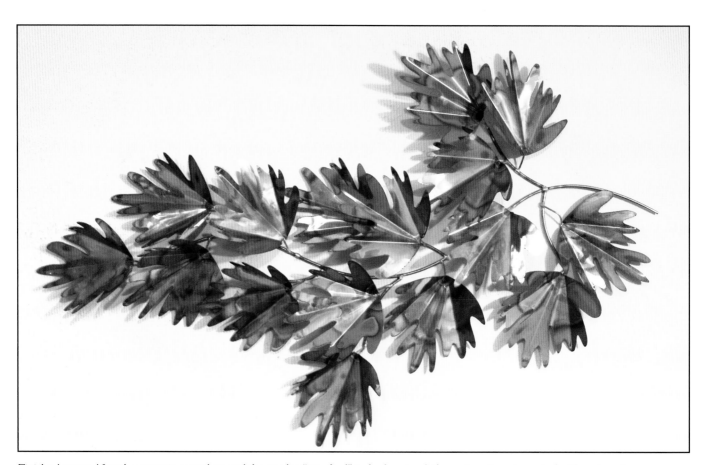

Finished spray. After the spray is complete and the angles "tweaked" to look natural, the entire piece is coated with polyurethane.

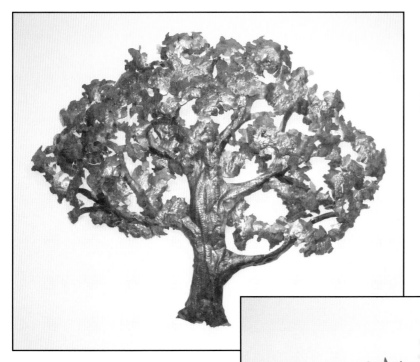

Sugar Maple. Hammered copper, 46" by 44" tall.

Maple Leaf Spray. Constructed of .015 brass and welding rod.

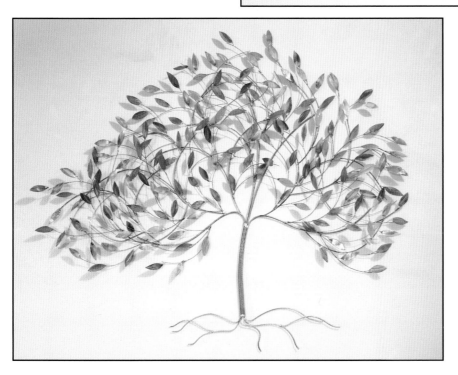

Blowing Elm Tree. Hand-cut, hand-painted copper leaves. 60" by 36".

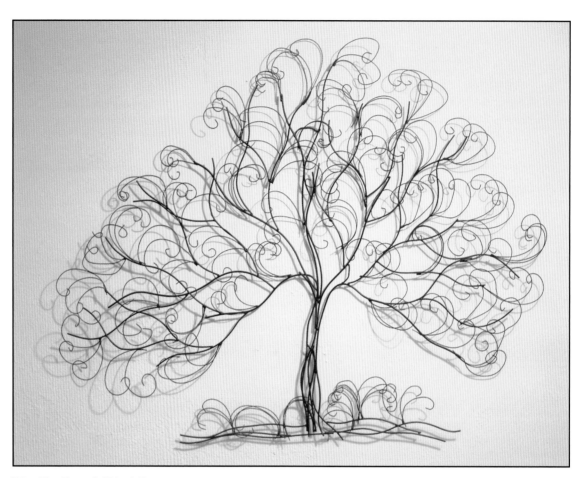

Wire Elm Tree, 4' 6" by 36".

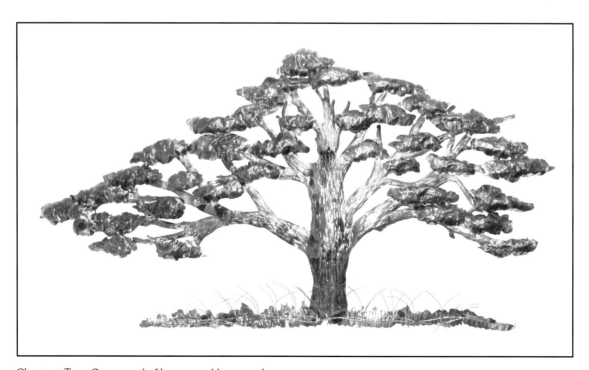

Chestnut Tree. Composed of hammered brass and copper.
60"wide by 36"tall.

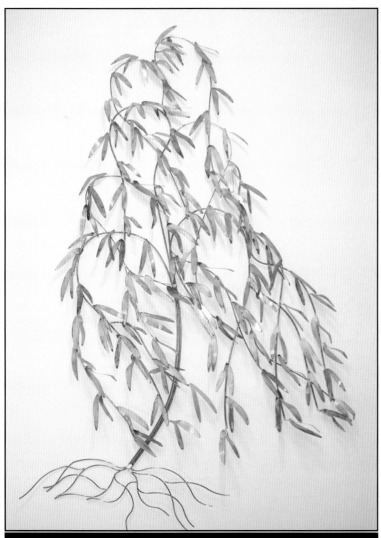

Weeping Willow. Hand- painted copper leaves on welding rod trunk. 66" tall by 33" wide.

Wire Willow with copper sun.

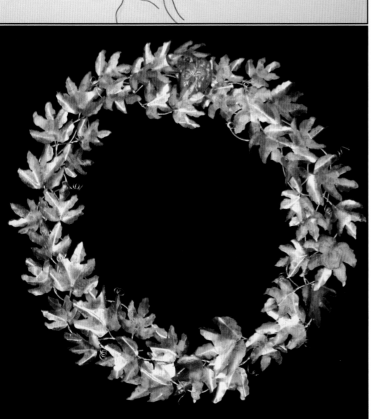

Maple Wreath comprised of .015 soft copper leaves, 36" diameter.

PROJECT II
A ROSE IS A ROSE IS A ROSE

(Intermediate Project)

There are as many ways to make a rose as there are roses. I'm going to show you one way to get you going and give you the basic idea. However, if, from the very start, your Muse is humming in your ear, "Let's change this baby. Let's make it our own!" listen to your Muse, and not the words on these pages. That's where the fun is.

You're going to need some thin copper, somewhere in the vicinity of .015 is easiest to work with, though if you have hairy-knuckled gorilla fingers, you could probably make it out of 16 ounce copper too. Thicker than that and it gets *really* difficult and less delicate looking.

First, trace out the five petal sections as well as some leaves onto the copper. A sharp scribing tool is fine, or a crayon, or a dry-erase pen. The permanent markers tend to leave a mark that's hard to get rid of later on.

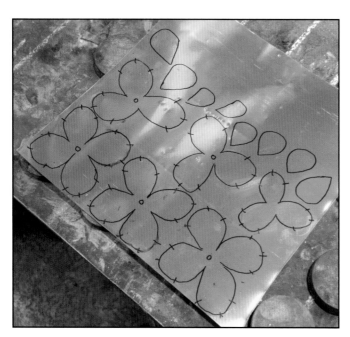

Laying out the pattern on .015 soft copper. Notice the hatch marks where the notches are to be made.

Once you have your parts traced, it's time to cut them out. I prefer to cut them with a torch, though it's easier to make a mistake. Use a small blowpipe and a hot oxidizing flame. (Crank in a little more oxygen until the flame begins to hiss and the blue inner cone becomes more pale and thin.) You will notice two things when you begin cutting. First, you'll notice that the torch is coloring the copper. If you're using a Jet Fluxer, you'll notice that it's coloring it a nice rosy-red. If not, you're going to be more in the chestnut- browns. Not to worry. The second thing you'll notice with torch-cutting copper is that you get little beads on the edges of the copper. For this particular project, the beads are desirable. They look a bit like droplets of morning dew…or whatever.

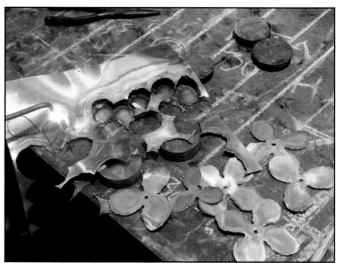

Torch-cutting the petals is preferred to cutting them with a tin snips. The torch cut creates small beads on the edge of the copper, which resemble the morning dew.

Next step is to go back over each of your petals, and using your oxidizing flame, make three tiny notches in each individual petal—one at the outermost edge, and one about three-quarters of an inch back on either side. The purpose for these notches is, when you are finished, to allow you to form each petal into a lovely complex curve. While we're at it, you need to put a hole in the

middle of each layer of petals….except the smallest one. This is to accommodate the stem, which for the purposes of this project will be a 1/8" diameter copper-coated steel welding rod. You can either burn it with the torch or drill it.

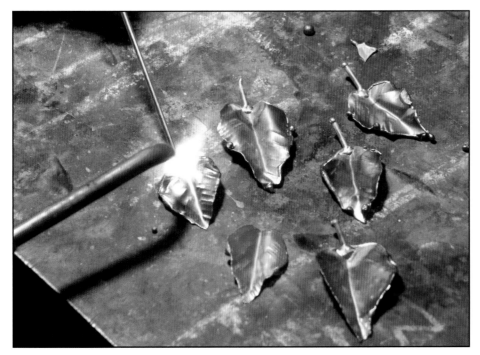

Making the leaves. Torch cut the leaves using the same .015 soft copper, then hammer veins with a welder's chipping hammer. Then braze a stem using brazing rod.

The last step before we begin putting it all together is to cut out the rose leaves. For the sake of this project, we'll cut six: two large, and four small to be placed on two separate stems. Again, if you're really *into* leaves, go for it; that's the beauty of a project like this. You can customize right from the start. Once you've torch-cut your leaves, a nice added touch is to give the leaves a little detailing. I like to use a chipping hammer from a welding supply store. It has a wire coil for a handle and two usable ends, one pointy and one slotted. We're going to use the slotted side to tap little veins into each leaf. Most leaves have a center vein, and smaller veins, which radiate out from the center vein at an acute angle. Be sure you aim; the goal isn't to tap little veins in the ends of your fingers.

We're almost done! Naah, not really. Now comes the hard tricky part where if you're not careful, you'll be drop-kicking your rose parts (and this book) into the garbage can. Forewarned is forearmed. It's difficult.

In preparing for your first braze, cut an 18" stem for your rose out of 1/8" welding rod. Braze a little glob of brass on one end of the rod and then…very carefully braze that glob to the smallest, that's right, the *smallest*

rose triad. The tendency will be for you to point the flame down at the thin copper sheet. Do that for an eye blink too long and it's ruined. Instead, bring the torch tip in parallel to your welding table and at just a slight angle so that you are focusing mostly on the brass dot on the end of the rod (and not the copper sheet). As the brass glob begins to melt, increase the angle slightly, as if you were using the force of the flame to push the glob down on the rose. Once it melts together— quickly remove the flame. Did you get it? Yay! That's a difficult braze! What? You utterly destroyed the copper petals? Join the club. Sooner or later, you're going to do it. Better to get it out of the way now.

The reason I spent so much time on this seemingly small maneuver is that the concept of being aware of the masses of the two objects you want to join is fundamental to your success. Once you learn the concept, it's a piece of cake. But until you take it seriously, you're going to go through a lot of leaves. Practice.

Once you've finally attached the rod to the tiny copper triad, plunge the whole thing in a bucket of water and then go out to the kitchen, have a cup of coffee and a cookie…toast yourself that you're entering an extremely small and elite community, and then get back out to your studio and finish.

The next step is almost as difficult as the first, but not quite. Slide one of the large triad-shaped petals down the metal stem. Take note: Two things you have to constantly keep in mind during this phase of attaching the petals. First: How *far* do I slide this next piece down the stem? Logic would dictate that you slide it all the way down. But you're learning art here, not how to fix carburetors, so forget about logic. You're going to slide the triad down, then bend the leaves slightly so that the triad rests about a quarter-inch up from the first triad. The reason for this is: When you begin shaping the flower, it'll give you more realistic depth to the rose. Second point: When viewed from the top, do NOT align each petal with the petal below it. It's an unexacting science, but stagger the petals with each layer that you apply. Each should be approximately a quarter-inch from the last and staggered. Remember to point your torch more sideways than down. Add a petal, position it, and then braze until you're out of parts.

Okay, right now you have a *really* ugly-looking rose that looks like someone ran over it. That's precisely where you want to be. Here is where the magic comes in. Begin by bending all of the petals upwards. Next, go back and bend a slight concavity into each petal so that every petal is hugging around every other petal. It's prettier now, but it still looks pretty homely. Now, we begin to work the real magic, using those notches we made earlier. With a pliers or your fingers, begin to bend the edges of the petals downward. Experiment. Among the three of us at Harvey Galleries, each of us makes a slightly different rose. Yours will be different as well.

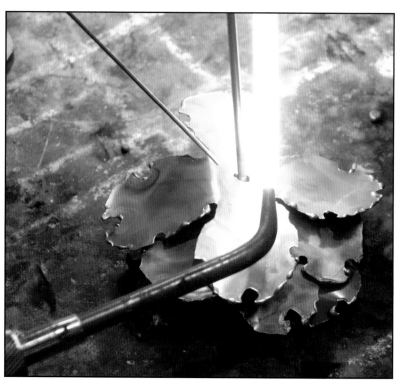

In attaching petals, be certain to allow between 1/8" and 1/4'" of space between layers.

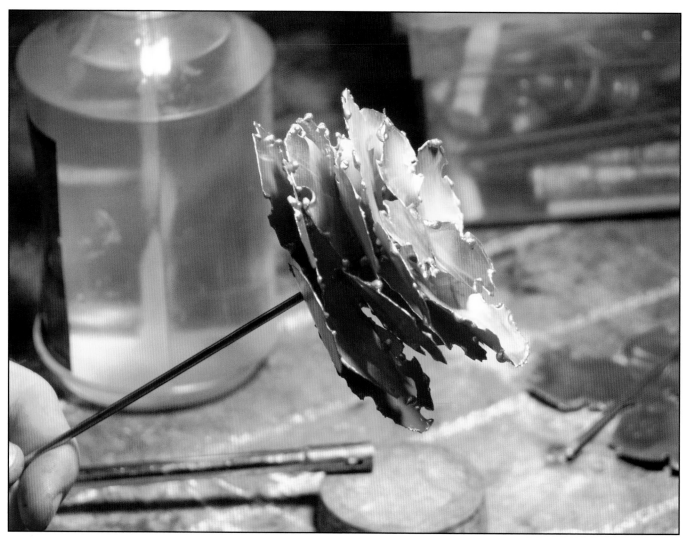

All petals attached.

We're coming into the homestretch now. Your rose is seriously beginning to look like a rose, and if you have a loving family, they will probably remark that your rose is *much* better than the lousy one in this book. Believe it or not, that's my goal. But you're not done yet.

You still have a pile of leaves to contend with and some final details. Ready? First, give the stem a little bend here and there to make it less straight. Second, braze a small glob of brass on the far end of the stem to finish it off. (Always remember to quench.) Now, the leaves: Take a 5" scrap piece of welding rod, preferably 3/32" and give it a little bend to make it look more organic. Now, nip it into two pieces and add globs of brass to each end. These will be your secondary stems.

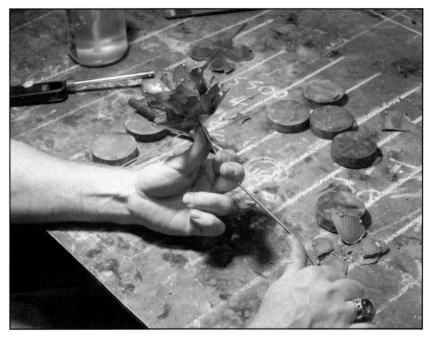

Shaping the petals can be done with fingertips or a pair of pliers. Each person has his own style.

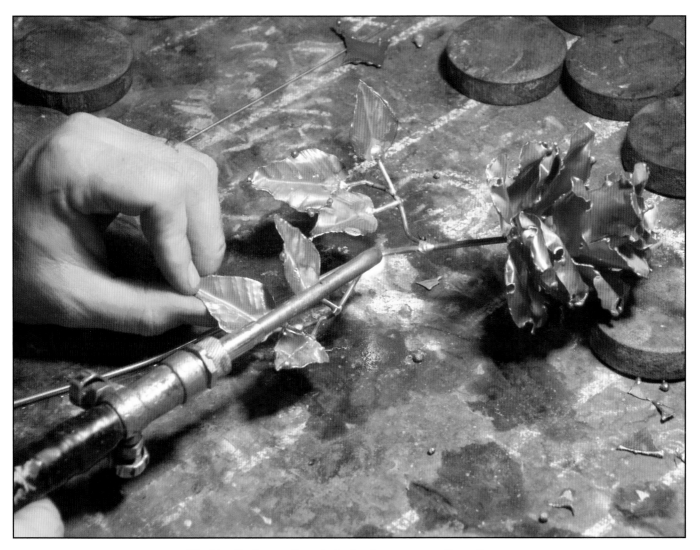

Attaching the leaves. If you look closely, you can see the pattern on each stem, a large leaf at the bottom flanked by two smaller leaves.

57

Next, braze a short length of 1/16" brazing rod to the end of each leaf. These will be your connectors. We're almost done. Now…keeping the Zen concept of rose leaves in mind, and using a pliers to hold the leaves, carefully braze a large leaf on the end of each rod, then two smaller ones farther down the stem. Quench them and then attach the two secondary stems to the rose stem preferably one on either side, and staggered slightly.

The last finishing steps: If you used a Jet Fluxer to make this rose, your copper is probably already a shade of pink and red. Using the torch flame, carefully go over the petals, heating them slightly to give them a nice patina. Focus that flame too long, however, and your rose will look like the main course at a Japanese beetle convention. If you don't have a Jet Fluxer, and most people don't, take heart, we're going to make your rose even prettier. It's called giving the copper a *wash*. You'll need a little paint. Acrylic from the craft store is fine, and I would suggest for your first rose, stick with a red or magenta. If we were going to be crass, we could just use a spray can of red paint, but much would be lost. The goal here is to allow the oxides of copper to show through. Mix a little red paint, heavily watered down with water, and brush on. If it's too thick, wash it off and start over. The goal is to tint the copper rather than paint it, so that the metal shows through. When it's dry, you can spray it with a clear polyurethane spray to give it that finished look. If you like, you can also give a sage or forest-green wash to the leaves. *Now*…you're done. When you surprise your significant other with it, you will be amazed at how impressed they are with your feat. This is a difficult project and you should be proud. Eleven more…and you've got a dozen!

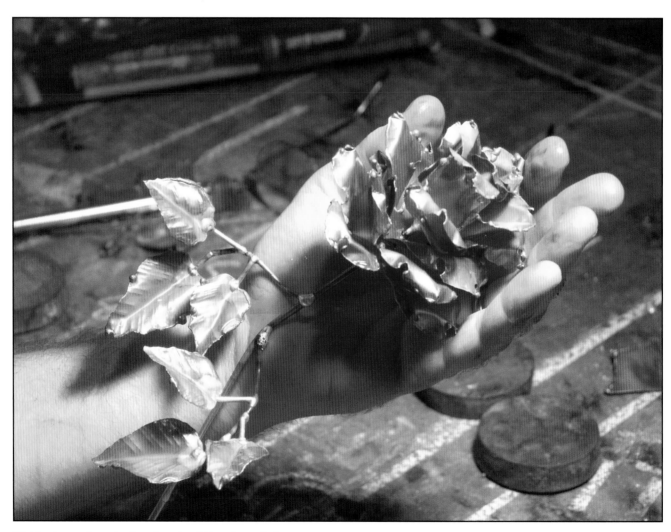

Finished rose. A work of art that should last through the eons.

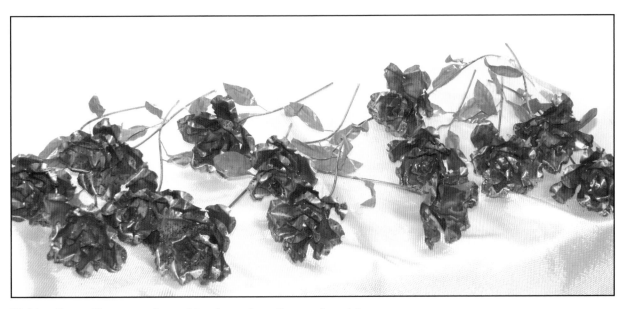

Wedding Roses. These were the wedding favors from Cameron's wedding.

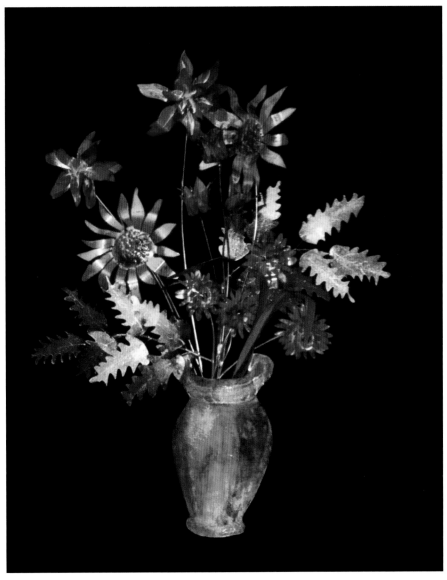

Vase of Flowers.

THE ROSE THAT
SURVIVED EVERYTHING

Way back when, when we were just getting going in Tucson, we were making everything and anything, trying desperately to figure out what would sell so that we could pay the mortgage. It was the process of natural selection at its most fundamental level. I discovered that roses were popular. In the big scheme of things, it made sense. They were hard to make and time consuming. God forbid, customers would flock to something that was easy to make.

I began making lots of roses and then adding them to words that I had brazed together in square cut nails. Remember now, we were in Tucson, Arizona, where you can actually burn your flesh against a car that's been sitting in the sun. I brazed the word *Love*, and that sold. I brazed *I Love You*, and that sold. I brazed *Think Snow*, and that sat there for a year. One time, in an effort to be clever and swanky, I brazed the word, *Panache*, and was informed by every fifth customer that I'd misspelled *Pancake*. Oh well.

One day a young couple (but old customers) came in with one of my old rose-and-nail creations. They were carrying it in a paper bag and they were acting a little weird. After an exchange of pleasantries, they told me that their house had burned down recently. They were covered by insurance and no one had been hurt, but they had lost…everything. Then the wife began removing it from the paper bag. They had bought it just before they had gotten married. It was now gray and sooty but otherwise okay. "This is the *only thing* that survived the fire," the woman said.

For a moment we all just stood there, looking at the crude nails and the sooty rose. It was then that I began to realize that sometimes a thing transcends what it's made of. The sooty rose and the "I Love You" in nails had become VERY important. "Do you think you can…clean it up a little?" the woman asked.

"Oh, you bet I can."

"Whatever it costs," the husband said.

"It costs nothing. It's got a lifetime guarantee."

PROJECT III
BEHIND THE SCENES WITH THE BLUES PLAYER

PLUS…ANOTHER SECRET WEAPON!

This project began with an e-mail from a gentleman out in California. He had seen our Blues Player sculpture on our website, www.harveygallery.com and fell in love with the concept. However, what he really wanted was a fountain, and he wanted to know if there was a way we could modify the Blues Player to accomplish both tasks.

As is typical for us, we accepted the challenge and then began scurrying around trying to figure out exactly how we were going to do this.

The first obstacle was that, while our client really loved the initial sculpture, he also wanted to have more apparent mass to the piece. The original was constructed of 3/16" plate steel and while it was physically massive, when viewed from the side and at certain angles, it needed more visual mass. As a caveat to budding young sculptors, if cutting a design in steel takes X amount of time, making a hollow-core version takes at least 4X … four times the amount of time, which is a factor that must be considered in due dates as well as pricing.

After sending sketches and negotiating an acceptable price with our client, we received our usual 1/3 commission to begin work, and began working in earnest on the construction details. Cameron and I were in the midst of designing the routing of the water, when we got another challenge from our client in our e-mail. He was doing his homework as well and had decided that he preferred a smooth edge to the piece as opposed to our traditional brazed edge, which is elegant, but a trifle lumpy.

This sounds like a minor thing, but it was *huge* for us because, well, that's the way we've always done it. We told our client that we would work on the problem; there was a period of about a day, when all construction stopped as we grappled with the problem. "We could Epoxy the copper to the framework," Cameron suggested. That was a possibility, though Epoxy hardens to a somewhat brittle state, and I was concerned about the trip across country, bouncing around and possibly splitting a seam.

More time went by and on a whim, I went on to the internet and began surfing for solutions. Somewhat serendipitously, I wandered into a virtual chat room where two individuals were discussing the best way to restore side moldings on their vintage sports cars. One was raving about a little-known industrial product from 3-M, a tape that was so powerful that it was better than welding, better than riveting, with the only caveat being, "align it correctly the first time, because you'll *never* get a second chance."

The nomenclature for the mystery tape was 3M- VHB (Very High Bonding) 4910 and I discovered with a quick trip to the 3-M site that the tape was so powerful and so resilient that they had constructed an entire motorhome with the stuff, using only their tape to connect the panels together. It sounded promising.

We received our rather expensive roll of VHB tape by next day Federal Express and began experimenting, applying a square inch to a square of copper, sticking it onto another square, and then trying to remove it. In a word, it really is remarkable and no amount of yanking, straining, or throwing it against the wall had any effect whatsoever.

What was even better, it's waterproof and leaves a beautiful tight and nearly invisible seam. Touchdown!

As you can see in the accompanying photos, we began plasma-cutting our Blues Player and working on the skeleton that would hold everything together.

The next real-world obstacle we ran into was the fact that by making the Blues Player more massive, the cost of shipping this sculpture to California…in one piece had become nearly prohibitive. We called our client and asked if in exchange for a reasonable shipping fee, would he mind bolting several components together? Fortunately, he was (and is) a very gracious and understanding customer and agreed…and then we were confronted with the prospect of making our sculpture a bolt-together project.

As you can see, we were successful. The piece was sent in essentially five sections and it looks beautiful. However, beware of what you get yourself into. In this business, the initial goal is to create something beautiful. But the job doesn't end there, and often you'll have to innovate and problem-solve to get the job done.

Sketching Blues Player. The template is copied to a sheet of 36" by 96" half-hard copper, then plasma cut.

Plasma cutting the body.

Cutting the arms.

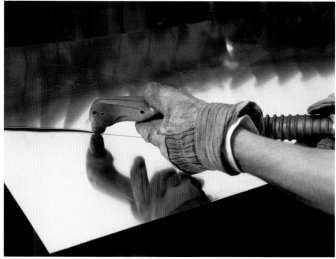

Close-up of plasma cutting. Notice the clean and precise kerf that is cut with the plasma cutter, with no heat discoloration.

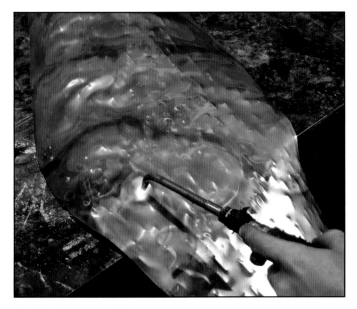

Creating the heat patina.

Interior bracing of the player. Notice the use of our secret weapon, 3-M VHB (very high bonding) tape in strategic locations.

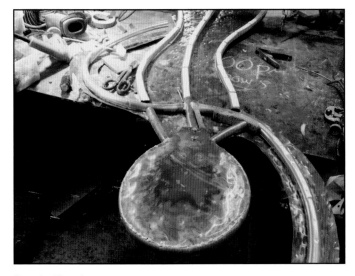

Detail of head.

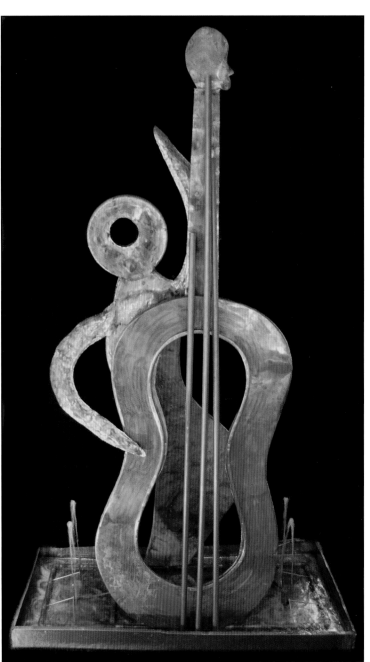

Blues Fountain, courtesy of Mr. Frank Sheets. This piece is approx. 8' tall and 5' wide. It shoots water from four separate jets located in the basin.

PROJECT IV
HOW TO MAKE A SPIDER WEB

What can I possibly have to say about a spider web? It's pretty straight-forward…or is it? This is one of the few exercises that's good for beginner, intermediate, or advance-level sculptors, depending on what metal is used. If you're a beginner, make the radiating spoke pattern out of steel welding rod, then join the spokes together with a smaller diameter welding rod. If you take it slowly, it's a fairly straight-forward project. Just make sure you obey the laws of physics. If the connecting strands are going to droop as they do in a real web, make sure they droop down.

If you're at an intermediate level, try making the radiating spoke pattern out of welding rod, and the connecting strands with brazing rod. And if you're beginning to really get the feel of the torch, try making the whole thing out of 1/16" brazing rod. It's trickier than you think, but it's terrific for developing your timing.

The thing that really got me into spider webs was a book by E.B. White entitled, *Charlotte's Web*. In White's book, Charlotte, the spider, constructs several bizarre webs, one with "Some Pig" woven into it and another with "Terrific" in the strands. In my own private collection, I've followed in Charlotte's footsteps.

To kick off, let's cut 12 lengths of 3/32" welding rod. The rods should *not* be measured with a ruler. We're looking for a certain randomness here, and your spider web will look fake if it's too perfect. Plan on making your rods somewhere in the neighborhood of 12" to 16" long. Give each of them a gentle, almost invisible bend, to cancel the machine-like perfection of the rods, then make a radiating pattern…again…not perfectly symmetrical. Some gaps should be larger than others. If this concept of imperfection is annoying to you, perhaps you'll be happier designing printed circuit boards.

And there will be a few of you, who are already thinking of ways to improve on this basic design…a spider web in a doorway, a spider web in a crook between two branches, a spider web that's been rained on. (How do I do that?) Think 5-minute Epoxy.

Once you have your spokes and you've checked to make sure nothing is perfectly straight, we can begin adding the connecting lines. It's best if you can support your spoke pattern on a makeshift (nonflammable) easel so that you can keep the law of gravity in mind. Begin by bending several 1/16" diameter welding rods into a gentle curve. Then start attaching the connecting rods at the bottom.

Make sure that the droop or curve in the rods is always down to account for gravity. Do a whole "slice of the pie" starting with fairly large gaps on the outside and tight gaps toward the center of the web.

Once you have a section done, go ahead and complete the perimeter of the web, keeping gravity in mind for your curvature. Once these are complete, you can relax a little and just follow the curvature of your perimeter lines. If you're having trouble completing the joint with two 1/16" rods meeting on a 3/32" rod … practice … and be glad you didn't try it with brazing rod, where things happen much faster.

After you've filled in all the "slices," it's time to go back and do a little detail work. If you look closely at real spider webs, you'll see the occasional extra brace, an extra stretch of thread that connects the two radiating lines. Go around your web and add a bunch, then step back and analyze your work. Does it look realistic, and magical? Or perfectly symmetrical? If it's perfectly symmetrical, you can hang it over your computer terminal.

No self-respecting web is complete without a spider. I like big hunky ones, bordering on tarantuladom, but that's just me. Just remember they're arachnids and so they have eight legs. I usually make my spiders out of brass. Melt a big round lump of brass, about the size of a nickel for the body, and a smaller lump, about the size of a small pea for the head. Connect lumps, and then using 1/16" brazing rod, braze eight legs on (four per side). It's easiest if you make your spider on a welding table and attach the legs flat-out as if the spider had just been squished. Afterwards, you can bend the legs up at about 45 degrees, then back down, with a little curve to them. Lastly, you may want to have your spider hanging by a thread. Attach a 1/16" brazing rod to the rear end of the spider and then attach him or her wherever you think it looks best.

Option: For the dark-thinking ones out there, you can roll strands of fine wire into small cocoons and attach them here and there on the web. I suppose you could also attach tiny red beads to the spider's head for glowing eyes…but that may be pushing it.

For the hotshots, whose testosterone demands that they do this easy project the hard way, do everything above in the same way, only use 1/16" brazing rod for everything. Oh, and if you really want to suffer, use a big and hunky 204 torch tip and blast away! It's possible!

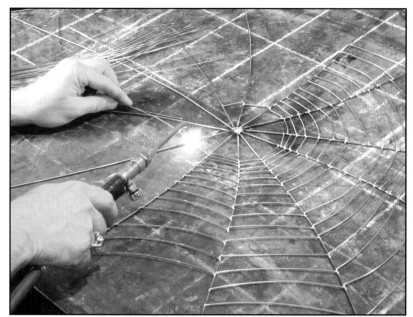

Begin with slightly bent wire.

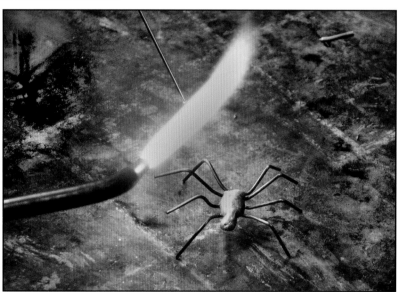

Creating the spider.

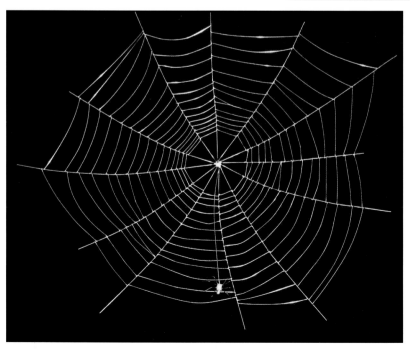

The finished web.

Like most of you, I have a working knowledge of the term, multiple personalities. I have seen the movie, *The Three Faces of Eve* several times and I've watched several talk shows on the subject. But that's about it. One day a woman walked into our gallery. She had spied a sculpture in our window that she said she resonated to. The piece was completely black with figures resembling flames as much as people. We learned that our customer had multiple personalities and that she did, indeed, have seventeen separate personalities.

Naïve questions quietly came to mind. Did each of her personalities have their own taste? What if Susy ordered the sculpture and Wendy didn't like it? Intrigued as I was with the concept, however, I took the commission. A month later, the customer picked up a large black sculpture with seventeen flame-like souls emanating from a circle. The gal was very sweet and introspective, and there was no problem at all. I guess they all liked it.

PROJECT V
HOW TO MAKE TWENTY RINGS IN TWENTY SECONDS

Well, maybe thirty or forty seconds. And preparing to do this is going to involve going down to the hardware store and buying some short lengths of steel pipe, eight or ten-inches will do, and you should buy as many diameters of pipe as diameters of rings you desire. Pipe is cheap. Splurge! Drag them all home and then drill an eighth-inch hole a couple of inches from the end. You've just made yourself a ring-making tool.

To be really extra safe, put on a pair of safety goggles, because in theory, if the wire you stick in the hole slips out of your hand, it could theoretically swing around and hit you in the head. It's a long shot, but I'm trying to take care of you here. Just do it, okay?

Stick the end of a welding or brazing rod into the hole, grip the pipe firmly and begin wrapping the wire tightly around the pipe. Bingo! You will find that because of the springiness of the metal, the final rings will be slightly larger than the diameter of the pipe.

Now that you have your coil, it's time to separate them. If you have a plasma cutter, just run it across the coil, and in about three seconds, you will have a handful of rings. For the rest of you...well at least you didn't have to pay for a plasma cutter. Get your bolt cutters or your

Making Rings. A variety of diameters are available depending on the diameter of pipe chosen.

nippers and begin snipping them off one-by-one. Now you can make: bicycles, toy cars, abstracts, eyeglasses for creatures, all kinds of things!

TIP

Sometimes very small breakthroughs in technique yield large results. For years, perhaps decades, I have made abstracts with many randomly curved wires. Most of the names of these works were derived from food, as in Linguine with Clam Sauce, Spaghetti Night, etc. because of their random nature.

I began experimenting, trying to bend many wires at the same time, so that they would have continuity. It wasn't impossible, but it was difficult, because they kept slipping and turning. Finally, I brazed the ends of a handful of welding rod together, and instantly realizing I was on to something, I brazed the other ends together as well. I then began bending them in all kinds of configurations. The result was as spectacular as it was simple. Now there is a harmony to the curves that is extremely pleasing when viewed in the flesh.

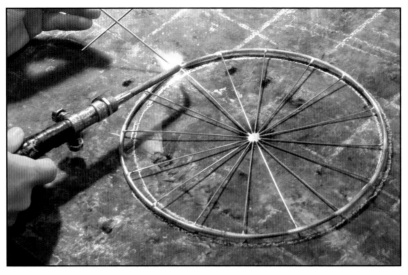

Making a large wheel.

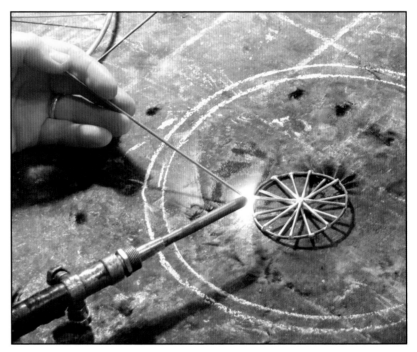

Making a small wheel.

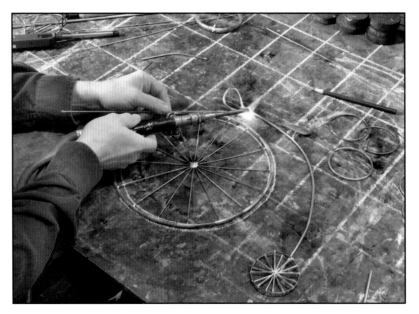

Making a penny farthing bicycle.

CHAPTER 6
THE MUSE

THE RANDOM FACTOR AND THE "NOT ME"

Lately, I find myself trying more and more to take the "me" out of a piece, whether it's an outdoor sculpture, a short story, a fountain, or a novel. I suppose this requires a bit of explanation. The concept came about when I began writing for a living as well as sculpting. With writing, it's always best to try to breathe life into your characters and then let *them* go and say and do what they want. In the medium of writing, the writer and the style of the writer should be invisible, which is to say, *not* self-conscious, so that the reader and the characters are able to develop their own relationships. I found this concept exciting and decided to apply it to sculpting as well.

The other concept I learned when I began writing was that of *The Muse*, and that too requires a bit of explanation, because randomness and taking the "me" out of your work, and finding your Muse, are all different ways of expressing the same thought.

With the writing, I began to discover that my best writing occurred early in the morning, when the "me" was not quite awake and the Muse was strongest. Many writers notice this, and when they are in the "zone," they say that their Muse is sitting on their shoulder and running things. When they're not in the zone, they wonder where the hell their Muse went. "Is she out having coffee at Dunkin' Doughnuts? Is she on vacation in Portugal?" Or worse—"Did I do something wrong and she's left me forever?"

You can call it what you want, your creativity, your Muse, your inner self, or your subconscious, but the fact of the matter is, much of your best art is going to come from there and *not* from you sitting down and glaring at a blank sheet of paper or copper.

To the uninitiated, this may sound like so much mumbo jumbo, as if we are talking about leprechauns, trolls, and fairies. I assure you, it is not. And, no offense to engineers and accountants, but it is this precise deductive type of thinking (so important to one sector of life) which tends to slam-dunk the creative or subconscious part of your brain.

Call it left-brain, right-brain thinking; call it whatever you like, but this is an art-focused book and the goal here is to learn to cajole your Muse into coming out to play. Start your sculpture with a blueprint, however, and the Muse will be gone. Worse, your work of art, without the magic of the subconscious, will suffer.

Many metaphors apply. Yell at your dog for him to come to you, and chances are he will cower in the corner and probably piddle on your rug. Get down on your hands and knees and soften your voice, and your pup will be over like a rifle bullet. Or…hop in bed with your mate on a Friday night and *demand* that he or she be wondrous in bed. Chances are, you'll be sleeping alone. The Muse reacts the same way. About the worst thing you can do, is declare, "Today, my goal is to make a GREAT sculpture!" It's not going to happen.

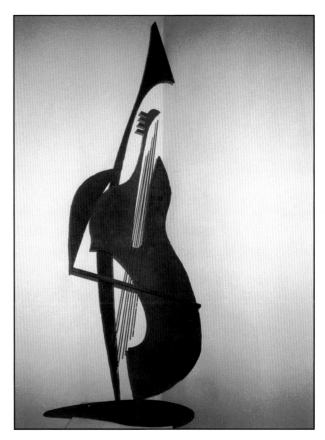

Early Bass Player composed of Cor-Ten steel 1982.

Cajoling Your Muse

This is harder than it sounds. It's a little like trying to see something with your peripheral vision. The moment you turn your head…it's gone. And you can't very well lay out peanuts or M&Ms to coax your Muse out of its hole. The Muse, fickle thing that it is, hates to be pushed or yanked on. The best place to start is to find what time of the day your Muse is likely to be awake. For me, it's strongest early in the morning; for others, it may be late at night. You'll have to experiment getting into that zone. Another little trick that might help, is approaching your goal obliquely. Rather than saying, "I want to make a great and spectacular sculpture today," you might try asking *What if*, or *I wonder* questions. "I wonder what a robot spider would look like?" "What if I made a woman's torso…completely out of pieces of driftwood?" "What's the simplest way I could convey a guy with an umbrella and a briefcase, waiting for his bus?" "Instead of a rocking horse, what would a rocking aardvark look like?" These are all questions that lure your Muse out like cheddar cheese to a mouse. Try it. You'll find mental images popping in your mind like crazy. Once you get your image…begin work. But keep in mind that your Muse is not a linear thing. Half way into the project, she might decide that it's not a rocking aardvark she wants…but a rocking crocodile. Listen to her. Follow her, and really *try* to stay the hell out of her way. You'll be glad you did.

Critique

A TALISMAN

A talisman is a stone, ring, or other object that possesses powers or has an influence over something or someone's feelings or actions. This talisman sits in a clearing in a woods protecting approximately 10 acres. The deer sniff and move cautiously around it. The ground hogs like the grass beneath it, and the blue jays like to perch on top of it. As for me, it makes me smile, something many comedians are incapable of doing. In a small breeze, the copper globe turns slowly, and the cast bronze hand inside, turns back and forth. Sometimes it looks like the hand of the Pope, waving to his well-wishers. This piece went through a number of transformations. The globe was initially a set of plasma-cut gears within gears. I was hoping for a delicious juxtaposition between the wood and the gears. It didn't happen. Days went by and as I was unraveling a coil of copper, I happened to hold it up in front of the waiting driftwood. Even in its rough state, it looked good. The top piece of wood, cradles the globe in a comforting way. Then I tried a number of objects inside the globe…a bird, a face, a collection of small spheres. But the hand seemed to be more in keeping with the calming feeling of watching over the property.

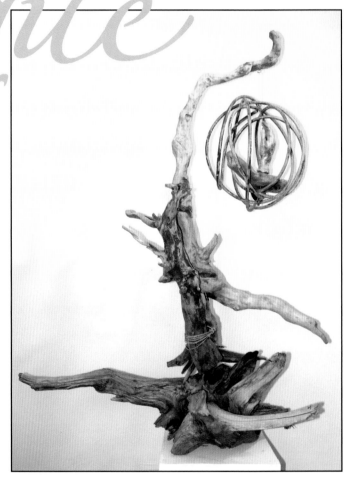

Talisman. This outdoor sculpture is 64" tall and is comprised of several sections of driftwood that have been pegged together, then wrapped with copper tubing. The hanging portion is copper tubing, and in the center a cast metal hand.

THE WIRE MATRIX

All the sculptures in this section have one thing in common. Their skeletons are composed of different thicknesses of wire and/or welding rod that are brazed together.

In the case of Flags of New York, New Orleans, Festival in Cuba, and New York, the matrices are parallel welding rods laid out on a table, overlaid with rods that are perpendicular and then carefully brazed together. Be careful, one bump of an elbow and you'll probably have to start over.

In the case of Pastel Squiggles and Blue Spheres, the matrices are curved, not straight, and if you look closely, they are grouped in bunches that are roughly parallel to each other. The easiest way to do this is to braze several straight rods together at both ends and then bend them into curves.

In the case of Velocipede and Bubble Cycle the matrices play a much more serious role in the design of the sculpture. Indeed, they are the heart of the sculpture. In both of these sculptures, I completed entire layers of matrix and then spaced them away from each other to create more dimension. If you look carefully, you will see bubbles (rings), curves, and it's not uncommon to use springs, washers, cable, or caricatures within the matrix itself. There's no limit to the number of layers you can use. Just remember, if you braze sheets of metal to the lower layers, and you want to color them, color them ahead of time, because with each succeeding layer, access becomes increasingly difficult.

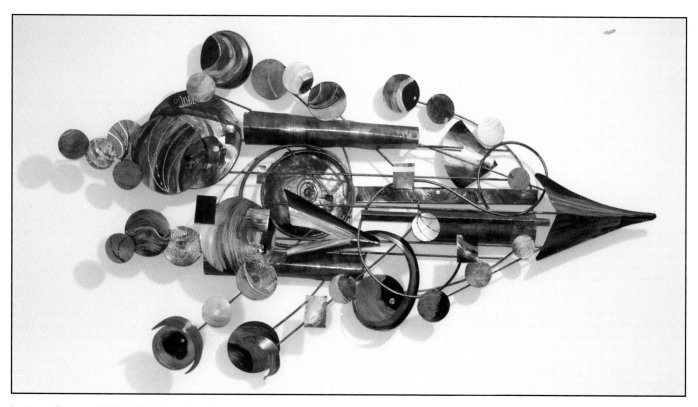

Lollipop Factory. 53" by 33" Painted steel.

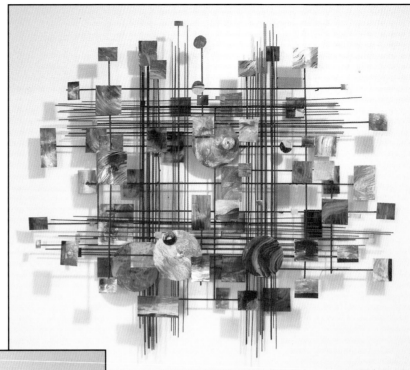

Blue Metropolis. This sculpture is comprised of four layers of matrices to provide depth of field, then copper squares are painted and attached. 48" by 53".

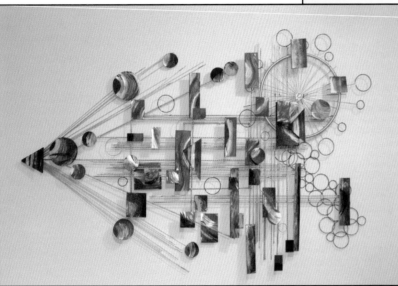

Velocipede 2. This is one of our whimsical wire abstracts. 66" by 45". Brass and painted copper.

Blue Spheres. This is an example of a modular abstract, in that several similar pieces can be hung in close proximity to achieve the desired effect.

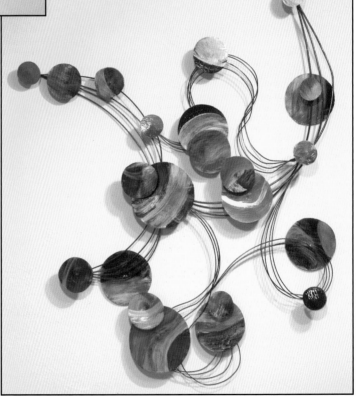

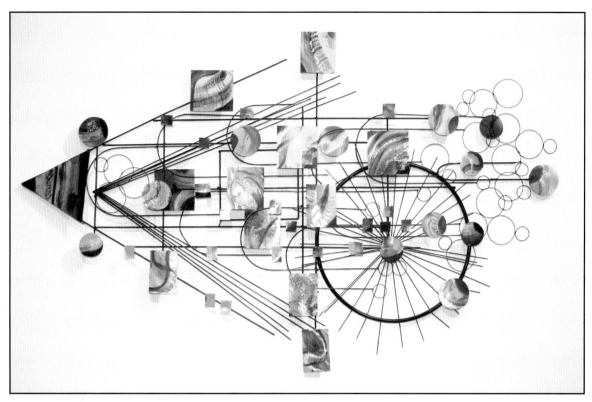

Bubble Cycle. Brass and painted copper, 62" by 43".

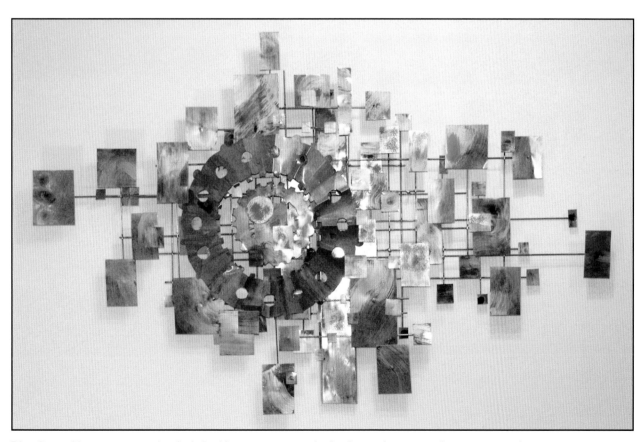

Blue Gears. Here is an example of a hybrid between our standard cubistic abstracts and our new gear abstracts. The juxtaposition is quite pleasing.

Festival in Cuba. 44" x 46".

Pastel Squiggles. Another example of our Squiggle Series, this is a modular piece which can be created in any size or configuration.

Chicago. 52" wide x 46" high.

New Orleans. Black wire painted matrix with colored squares and circles. 55" by 45".

Flags of New York. Our flagship in this style, created just after the 9-11 crisis. 66" by 66".

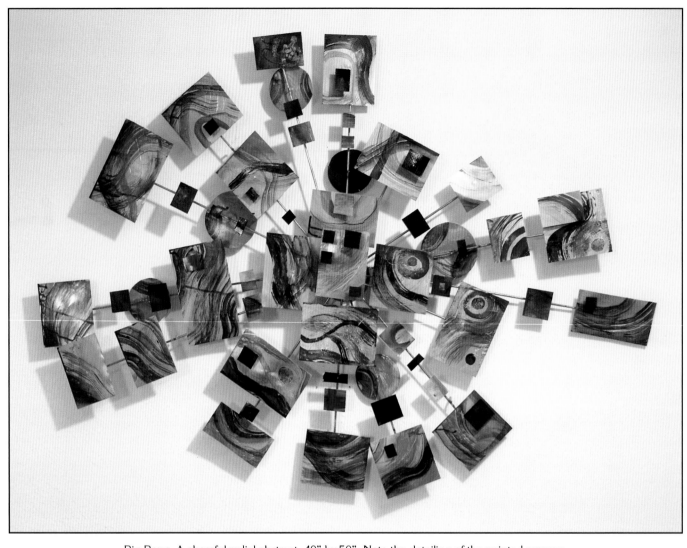

Big Bang. A cheerful radial abstract. 40" by 50". Note the detailing of the painted squares.

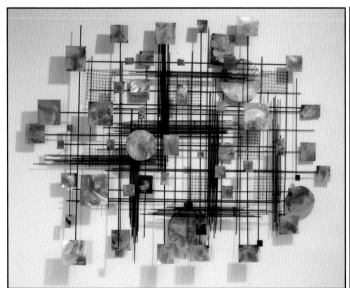

Tick-Tack-Toe. 50" by 40".

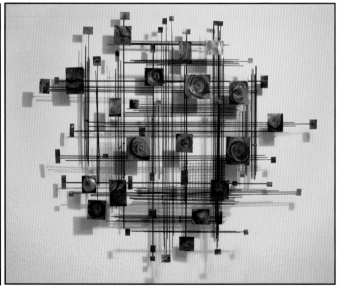

Intersect 1. Copper-plated wire matrix with copper squares. 48" by 48".

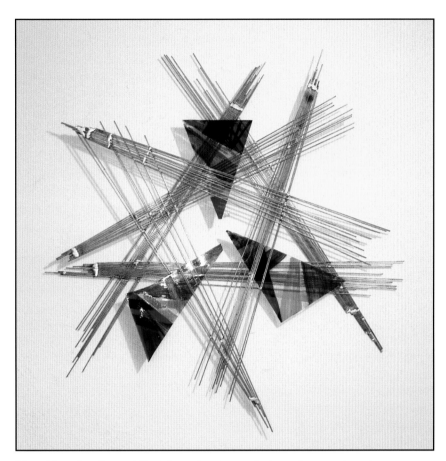

Three Triangles. Stained Plexiglass triangles applied over brass and steel.

Blues in the Round. This musical abstract was a commission. It was formed in three separate modules to aid in hanging and in shipping. 66" by 70".

Compliments and Criticism

Believe it or not, compliments and criticisms are flip sides of the same coin. Beginning artists, whether they are sculptors, writers, musicians, or painters tend to crave compliments and, of course, shrink from criticism. If you *buy into* the compliments, you also have to *buy into* the criticisms and both are slippery slopes. The reason for this is you are relinquishing control of your art to someone else. If you think about it for a moment, when someone looks at your work and tells you that it is good…or bad, he or she is making a judgment or pronouncement. "This little blue square is good, but your execution on that large triangle is bad." Essentially, they have put themselves in a position slightly above you to tell you where you have done well, and where you have gone awry. It's a potentially dangerous position. If we're talking about a commission and your customer had commissioned you to make an abstract all with chartreuse copper triangles, that's one thing. You've entered into a contract with that person and your duty is to satisfy your customer. But if you're making a piece to feed your soul, that is something else and it's nobody's business but your own. These are two divergent concepts, but in the world of art, there is much precedent for it. The ceiling of the Sistine Chapel was a commission…and it was painted under protest…but it was done.

Most experienced writers, playwrights, and poets ignore the compliments with the same zeal with which they ignore the critiques. This is because you can easily fall into a "Wag-The-Dog Syndrome." One person hates the red triangle you put on an abstract. Another loves it. Another likes it but suggests that it should be blue. There is no universal answer here and you MUST travel to the beat of your own drummer. Otherwise, you will constantly be wavering between vanity and insecurity as you bounce between compliments and criticisms.

The very best response to a compliment is: "Thank you." The very best response to an unasked for criticism is, "Interesting," and then flush your brain and press on. Many people *love* Picasso. They love seeing two eyes on one side of the head. Others can't stand him. Many people love Chagall. They love his Rustoleum red horses and his purple cows. Others … traditionalists … abhor Chagall. The list goes on and on, but what would have happened if Picasso or Chagall, or Rodin, or Monet had listened to the critics? The world would not be a better place. March to the beat of your own drummer … while still keeping in the back of your mind that commissions are in a different category.

When we were living out in Tucson, we were finally invited to our first *really big show*, as they say. It was at the Tucson Museum of Art, a beautiful white spirally structure à la the Guggenheim in New York. Pam and I felt very small and ant-like bringing our handful of large pieces in with hand trucks, and while we were doing this, there was a small clot of people in suits and cocktail dresses, sipping wine and commenting on everything.

It was pointed out to me that one of the wine sippers was the foremost art critic in Tucson, and as I kept passing by, I couldn't help but overhear her critique of a rather bold and angular metal structure sitting in the middle of the aisle. It had been painted a brilliant school bus orange; it was of sturdy construction and very serious -looking. The art critic, who shall remain nameless, was going on and on and on about its aspects of industrial renaissance, post modernism, its tributes to cubism, and its wry wit in that it had four small casters on the bottom. I guess that made it a kinetic sculpture as well.

Then, with perfect timing, a man in overalls walked over and wheeled it up against the wall. Then he climbed its post-modernistic ladder to change one of the floodlights that had blown. The portable scaffold the man was using had had its moment of Zen.

Unfortunately, I was still in my young and stupid period and the next day I wrote a humorous tongue-in-cheek letter to our illustrious critic-at-large in the Tucson newspaper, congratulating her on her most excellent job of critiquing the scaffold. I was blackballed for about a year and a half. I guess I deserved it for being a smart-ass.

Scaffold Man. This free-standing piece is a whimsical sculpture. If you look closely, you will see the little man with the scrub brush on the ladder. 24" tall.

In another life, I think I might have been a cartoonist. The concept of being able to make someone smile is right up at the very top of my list. The frustrating thing about some forms of sculpture is that they become cerebral, rather than visceral. When I do a large abstract for a corporate lobby, often the lines are strong, the piece massive, and if I'm lucky, someone will say something on the order of, "Wow, that's pretty impressive." And it feels great to hear that. But what tickles me the most is when I'm working in the studio and I hear a cackle from one of the rooms in the gallery. I find that I'm compelled to turn off the torch and see what it was that made them laugh.

A scholarly analysis of Scaffold Man wouldn't bear up under any sort of close scrutiny. It's nothing more than a little guy up on a ladder, scrubbing away at a HUGE entity who is peering down at him from behind a pair of ominous sunglasses. You either get it or you don't. And it tickles me when I create something truly off-the-wall and some kindred spirit comes in and understands what I was trying to convey.

In a related incident, Pamela and I had decided to visit our favorite galleries in New York City. We hit the MoMa, (Museum of Modern Art), The Whitney, and the Guggenheim, in that order. That's a lot of art to consume in one day, and by the time we were trudging up the spiral inclines of the Guggenheim, the two of us were getting punch-drunk from all the terrific art we had seen. At one diorama that was under construction, we stopped to rest and compare notes. Apparently, the New York Times had dropped off a bale of newspapers at the museum…I didn't think to ask why. They had just been dropped there in a big lump, and some idiot had left his half-eaten apple on top of the newspapers. It had already oxidized to a deep cinnamon-brown and there were fruit flies swarming around it. In my naïve country mouse feeling of civic duty, I walked over, picked up the half-eaten apple and began looking for a trashcan. I never made it. I was confronted by an armed guard, who politely told me to put the apple back…exactly as I had found it. "But officer," I said. Then it dawned on me. I had almost thrown away part of somebody's exhibit. And my own personal mantra began humming inside my head. "Is it art?" "…Yup. "Is it *good* art?" Ask the fruit flies.

Here's a germ of truth that most artists are reluctant to admit…and most art critics refuse to admit: *Sometimes* aspects of art are purely accidental. There are also times when the interpretation of a great work of art goes way beyond what the artist was thinking when he or she created it. Case in point: Henry Moore is one of my favorite artists. However, I learned that one of his large pieces, which had been carefully designed and conceived as a vertical figure, when lowered to be worked on, was noticed by his wife. I'm paraphrasing, of course, but essentially, she said, "I think it looks better horizontal, Henry," and Henry Moore, in his great wisdom noticed that she was right. It did look better. The point: realizing that the work was better horizontal than vertical wasn't

planned, but purely accidental. I wonder what the critics would have said.

Another great artist whom I admire greatly is Claude Monet. I find his painting technique to be absolutely magical. But did you know that Claude Monet had terrible trouble with his vision and that it affected how he perceived things? What part did that play in his art? Was it key? Or was it incidental?

Elephants. This outdoor sculpture was a commission. It is constructed of Cor-Ten steel.

Lastly, David Smith, another sculptor whom I admire greatly, was given the opportunity of going to Italy to the abandoned Voltri factories to create several works from the abandoned pieces at the plant. Through a small misinterpretation of the language, he thought he had to create thirty works in thirty days, a monumental feat by anyone's standards. It was only afterwards that he realized he had only been asked to do two pieces. Thank heavens for the rest of the world that he didn't speak Italian.

Bringing The Muse into this equation: I suppose we could get really deep into the philosophy and Zen of art and say that nothing is accidental; it's all there for a purpose, and if that's your position, I have no problem with it. The question, I suppose is, if the artist wasn't totally aware of what he was doing or why…does it still count? You bet! Over thirty years of sculpting, I have had many instances where I would create an abstract, hang it on the wall and forget about it, only to have a person come in and say, "I'm enamored with your space fish…or your sperm cells impregnating an embryo," or…well you get the idea. "What sperm cell impregnating an embryo? Where?" I'd follow the customer into one of the rooms of our gallery. The customer would point, and then I'd see that he was right. This quietly happens every day in the world of art; and then the art critics devote pages and pages to explaining to us *why* we did it. I'm glad someone knows.

Rachel, A Tribute to Erte. 60" tall and approx. 58" wide. Hammered and oxidized copper and steel.

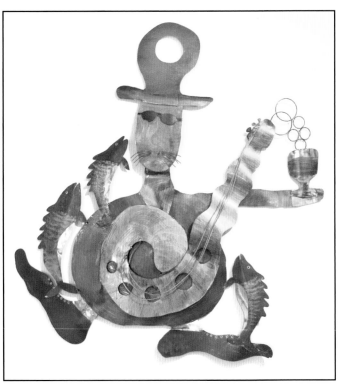

Fish Monger. The intent of this piece was a bit of nouveau story-booking. Notice the guitar construction and the fish dancing…and the hole-in-the-head.

Fish Walker. This is one of our whimsical people characters. The head, hands, feet, and fish are cast aluminum. 30" by 36".

Snowman. A painted copper Christmas ornament.

ABSTRACT PAINTINGS

There are still a number of people out there who believe that art that is to be hung on the wall must be rectangular and coated with paint. This section is dedicated to those people.

My favorite of the bunch is Fifth Avenue from the 14th Floor. It was done without the aid of a paintbrush. Instead, I cut small pieces of cellulose sponge into squares and glued them to a washer on the end of a welding rod. It wasn't until I was about a third of the way into the painting that I realized what it was I was creating. That's how it goes sometimes… I saw tall buildings in the darkness casting blue-black shadows. I saw the glow of expensive shops below, taillights, headlights, and a magical glow of life emanating from the streets.

At that moment, I began to clutch a bit because I saw tremendous potential, but also tremendous potential for messing it up. At that point, I became careful. The impressions from the sponges slowed to the pace of a slow-witted snail and the painting hovered precariously in time. To make a long story short, I realized almost instantly that being cautious was killing the painting right before my eyes. I went back to my usual frenetic pace and the painting was completed in a day rather than a week. I have no idea if anyone else on the planet can see what I see in the painting, but it's enough that I can see it. It's my tribute to my love affair with New York. Later that week, I tried to duplicate the technique, hoping perhaps for a series. The next one would be…Nights on Broadway? It was not to be.

Textures One-Three are studies in texture, color, and to some extent bas-relief. The surfaces of the pieces are sheets of copper that have been highly manipulated with heat and chemical patinas, then etched with a plasma cutter set at its lowest setting. The holes were also cut with the plasma cutter set at a higher setting, then they were backed with chromium plates and air-hammered for additional texture. The painting comes at the very end. In these cases, oil pastels were used extensively with acrylic paints, and for additional texture, striations of metallic fabric paint were added last of all.

Brooklyn by Night was painted on a sheet of glass (from the back) and it was done half a decade after Fifth Avenue from the 14th Floor. No homemade sponge

5th Ave from the 14th Floor. This is a 48" square abstract painting. The "brush" used to create this was a small square of cellulose sponge glued to a metal rod and then dipped in paint. Up close, there is an impressionistic view looking down at 5th Ave in New York.

brushes were used and I was initially disappointed in the way it looked. But when I turned it around so the paint was showing through the back of the glass, there was magic there. It didn't look like Broadway. It didn't look like Fifth Avenue…more like Brooklyn, or rather how I imagine Brooklyn in my mind.

Jamaican Beach is a hybrid, with the painting technique of an impressionist painting and the framework of an abstract. My first hybrid consisted of myriad copper squares on a matrix, and then painted to look like a tree against the horizon. The interesting thing with it was the negative space. Often there were several inches between the squares, and it required the mind to fill it all in. It's frustrating, and yet at the same time, fascinating, trying to imagine the completed whole.

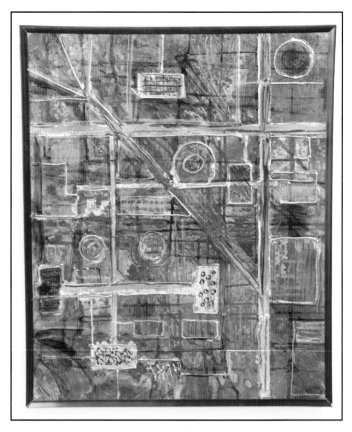

Textures 1. Hammered copper which has been striated with a plasma cutter and then colored using oil pastels and texture paint.

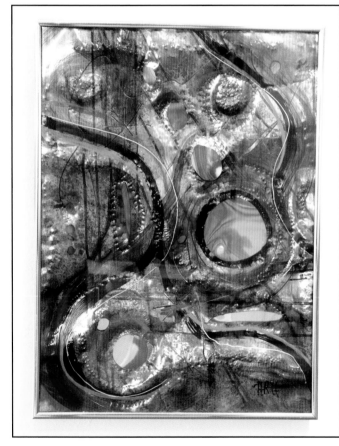

Textures. Striated copper with plasma -cut holes, backed by chromium.

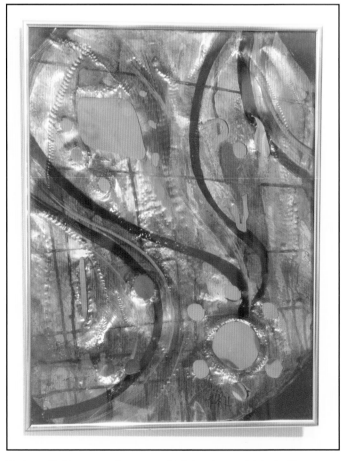

Textures 2. Hammered copper which has been striated with a plasma cutter and then colored using oil pastels and texture paint.

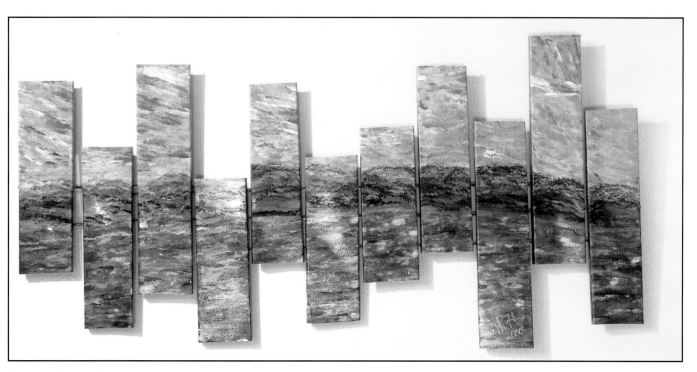

Jamaican Beach. Eleven painted metal panels welded to an iron matrix and then painted with an impressionistic beach scene of Jamaica.

Textures 3. Painted copper, 18" by 33".

Ode to Pollack. The paint technique is what is interesting on this piece. After an initial painting, a slurry of paint was washed over the piece, then blown into areas by the torch. Then a fan brush was used to spatter-paint the rest.

Brooklyn by Night. This is an experimental abstract on the style of 5th Avenue from the 14th floor, only it is painted on glass, specifically the *backside* of the glass so that the image is reversed and shown through the glass. The effect is interesting.

THE SCARECROW AND THE TINMAN

Recently we were approached by a couple who had seen the life-sized tinman who resides on the roof of our gallery. "How can I help you?" I asked at the counter. The man spoke first. He said, "We're celebrating. You see, our nicknames for the past few months have been, The Scarecrow and The Tinman." Then he began to relate the story of their trials by fire. I learned that his wife had been diagnosed with cancer of the brain, while he, on the other hand, had recently had a heart attack. It had been touch and go, but they had both beaten the odds! If I had been a little wealthier, I would have been ecstatic to do the sculptures for free. They wanted a scarecrow and a tinman sculpted in metal and approximately three-feet tall…holding hands. Never have I taken more pleasure in creating a sculpture. Sometimes the emotion hugely transcends the medium.

TIME MACHINE WITH FISH

For a little mental gymnastics, let's critique *Time Machine with Fish*, purely from an aspect of juxtaposition and, of course, Zen. The first thing you'll notice is that the basic construction is of heavy plate steel—steel gears, as a matter of fact, though you notice that they are *not* meshing with each other. Rather, they are defining some inner *space*. Space is being defined by matter, but at the same time, matter is being defined by space.

We also see a juxtaposition of scale. The actual sculpture is only a couple of feet tall, but the artist (in this case me) is nudging you and saying, "Yeah, but look at that little abstract guy lounging arrogantly against the gear." If we are to accept the size of the little man, then those gears are gigantic...big enough to chew a little person to shreds. But they're not doing that, and judging by the figure's body language, he seems utterly unconcerned...so I guess we can relax too.

Next we see that (here's that word again) juxtaposed to the huge, heavy, stationary gears are little *things*...creatures? fish? birds? swimming or flying by. They're on fine wires, and consequently, they are kinetic. They bob and soar at the slightest breeze. And yet they are constructed of the same heavy steel as the gears. Color: The gears are basically the natural color of iron oxide (rust), though they have, here and there, the suggestion of iridescence by means of metallic washes, suggesting that the gears have, indeed, been doing something.

Another juxtaposition. The creatures are all painted in the cool colors, except for one, which is a brilliant orange-cerise. This one is the renegade. It is also a minor focal point. And there is a relationship between the figure lounging amidst these supposedly frightening gears, and the fish swimming through them...particularly the renegade fish. Okay, I dragged you this far. Let's see if you can carry the ball the rest of the way.

The Back Story of *Time Machine with Fish*

I promised myself that I would tell the truth in this book, no matter how much it hurts, or how disenchanting it may be to the reader. I'd like to be able to tell you that the gears in *Time Machine with Fish* were carefully planned and thought out for this piece. The truth is, they

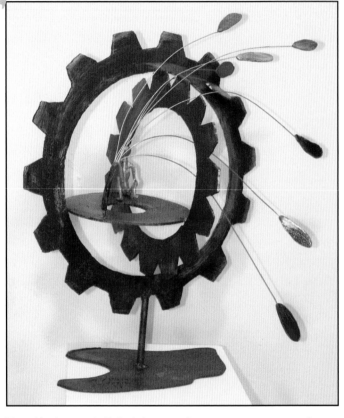

Time Machine with Fish. A free-standing piece, you can see the recurring theme of gears and time. The flag-like objects are kinetic and move in the slightest breeze.

were carefully planned and thought out...unfortunately for *another* piece located elsewhere in this book. They were sketched and cut for a sculpture called *Talisman* and well, they just didn't work out.

I had them propped up against the cubby where our dachshunds sleep and they finally fell over one day and scared the hell out of the dachshunds, particularly Bart, our male, such that they wouldn't go into their cubby anymore. I put the pieces on my worktable, poured a coffee, and began playing with them. I happened to snag the smaller gear so that it stuck inside the larger gear...and I liked the feeling of inner space it was giving. That's how it started. The little fish creatures were cut-outs from the wings of a huge iron butterfly which now resides on one of our trees at Crossbow. A humble beginning? Yup.

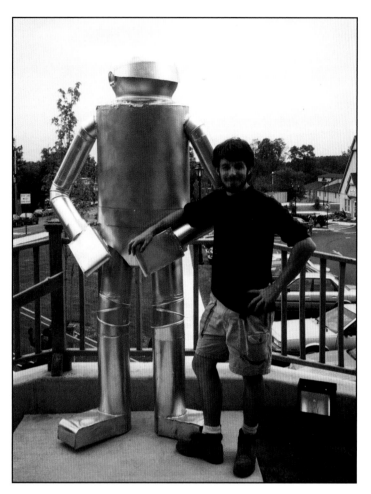

Cameron and Gort. This was a commission. Ultimately the robot's eyes were installed with small red lasers. Gort was approx. 7' 6".

THE ROBOT

In thirty years, we have received thousands of commissions. Hundreds of them have been a bit strange. A handful of them have been downright bizarre. Throughout this book, I will share with you some of the bizarre ones.

The one that pops to mind first was from a scary-looking gentleman who came into our gallery to order a robot with laser eyes to guard his home. Jovial guy that I am, I chuckled and said something to the effect, "Good one! Now what do you *really* want?"

This gentleman towered over my six-foot frame and didn't even crack a smile. "I want a robot to guard my house," he repeated grimly.

As it turned out, he wanted a huge hulking robot sculpture similar to Gort in the movie, *The Day the Earth Stood Still.* We began work and within a month, we had our own 7-foot robot guarding the shop. Talking to the gentleman, it was decided that Gort's eye would be a sighting laser from a gun shop, with a mechanism so that it could slowly scan back and forth.

When the man came to pick it up, he was driving a very serious-looking Chevy Suburban, and as we were loading it up, I regained my joviality and asked him what the story was and why he wanted a robot to guard his house. He explained to me that he too was in a creative field. But instead of making sculpture, he armor plates vehicles for dignitaries and politicians and…well anybody who needs one. He also arms them with machine guns, rockets, and bombs. He said that on this particular Suburban he had two missiles beneath the front bumper, capable of turning a garbage truck to dust from half a mile. "You're joking," I said. "Look under the bumper," he said. He wasn't joking.

CHAPTER 7
ZEN AND THE ART OF METAL SCULPTING

If I seem to use the word *Zen* a lot, it's because many of the principles of Zen come into play in the world of art. Zen is a philosophy as well as a state of mind. Zen embraces many seemingly divergent viewpoints and seems to be one of the few philosophies imbued with a sense of self-deprecating humor.

There's an old joke about two students of Zen, sitting upon a hill, contemplating the beauty of the universe. Their Zen master wanders by and decides to give them a test. He says, "You two have been studying now for four years. I want each of you to tell me what you have learned." The first student, not wanting to appear stupid, begins to recite all the lessons he has learned, all the observations made by his lecturers, and somewhere in mid paragraph the Zen master whacks him with his wooden staff. "Idiot!" the Zen master says, "Have you learned *nothing*, while you have been here?" At this point, both students are shaken and quivering in their sandals. Then the Zen master turns to the second student and says, "And you…you have been here four years as well!

Tell me what you have learned." The student takes a deep breath and says, "I have learned nothing, Master. I know nothing. I am nothing. I have no more wisdom than this grasshopper perched upon my toe." The Zen master squats down next to the second student, smiles and nods. "You are well on your way to becoming a Zen master."

Huh? The point of this story is that Zen is not a cerebral and quantifiable process, so much as a coming to realize that there are things you can't know, but must feel or intuit instead. Zen is one of those things. Art is another.

The Coexistence and Contradiction of The Opposites

You don't have to look very far in this world to see that there's a strange Zen-like contradiction within almost everything around us. Love and Hate are often *much* closer together than you think. And the opposite of love isn't hate, it's apathy. Snake venom is certainly something to be avoided and yet there are hundreds of positive uses for snake venom. And what do you use to counteract snake venom? A form of snake venom called antivenin. The atom…a great power for the good, so utterly clean and efficient, and at the same time, utterly lethal when used incorrectly. I could ramble for pages, but I won't. You might find it interesting, however, to look at something or someone you really hate and attempt to find the Zen paradox inside it…the beauty of it. In doing so, you may find a new perspective. Or, the other side of the coin, consider something you find

Tucson. This is a hybrid of painting and sculpture. 42" x 60". Copper, wood, and acrylic.

beautiful and see if you can find the Zen contradiction within it. It's there, if you look closely.

So what does all this have to do with Art? *Plenty*. If you look around at some of the sculpture you like, you will see the contradiction, or juxtaposition within. This is Zen, but you could also call it the child that's still hiding somewhere inside you, despite the wrinkles, and creaky bones, and growing disenchantment, there's still a little bright-eyed creature lingering inside all of us, and wanting desperately to be…delighted.

Look at Alexander Calder's mobiles, or for that matter, anything that Calder did. Some of his mobiles are huge with amorphous shapes the size of Buicks…floating noiselessly above your head. Calder was having fun, so that you could, too. Or if you go to Storm King, a huge 500 acre sculpture garden in the Hudson River Valley in New York, you will come across a myriad of sculptures, which for the most part look like the gods came down, or perhaps child gods, and played with their blocks and cubes and crescents, though on a gigantic scale.

One sculpture entitled *Suspended*, by Menashe Kadishman, squats in the middle of a field, and is a huge monolith perched at such a precarious angle that it looks as if it will fall with the slightest breeze. Dangling impossibly from this is…*another* huge monolith, utterly defying the laws of gravity and logic. Every time I go to Storm King, I sit on the hill and watch as people walk down and stand under the precarious cube, tempting death. It is the child that's looking up at the monolith and saying, "Nyah nyah, you can't get *me*!" Calder, Moore, Noguchi, Smith, Nevelson, Brancusi, Ernst, Picasso, Giacometti, di Suvero, Hepworth…all great artists, all very much in tune with the little kid inside them.

Looking back at 30 years of sculpting, and trying to be objective, many times I have been approached to do a commission for a client who has setup his house in a purely logical manner.

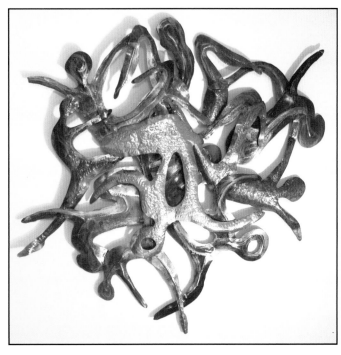

Yoga Class. My wife and I have become avid students of yoga. This is how I feel sometimes after a yoga class. Chemical and heat oxidized copper.

Everything is white: the walls, the ceiling, the carpet, the furniture, and they come into our gallery and see wildly colored and weirdly shaped abstracts. They become fearful and jumpy like a herd of horses during a thunderstorm. "But, I don't have any orange in my house," they say. "Yes," I agree, "You don't have any color at all! Your entire house is a big, white picture frame. Now it's time to put a picture in the frame. Be brave!" What's funny is, once the dam has broken and they see that huge abstract hanging over their fireplace, they become converts. They come in with childlike eyes, looking for their *next* acquisition. The child has awakened.

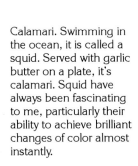

Calamari. Swimming in the ocean, it is called a squid. Served with garlic butter on a plate, it's calamari. Squid have always been fascinating to me, particularly their ability to achieve brilliant changes of color almost instantly.

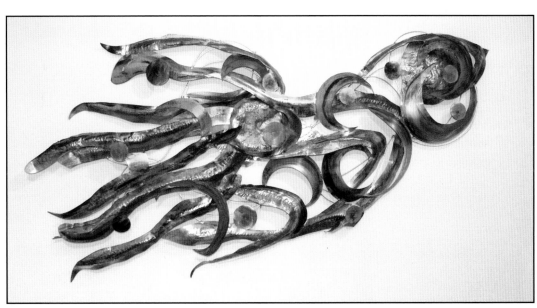

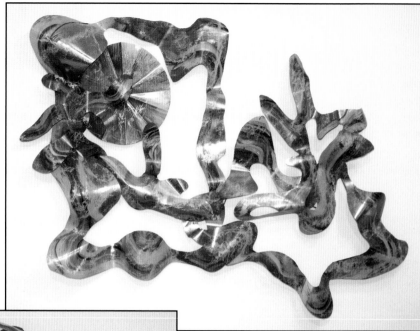

Sunset Ribbons. A modular abstract in two pieces, cut with a plasma cutter.

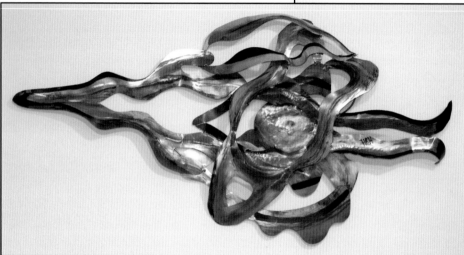

Ripples. This is another experimental piece, created by cutting two mirror-image pieces simultaneously. 33" by 48".

Ribbon Puzzle. Interesting knots, tavern puzzles, they are all fascinating to a sculptor, because of the interesting interaction between positive and negative space.

Amoebas. This piece is meant to depict something that would be seen under a microscope. There's an entire micro-world of art lurking everywhere, in the scales of fish, or the stained blood cells of a frog. Brass and copper mesh.

Copper Bubbles. This is just a fun piece. The inherent nature of a circle is very Zen and very comforting. I prefer the circle to all other shapes in the world of art. 40" by 66".

Beneath the Ocean. Many of my earlier abstracts were representational of oceanic or underwater vegetation. This is an excellent example, circa 1981.

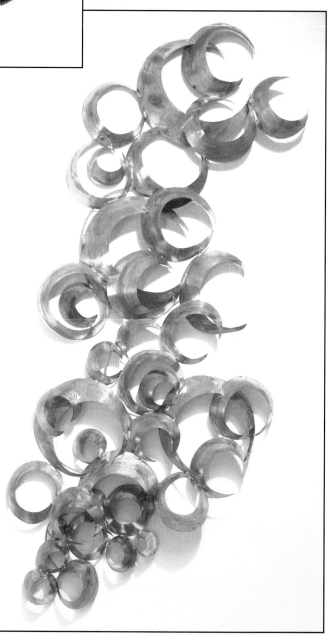

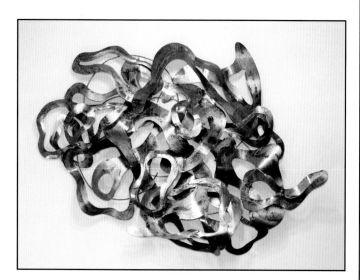

Metallicus. This is a complicated piece, using many, many thin ribbons of metal. The difficult part was hiding the bracing rods behind the pieces. 45" by 66".

Crescent Galaxy. The ocean, under a microscope, or out in space, these are all wonderful frontiers for an artist to explore. In two modules, total height is 66" by 32". Circa 2001.

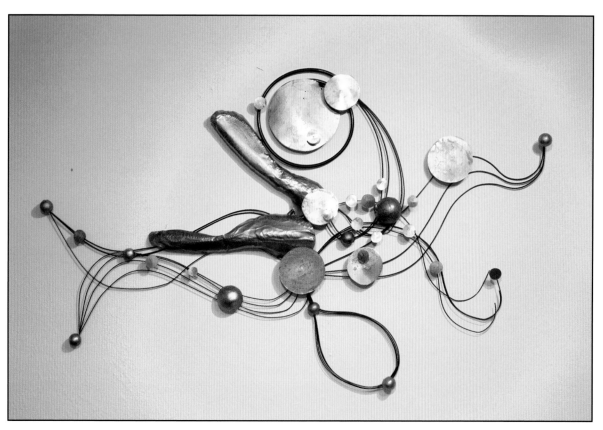

Microcosm. This is one of my more simplistic abstracts, using cast aluminum spheres and sheet copper. It measures 60" by 30".

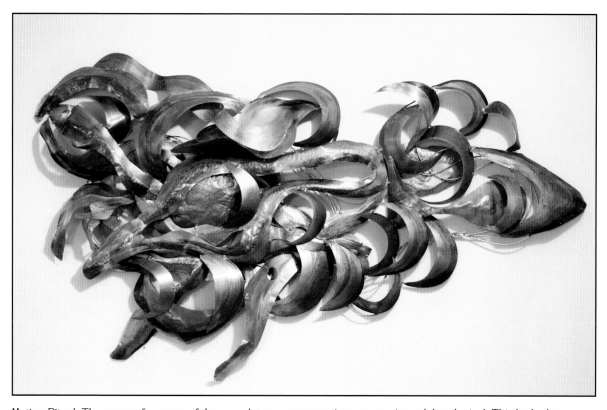

Mating Ritual. The names for some of these sculptures are sometimes more visceral than logical. This looked to me like a collection of mollusks mating with each other, hence the name. 50" by 29".

Pastel Ribbons. This is another modular two-part abstract. There's a real advantage to the modules in that they can be reconfigured when the viewer gets used to them.

Phoenix. A slightly abstracted bird…Phoenix Rising, composed of brass sheet and steel wire. Phoenix is approx. 55" long by 33"tall.

Juxtaposition

Juxtaposition: If this were a seven-series seminar, I would begin by asking the class what juxtaposition is. Five or six hands rocket upward. "Oooh! Oooh, pick me!" "Yes, Penelope?" "Juxtaposition concerns the placing of two or more things together, for the purpose of comparing and/or contrasting them." "You'll make a fine lawyer, Penelope." There's something about people who actually use "and/or" in a sentence that's a little scary.

Think about some of the music that you've heard over the years that really makes you resonate. A song beginning with lilting violins for the first eight bars and then…the crashing power of a well-executed guitar riff. Or…an oboe or an electric violin in the background that's completely out of place…but you *love* it. Or one of Elton John's killer chord progressions that takes you from a to b to c, and your entire soul waits for him to resolve it. Again, I could go on and on. Oh well, one more. Think of eating an entire plate of chocolate chip cookies. Suddenly your mouth craves a glass of milk. The cookies and the milk are linked, they're related; your taste buds are waiting for the resolution. – Okay, back to art…and to be specific, back to Storm King. If you look at the monumental works of Alexander Liberman, or Alexander Calder, or Mark di Suvero, you'll see one thing in common to them all. Either they all got a tremendous deal on orange paint…*or* they wanted something that would give maximum *pop* against green grass. From an airplane, you can see Liberman's *Iliad* from ten miles out. The secret lies in a quick examination of an artist's color wheel. Orange and grass-green are at the opposite ends. They complement each other. Milk and cookies.

THE BIPLANE

There's a little dance that occurs between a buyer and a seller. The buyer essentially wants a discount. It doesn't even matter what the price is. I've seen people in dollar stores, haggling over a package of six disposable razors, which should cost $5.95, and now they cost a dollar. Even then, the customer wants it for fifty cents. Usually this all works itself out amicably.

One time, however, we were doing a tiny show in a shopping center in Tucson. We were having a lousy time. It was a demonstration show, which meant dragging our welding equipment out to the center and trying to work without burning anything amidst myriad off-the-wall questions.

As luck would have it, a fellow metal sculptor was set up at the center as well. We'd walk over when things were slow and compare notes about how tough the crowd was. So far, that morning we had had one sale. A woman came up to our booth and fell in love with, of all things, the scrap metal plate that was forming from all the things I was burning out of it. At first, I tried to explain to her that what she was looking at was well…scrap. "Don't you want to look at my 'Venus Ascending' or 'Mother Earth?'" But this gal was completely mesmerized by the scrap plate. My wife and I exchanged glances. These were still the lean years, and Cameron, our son, was in a little folding crib in our booth. "I really want this piece," the woman said. "What do you think?" I whispered to Pamela…she shrugged. Then I glanced back at the woman. "A hundred?" I asked. Back then, a hundred dollars was actually worthwhile money. "Sold!" the woman chirped. After the show we delivered it to her house and you know what? In the place she put it, it looked pretty good. Such is art.

I walked over to my sculptor friend's booth to share the experience, only to discover that Skip had had a different kind of day. He had crafted a small intricate copper biplane, nice detail in the rigging, nice action in the propeller, and he even had a little figure in the cockpit. To make matters worse, he had priced it at a pittance of its actual value…fifteen dollars. Apparently, a guy wandered up to Skip's booth and wanted to buy it. "Here's five," the man snapped, "That's all I'm gonna spend." From what I can gather, Skip collected the five, picked up his tin snips and cut off the two left wings. Sometimes even a struggling metal sculptor has had enough. Be nice to artists. They have to eat too.

Critique

THE LAST WALTZ

This started out as a somewhat standard still life. A café table, a bottle of wine, (notice the label on the bottle? What better way to sign a work of art?) two lobsters, some cheese, and a pair of wine glasses. Each piece was constructed of .015 copper-plated steel, cut with a plasma cutter, and then brazed together. As with many of my traditional pieces, after the piece is constructed, it's back to square one, where it is treated like a three-dimensional painting. The piece is primed, painted, detailed with pastels, and then sealed with clear polyurethane. Where the piece became more than just a still life, was in the very last stage, which was the placing of the lobsters. It had been my assumption that they would just lie there on the plate. But in this particular case, I began empathizing with the lobsters. I saw them as Pamela and myself, and so…they are having a last bittersweet waltz together before the drawn butter arrives.

Last Waltz. If you look closely and empathize a bit, you will see that this is, indeed, a bittersweet moment. One last waltz before the garlic butter arrives. 50" by 30".

PROJECT VI
SPLATTER LEAVES
JUST LIKE MAKING 2000 DEGREE PANCAKES

(Advanced Level)

Here's a little something you won't find in your votec welding classes. They're called *splatters*, and you can make them in almost any metal, though for our purposes, we'll be dealing with copper and brass.

Anticipating your first question: "What precisely are we going to be doing with these splatters?" The answer is: a lot. But here's where you enter in with your own creativity. You have to think, too. What I usually do with splatters is make leaves out of them. Trees, seaweed, abstract amoebas, and the like. The lacy quality of the splatters particularly lends itself to leaves.

Before we begin, however, a note about safety. Since this is an advanced level lesson, I'm assuming that you already have a fireproof work area. If you don't—*skip this lesson*, or drag your torch outside and do it on a cement porch, or in gravel or some place equally innocuous. And if you are in doubt, or if you're ill-prepared, skip this lesson. *Really.*

Anybody left? Okay, the hard-core. Good! The reason for all the caveats, is this. In the process of learning this technique, you are bound to make mistakes in the beginning. When you mess up trying this technique, you get little molten BBs skittering around at your feet. They roll, they run…and if you're not wearing proper attire, they *love* to leap inside your shoes and eat holes in your socks…and skin. Wear jeans and boots and lace your boots tightly.

Anybody left? Okay, the *real* hard-core. Let's get to it. The trick of this process is in the griddle, or splash plate. It has to be a clean, smooth, sheet of metal, thin enough to preheat easily; anything under 12 gauge will do. I like to angle my splash plate at about 30-45 degrees so that the splatters slide down to the bottom once they're formed. Next, we need to look for a source material. For the copper, I use copper refrigerator tubing. It's relatively inexpensive, and its form makes it easy to melt. Ready? Okay, assuming all the caveats, old clothes, boots, safe area, etc. you begin by preheating the splash plate with your torch. This cleans the metal of oil or impurities and heating it makes the molten copper spread out better.

First, crimp the back end of the copper coil with a hammer. You'd be amazed how far the heat will travel down the tube. Next, get a comfortable position for yourself and begin heating the open end of the copper tubing…over your preheated metal splash plate. Pretend it's World War II and you're dropping bombs on the bad guys. The trick here is in heating the tubing to a molten consistency, while not having the molten copper fall prematurely. In short, you want the biggest glob of molten copper to hit the plate and form a splatter. If you've done it right, you should get a beautiful and detailed splatter about the size of a quarter, capable of passing for all kinds of things in the art world.

Experiment with the *altitude* you hold the copper tubing above the splash plate. Too high and it will cool too much and hit with a clunk. Too low, and the copper won't have enough energy to spread out. Try 18-24 inches and adjust. If nothing is happening, and you're just heating the copper to no avail, you don't have a hot or large enough flame. The flame should really be roaring away. Once you get a feel for it, you can guide the tubing around over the splash plate, making copper or brass splatters by the hundreds. Just be safe, careful, and cautious. This is one of the only techniques best left to someone with advanced ability. You also see, very quickly, that you can make larger and larger leaves by overlapping your splatters as you drop them.

Making Splatters. In this photo, the thing to note is the angle of the torch. It is parallel to the table to keep from instantly melting the delicate brass splatters.

Critique

EMPATH OF MARS

What would cause a person to create the sculpture pictured here? The immediate trigger that set the process into motion was the acquisition of a peculiar piece of driftwood. It had been occupying a swamp in the Pine Barrens of New Jersey and it called out to me. No, not really. I called out to it. I said, "What's it gonna take to pull you out of the mud?" The answer is: A good friend and a Chevy Silverado with four-wheel drive. Back at the gallery, it looked like crud. (Perhaps I could lend it to the MoMa just as it is?) Seriously, it was encrusted with mud, leaves, creatures, and other unmentionable things. Pressure washing and Clorox helped, but it was still scraggly.

Then I used a technique I'd learned out in Tucson. Sandblasting would have destroyed much of the texture. Instead, I doused it with charcoal lighter (yes in a very safe place) and watched it burn. It smelled strange as it burned, like some of the dormitory rooms at Franklin & Marshall College in the 60s. Afterwards, a stiff brush removed the surface char, leaving a nicely detailed and still very peculiar hunk.

Set that concept aside for a moment, and let's get to the real question. Why an empath, Why a *Martian* empath? The simple answer is: I already know what a frog looks like, but I hadn't the slightest idea what a Martian empath looks like…and I was determined to find out. I'm assuming you're looking for the truth here, not some made-up art critic lingo as in: *It's hyper-techno, neo-futuristic post-industrial…art.* Every artist is a child of his time, and I'm no exception. I love the concept of magic, science fiction, as well as science fact.

If you look very closely, you will see that a section of the wood contains hundreds of small marble-sized holes. Through pure experimentation, I began pressing small translucent metallic-colored glass pieces into the holes. Suddenly there were small eyes staring back…dozens of them, giving a very queer lifelike quality to the wood. The core of the empath, in this case, is a woman's head, which seems to grow out of the wood. She has a headdress similar to some of the other Martian maidens, only in this case, there are also tubes attaching her to three crystalline structures. The effect, when viewed in the flesh, is that of a human life form coexisting with another amorphous life form in some bizarre form of symbiosis.

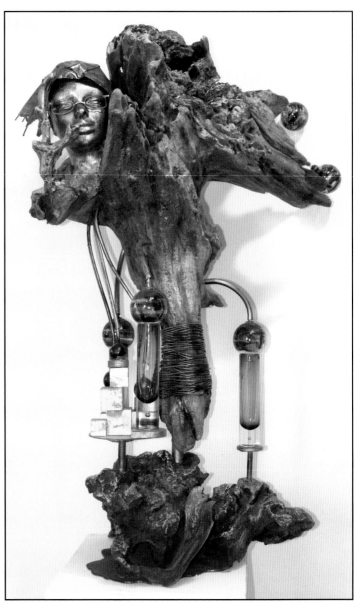

Martian Empath. Five- feet-tall with driftwood and glass. The driftwood was "sanded" by fire and then the charcoal was rubbed down. It is, in one manner of thinking, organic, yet at the same time high-tech in a sort of alien sci-fi sort of way.

For me, it creates an artistic three-dimensional bridge into a fantasy world of science fiction. And as in all art, some will resonate to it. Others will throw up their arms and say, "I don't get it."

YOUNG WINSLOW

The genesis for *Young Winslow* was an old friend and roommate from college. Senior year, it seemed like both of us were about at the same level of culture and refinement. Our dorm room had leather decanters of Courvoisier instead of empty beer cans, and we could listen to Led Zep or Shostakovich with equal enthusiasm. Through the years, we've gone through many metamorphoses, but our friendship has continued...and continues even now. My friend went the government, then the corporate routes, while I have remained content being more of a country gent. Whenever I picture him, it's with an umbrella or a briefcase, bespectacled, and moustached, perhaps reading *The Wall Street Journal.*

The first iteration was rather crude, which is not to denigrate it. Crude is as viable as any other technique and there's a beauty in its simplicity. His hat is a metal ring with the cap of an oxygen tank. His eyes are huge steel balls, and his body a piece of steel pipe. Humble ingredients, but when it was finished, I saw my roommate grinning back at me.

As I went through phases, my attempts at capturing the feeling of this series became more universal. I suppose, to be absolutely honest, there's a bit of glee in them, because I can't imagine, particularly at this point in my life, waiting for a bus, briefcase-in-hand, to go to a job, where I had to say "yes sir" or "no sir" to, well, *anyone.*

The second iteration was a boxy man, vaguely resembling a rusty tin man, albeit with a gleam in his eye. The third iteration became quite abstract, with lines and wires, a curve of metal here and there, suggesting legs, arms, and head. And the fourth iteration is a humanizing of the third...only a bit warmer. But I like them all, and to tell you the truth, if the iteration had progressed in reverse direction, I wouldn't be ashamed at all.

Old Winslow. This is the first and crudest version in the series. Note the derivation of his hat.

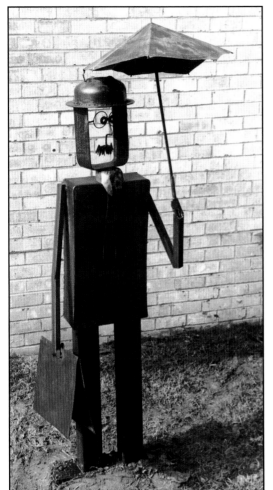

Wall St. Journalist. This is a more recent iteration of this series, slightly resembling a rather rusty-looking tin man...with an attaché.

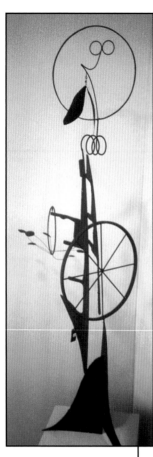

Young Winslow. This is the most recent iteration of Winslow, slightly more simple in its lines and yet more personality, I think. 6' tall and constructed of steel.

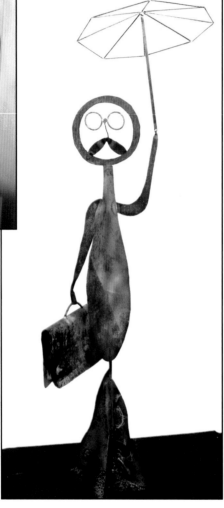

Winslow. Oxidized steel and copper. 7' tall by 24" wide.

Winslow Sketch. An early sketch of the most recent iteration.

CROSSBOW

Over the years, Pamela and I have converted CrossBow, our ten acre farm in Bucks County, Pennsylvania from a tangle of overgrown forest to a sculpture garden/wildlife preserve. We dug two ponds, stocked them, and then cut, pruned, and sculpted the land as well. We created a labyrinth of nature trails, punctuated here and there with works of art, which are illuminated at night by sensor lights. Overlooking the ponds is a gazebo with a waterfall. It was a lot of work, but it was well worth it. Sometimes on a summer's eve, sitting in the gazebo with the water gurgling, listening to the peepers, watching the fireflies, and viewing the dramatically-lit sculpture, the effect is nothing less than intoxicating. An unexpected benefit of the ponds and the pruning is that we now have wild turkey, fox, deer, raccoon, ground hogs, squirrels, various songbirds, and even a family of flying squirrels who reside in a hollowed-out tree next to the driveway.

The first sculpture you'll see when you drive into CrossBow is the sign itself, as is shown in the photos in this section. Eternal Flame, however, was the *first* sculpture to be erected at CrossBow. It is composed of Cor-Ten steel that has been oxidized and then sealed with a mixture of tung oil and paint thinner. It is 12-feet high and approximately 4-feet wide and was created as a celebration of Pam's and my tenth anniversary of being married.

For those of you outside the Bucks County area, a shad is a fish which migrates every spring, up the Delaware River. We have a Shad Festival devoted to this. People eat shad cakes, and buy shad souvenirs, and generally go crazy. One year, I got carried away and decided to create a sculpture devoted to the shad. But not just any shad...The Shad King, pictured in this section.

Looking at him, I'm not exactly sure whose side he's on. He has a platter, a huge fork, and there are shad swimming around in front and behind him. Not every sculpture is meant to have deep inner meaning. Some are just for fun.

One of Pamela's most recent ideas is that of tree decorations, or tree jewelry as she refers to it. Three early examples are pictured in this section: First, The Gnome House which is in modules consisting of a door, ladder, and a chimney. I can only guess of the permutations that will evolve. Second, is a Tree Pendant, which hangs close to our gazebo. It's constructed of copper and the center section is a bronze casting of an insect. Finally, we have a large brown oxidized steel butterfly, which hangs next to our fire pit.

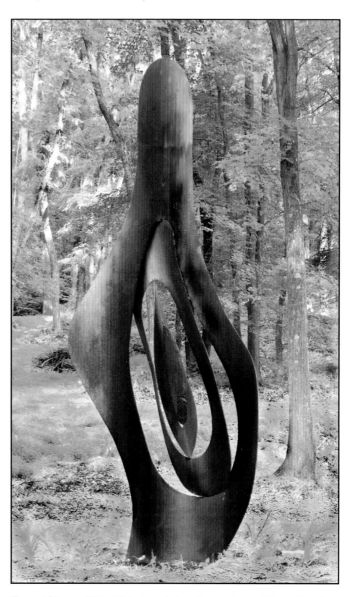

Eternal Flame. This 12-foot sculpture is constructed from Cor-Ten steel plate. It was my tenth anniversary wedding present to Pamela. It is 4-feet in width and is illuminated from several angles at night. The center pod is constructed of hammered copper.

Tree Pendant. This sculpture was designed and created for one of our trees at CrossBow. It is constructed of oxidized copper.

Tinman. "Tinny" is our shill. Tinny has been the "soul" of each of our galleries over the years and continues to delight children…young and old.

Bass Player. Six-feet high and constructed of painted plate steel.

Castle Birdfeeder. This birdfeeder is constructed of copper and provides five different receptacles for various bird seeds. What grander place to eat sunflower seeds than a castle!

Shad King. "Shaddy" is constructed of painted steel and was created to commemorate the Shad Festival in Lambertville, New Jersey. It is seven-feet tall.

Crescents. This piece is 72" tall and resides at CrossBow, our own personal sculpture garden in Bucks County, PA.

CrossBow. This is the sign that greets you upon entering CrossBow. It is constructed of wood, steel, and a huge truck leaf spring for the bow portion.

Gnome House. This is an example of modular sculpture. Our clients can commission an unlimited number of variations to this design, including bay windows, copper laundry, outdoor lights. There is no end to the magic!

Owl World. The globe of this piece is constructed of the scrap that is created when a machine part is "punched" out. The interior of the piece is an abstract iron owl.

Giselle. This whimsical sculpture is the very first in a series of this type. This first one was constructed for my wife's birthday. Its construction is hammered copper, bronze mesh for the tutu, and she has a jeweled crown and jeweled wand. The bluebirds perch on her wand all summer.

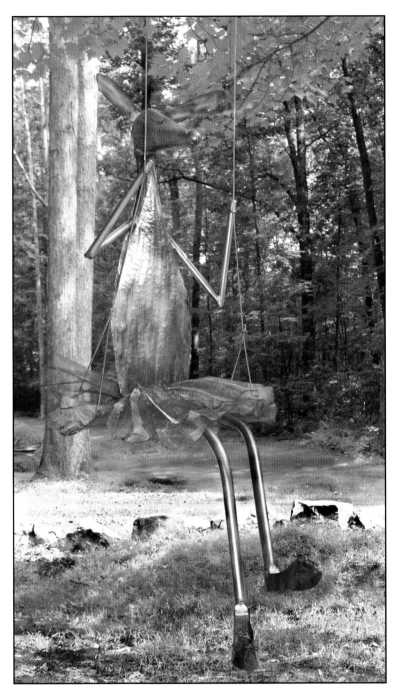

Giselle on a Swing. This is another iteration of the Giselle series. This one is on a real swing that suspends from a tree and moves with the slightest breeze.

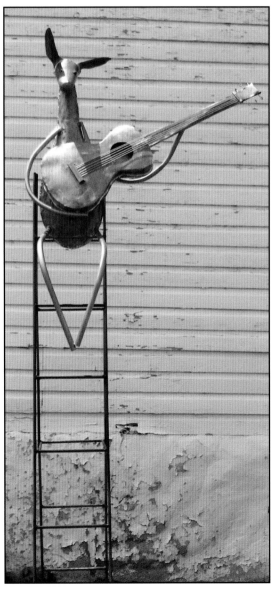

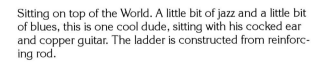

Sitting on top of the World. A little bit of jazz and a little bit of blues, this is one cool dude, sitting with his cocked ear and copper guitar. The ladder is constructed from reinforcing rod.

Butterfly. The obvious caption to this should be: Iron Butterfly. It is one of our many pieces of tree ornaments.

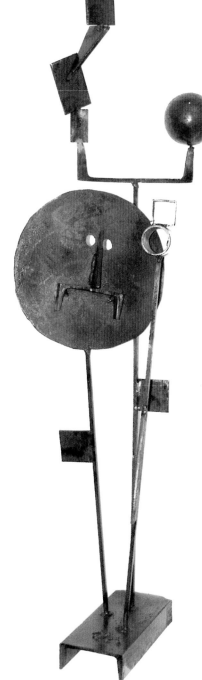

Jack of All Trades. This piece is comprised mostly from found objects. They look really easy to make, but are in reality deceptively difficult...not in the construction, but in the decisions as to balance and form.

STEVE

Before you read below, let's do a little cogitating about *Steve*.

First of all: What is it?

Secondly: Why is it called Steve?

Thirdly: Why did I make it?

Fourthly: Do I think it was successful?

You're probably thinking you're going to get esoteric answers to these questions. Well guess again. Answer 1. It's a stabile, which is to say, it's a freestanding mobile. Two of the pieces bob and turn in the slightest breeze. Answer 2. When it was finished, the top piece and the two black circles resemble Steve Dallas, a cool, but shallow lawyer, in the comic strip, Bloom County. Answer 3. I saw it in my mind and I became curious what it would look like in reality. Answer 4. By definition, yes. I was happy when I was finished. Steve makes me smile. And the greatest compliment of all, someone wandered into the gallery, understood, and complimented both Steve and me with his checkbook.

Steve, courtesy of Robert Wiseman. This free-standing kinetic piece reminded me of Steve in the comic strip Bloom County...hence the name. Steve is 3.5- feet tall and composed of painted steel.

FREE-STANDING ABSTRACTS

Alien Pod Vase. This was one of our experimental designs attempting to ascertain if we could make a vase by electroplating a balloon for a long enough time. Well…you can.

Juggler. This free-standing kinetic piece is a bit of fantasy…a juggler of sorts in a child's world.

Bronze Bubbles. This is a purely experimental piece. The bronze and copper abstract on the pedestal is, in reality, a four second "spritz" from a can of insulating foam. Once hardened, it was heavily electroplated and then given a sophisticated patina. Is it art? I haven't the slightest idea. Sometimes an artist just has to play in the mud.

Moon Pod. I always wanted to have a second child and name him or her, Moon Pod. I was vetoed on that one, and so I named this one Moon Pod. It looks like one, don't you think?.

Mandolin Player. This sculpture also depicts a recurring theme, which continues to "pop" out of my subconscious. Where the spiral guitars come from...I have no idea, and there's an almost angelic halo that keeps cropping up in the abstract heads. This is perhaps another small disclosure to the public. Artists don't always know the why of everything they produce.

Talisman II. This free-standing sculpture is approx. 20" high and is a hybrid of my traditional cubist abstracts. The center disk is somehow reminiscent of a gong and as such there is an oriental motif as well.

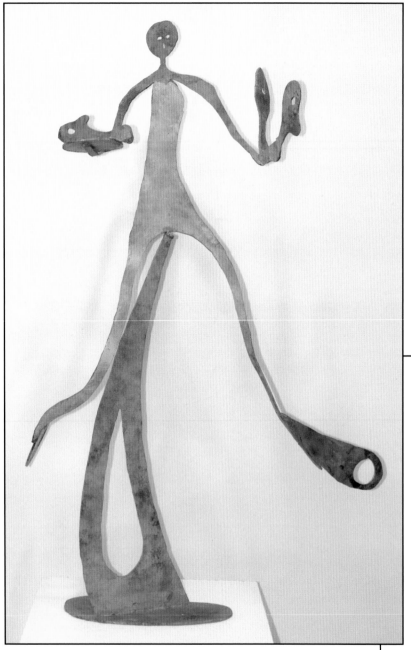

Kinetic Man. This moving stabile is four-feet high and tips precariously when given a nudge. It is constructed from plate steel.

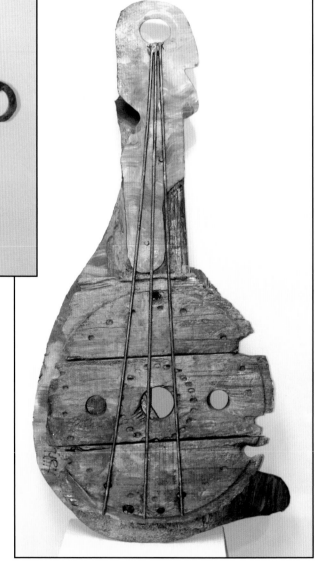

Spool Guitar. The genesis of this piece was a hunk of telephone spool that had washed in from the ocean. The textures that the seawater created in the wood were gorgeous and I tried to do justice to them.

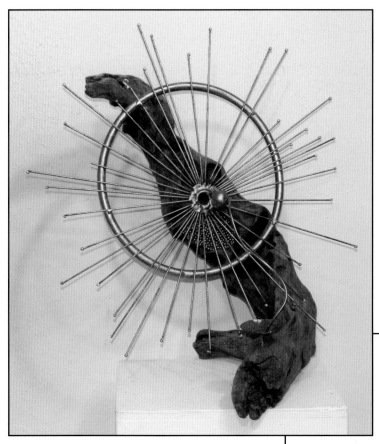

Ovum. If you look closely, you will see that this is an unabashedly symbolic rendition of a sperm cell contemplating an egg. It is mounted on driftwood and is approx. 20" tall.

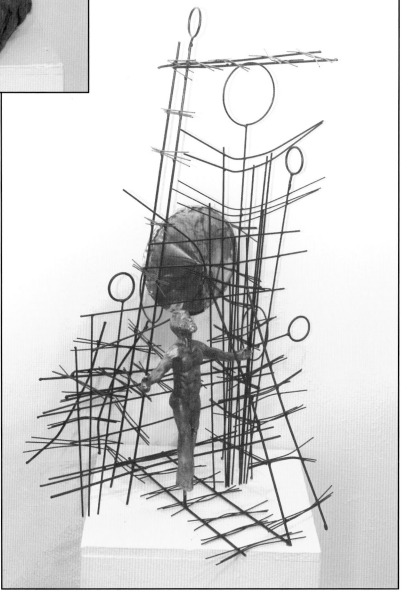

Quandary with Cast Figure. This is an old theme for me...the individual lost in a maze. The maze is iron wire and the figure is a cast, somewhat Jesus-like figure with arms extended. 2002.

113

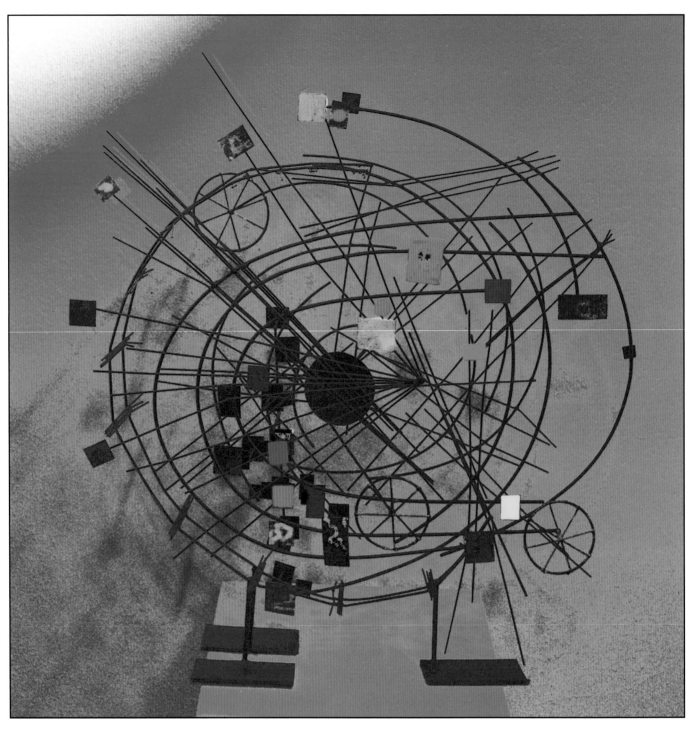

At the Fair, courtesy of Robert Wiseman. This was a fun piece, reminiscent of a Ferris wheel at a fair.

CHAPTER 9
FOUND OBJECTS

For the uninitiated, the term *found objects* is a bit of a misnomer. They could be costly objects from a flea market, semi-costly objects from a scrap yard; they could be stolen or donated objects. The thing that *found objects* all have in common is that they used to be something else. Finding a big sheet of steel lying in a field is not a found object. Well…it is, but not in the perspective of the art world. Finding part of an old hay rake that looks like a giant moustache…now *that's* a found object. David Smith used them. Picasso used them. Calder, Nevelson, the list goes on and on.

Once Pam and I were walking in the fields behind our house and we discovered that someone had dropped off an old broken water heater at the edge of the field. For a minute or so, we bitched about what sort of idiot would do that. Then I crouched down next to the rusting cylinder and smiled at Pamela. "This is the boiler for a big ole steam locomotive," I said and we dragged the thing all the way home. It came out great, by the way.

More often, however, we'll go to Rice's, which is a huge flea market close to us, and in between eating slices of Amish sour cream cheesecake, we'll look for strange things that might be the impetus for some future work of art. Usually, the concept in the back of my mind is another time machine. I've made several and they are delightful to make. For one thing, no one knows what a time machine is supposed to look like, so your critics are likely to settle into a litany of trying to discover what all the pieces of your machine…used to be.

Now, although this is a fun topic, I've had people bring things in to the gallery when they know I'm working on a new time machine, and insist that I add the entire faucet and sink that they've just ripped out of their spare bathroom. Open-minded as I am, some things just aren't going to work. There's a fine line with these found objects and if you don't have a feel about what's appropriate and what's not, you're going to have an up-hill battle getting them to all work together. If you're just getting your feet wet in this profession, I suggest you look for things such that, even upon close inspection, you end up scratching your head wondering what the heck it is. If you pick something that is obviously what it is, i.e. a Donald Duck telephone or a six-foot plastic sailfish, chances are you're going to have a hard time integrating it into your sculpture. Other things, the tines of a rake, parts of farm implements, old gears, etc. may work a little better for you.

The same thing goes for scrap yards. Often you will see bushel baskets of little widgets, circles, or squares, indescribable shapes that are the result of a punch press. Sometimes you can buy the whole bushel basket for cheap and use the pieces as components to a much larger abstract. This is where judgment comes in.

TIP

One way to *not* look like an idiot at a scrap yard: Carry a little magnet around in your pocket. If the metal in question is very shiny silver and your magnet won't stick to it—it's probably stainless steel. If it's grainy and gray or brown and a magnet won't stick—it's probably cast iron. If it's dull silver and marvelously lightweight—it's aluminum. If it's yellow and your magnet won't stick to it—it's brass, and finally, if it's copper color, or green or brown and your magnet won't stick…what is it? Yes, no trick questions here; it's copper. For our purposes, the rest of it is iron or steel.

Lantern. Brass plate, 22" high, by 12" wide.

For one of our time machines, we used such found objects as: the wire wheel from a Model A Ford, the tiny and weird instrument panel from that same Model A, a WWII aircraft shoulder harness, the mechanism to an old-fashioned twist drill, various gears, sprockets, and blown glass spheres, and to top it off, part of a motorcycle exhaust assembly. An old friend even brought in an old fire alarm breaker that we wired to blink the formula for pi (3.14159…) in flashing lights on top of our machine. It all integrated well. You really couldn't tell what was what, and a Donald Duck phone would have disturbed the karma of the rest of the pieces.

The Torch is Mightier than the Sword

They say that the pen is mightier than the sword. Sometimes that's true. Sometimes the torch is mightier than the sword as well. Right after college, there was, at least for me, a rude awakening from the ivory tower I had lived in for four years, studying Plato, Socrates, Immanuel Kant, and Rene Descartes and worrying whether I would get an A or a B on a term paper. Then, the real world hit with a vengeance. Suddenly my beard was a pile of hair on the floor of a military barbershop. I was marching, saluting, giving and taking orders, and soon making decisions of drastically more importance than I was accustomed to.

Pam and I wrote to each other during officer training and I was the only officer trainee in my flight to get three letters every day. Within the flight, Pam became famous for her letters, and they helped more than she ever knew.

We were both concerned about how the military would change me. Most of the guys we knew who had joined the military during the Vietnam War had *changed*. Pam used to say that she could see it in their eyes. What was once a twinkle had been replaced by a professional, though somewhat dead glint. I had seen it as well. Several of my high school buddies had died in the war and I knew in the back of my mind that there was a switch inside my head that should never be thrown. I know I'm not alone in this. Everyone who has served in the military during a war is aware of this switch, this knowledge, that under certain circumstances, we are capable of extreme violence.

I know that many artists, at this point, would have used their art form to create monuments to the pain, the violence, the suffering, the insanity of it all. That's one way to handle it. But at the time, there was so *much* violence. Every time you turned on the TV it hit you in the face. Every night there were the body counts on the six o'clock news, images of women and children, sometimes on fire, running through a village. It just seemed that the world was already overloaded with enough of these images to last a millennium. I didn't think anyone needed symbolic shards of metal, tipped in red paint to make us even more aware of the problem. Consequently, I went in the other direction. I began making little sculptures, goofy little things just to make someone…anyone smile, to remember the humor and humanity still inside us. Many of the sculptures were more like three-dimensional cartoons than sculptures: bicyclists going around a corner with their bicycles bent neatly in half, a man sitting on a bench feeding bats that are fluttering around on fine wires, a little kid with his kite stuck in a tree or fishing off a dock. I made impossible little-kid versions of airplanes, the kind you draw in math class, with guns and propellers and wheels everywhere. None of them appeared threatening.

But even within this mindset, I found things bubbling up and out to become sculptures, and usually not premeditated, they were more like self-forming psychic splinters which once they were created, somehow made me feel more at ease with myself.

Square Bicycle.

The Almighty Dollar. I created this piece in 1975 and it got me in a lot of trouble with the person that I sent it to. Over the years we both have changed and the symbolism no longer applies, hopefully to either of us.

CHAPTER 10
MODULES

The old adage, Necessity is the mother of invention, was never truer than when we began making a couple of our sculptures modular, which is to say, in small pieces which fit together.

The impetus for this brainstorm was a delightful British couple that had wandered into our gallery and promptly fell in love with one of our large abstracts. With fingers crossed behind my back I asked, "Of course…you're living in America now?" to which the reply was a polite wrinkling of the nose. "No. Actually we're heading back to the UK tonight," the woman said. "How much do you think it would cost to ship it?" to which I countered, "How much do you have?"

Conditions rapidly worsened and after a few minutes of mutual sighing, the couple began to trundle out the door. That is when "Mother Necessity" whacked me on the side of my head and whispered, "modules, Henry

… MODULES!" "Huh? What? Oh…" I chased the couple out into the parking lot where they were just unlocking the door to their rental car. "Modules!" I yelled. "I can make it in pieces and it'll only cost you an arm and a leg, not your entire life savings!" To make a long story mercifully short, we worked out the details.

A week or so after, another couple wandered into our gallery with their hopes set on a huge abstract custom made for their two-story foyer. "Of course, you'll be delivering it," the husband said. "It's far too large to fit in our car." "…Where do you live?" I asked.

"Connecticut." "Modules!" I exclaimed. At least I think I exclaimed. It's difficult to self-assess whether you're exclaiming or just saying. But this really isn't the important part of the story. The interesting part came, when I began making components for abstracts and then fitting them together. It became immediately clear that

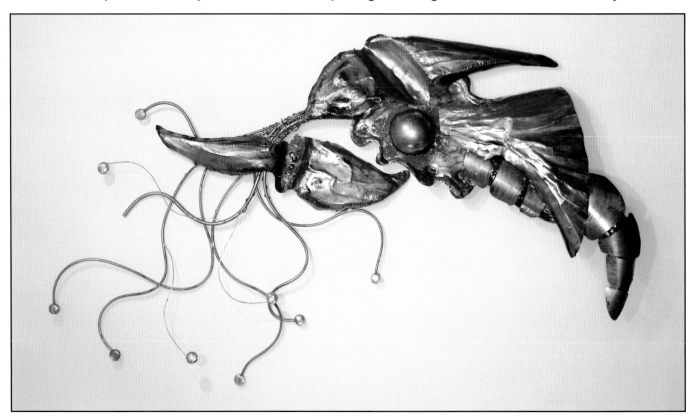

From the Deep. This piece is definitely oceanic in nature and large enough as to be a little scary.
It's constructed of: Copper, bronze, glass, steel, BBs, and brass splatters. It is 7' long by 3'8" tall.

there was more than one way that these components could fit together. In truth, there are an almost infinite variety of ways the components or modules can fit. That's the exciting part. Three modules: 5000 different ways to fit it together.

I really have no idea what the traditionalists have to say about all this, nor do I really care. To steal a lyric from an old Rick Nelson song, "You know you can't please everyone so you…hafta please yourself." That's one of those few universal truths written in stone for artists. Personally, I think it's neat to have 5000 different ways to configure one of my sculptures…and I don't mind a bit that the patron participates in his or her own way.

Pictured here are a small variety of modular sculptures. If you look closely, you'll notice that some of them are discreet modules and some are grouped. Interesting how the shape and flavor of the pieces change as they are regrouped. It's also a heck of a lot easier fitting them in the car…sending them to Europe.

Blue Squiggles. Modular abstract in two pieces. 56" by 45".

Scarlet Ribbons. Here's another prime example of a modular sculpture. This one is in two pieces and it really does connote the feeling of the song.

119

Martian Still Life. This is an evolutionary piece, as opposed to revolutionary. It's amazing how a very subtle change in construction and shape can bring about significant changes to the mood of a piece. This one is approx. 66" long by about 33" tall.

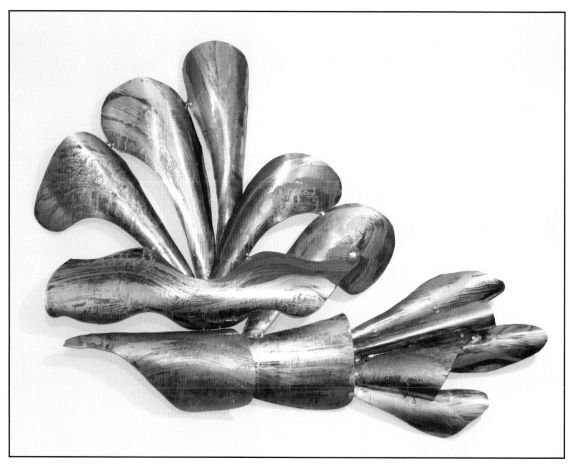

Headress. This is one of a series in a new type of Martian landscape series. Quite frankly, with these pieces, I'm not certain until the last piece is added, precisely what I have made. ...I presume you wanted to know the truth.

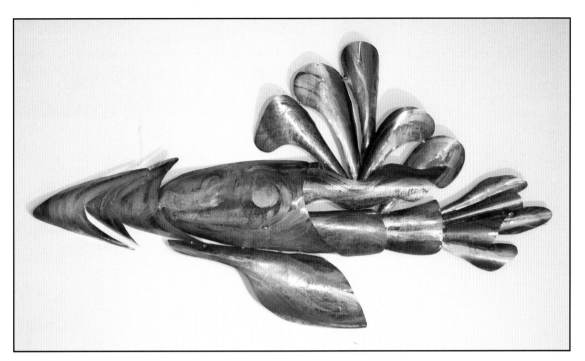

Taboo. This piece as well as the succeeding two pieces are variations on a theme in which modules are added or deleted to create a new abstract. Taboo is 70" long.

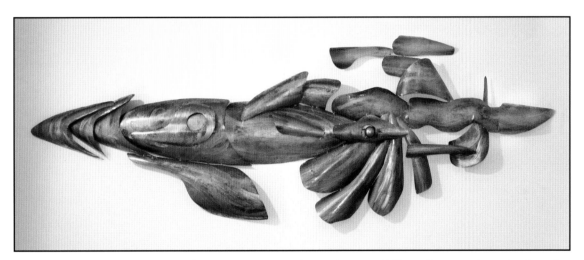

Taboo Totem. This piece is, in actuality, a permutation and reconfiguring of Taboo. Compare them closely, and then look at the next photo.

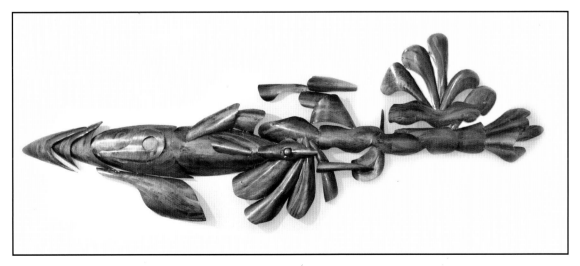

TabooTotem with Headress. In this additive configuration, this abstract is 12' wide. It spans an entire wall and yet it is, in its own way, a very tranquil piece. The point of these three photos is to exemplify the concept of additive modules.

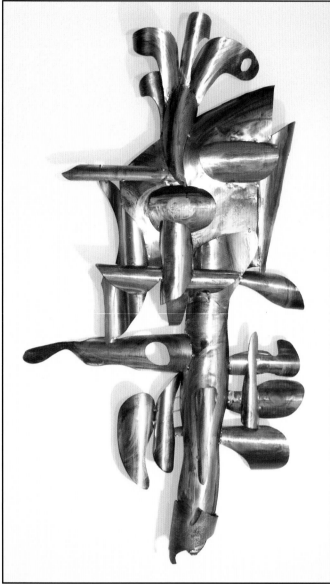

Royal Knight. This piece is part of our Martian Landscape Series and when it was finished it just...looked like a knight...a royal knight. That's how they are named sometimes.

Submarine. This is a Martian submarine at its docking port, near Barsoom. It is a bit of sci-fi fantasy and measures approx 72" by 35".

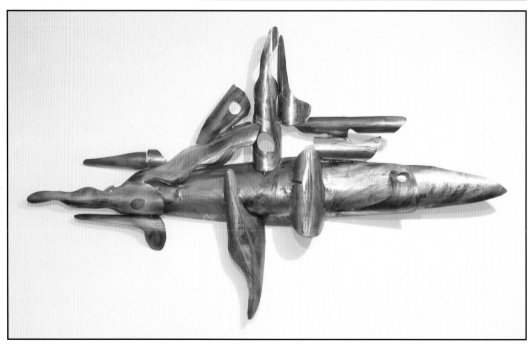

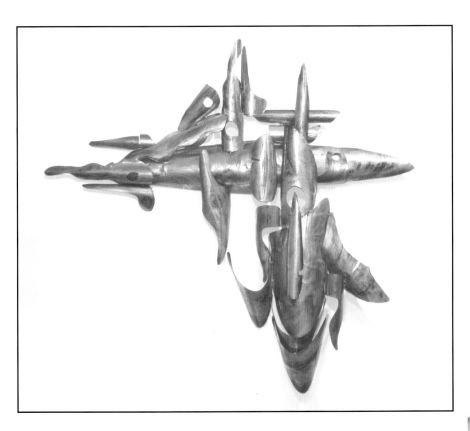

Posing with Submarine. In keeping with the submarine sculpture above, this iteration with a second module is a Martian in the foreground...posing.

Martian Sconce. This piece is an abstract sconce...appropriate for a Martian dwelling. The light shines out of the upper cone.

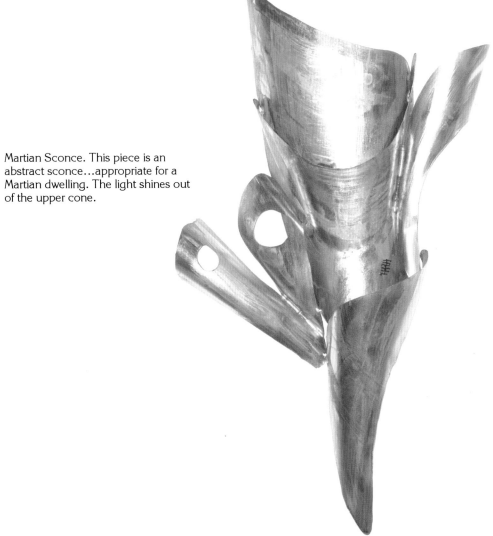

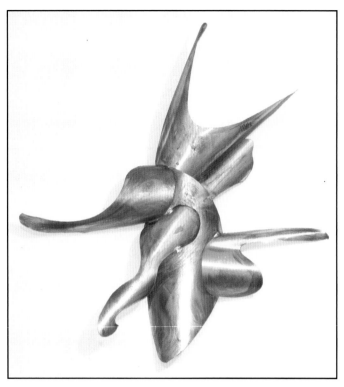

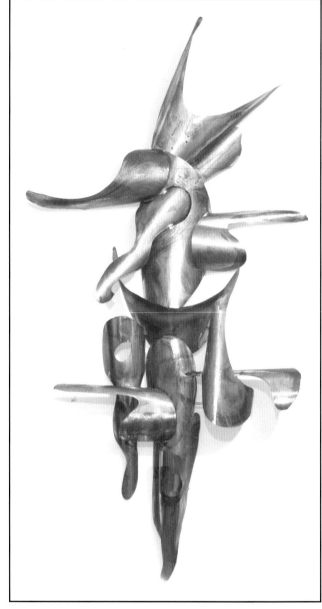

Crocodile King. Again, this is a new design concept for me...experimentation with modules. This piece and the next to it are related in that they share a modular piece.

Crocodile Totem. This piece is a side view of an abstracted crocodile coat of arms.

Planet-Eating Machine. This is a huge modular abstract, along the lines of the Martian Landscape series, only a bit darker in tone and construction. 120" by 55".

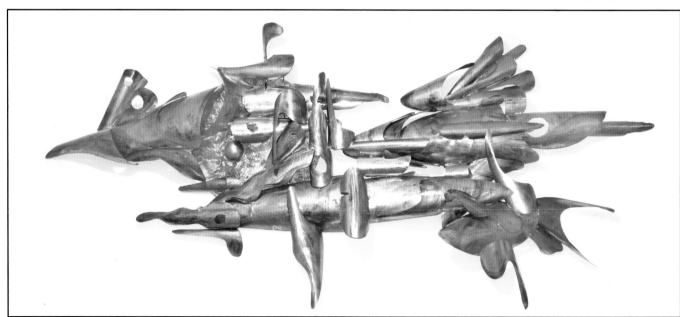

THE INQUISITOR

The Inquisitor began life with me standing in Pappadeas' scrap yard, in Tucson, Arizona. I was looking down at a grimy cardboard box full of tool castings that had been rejected by the manufacturer. Some of them were recognizable, halves of a pliers, pieces of wrenches, etc. I picked up the plier halves and held them together. The arch of the handles reminded me of the legs of a rather cocky man, spread and muscular.

Back at the studio, I upended the box on my worktable and began to play with the pieces. The ends of the open end wrench castings looked like robot arms and hundreds of permutations began swimming in my mind. I suppose that's the one magical place where the artist's talent makes itself known. Anyone can type words onto a page…it's finding precisely the right word. Mark Twain once said it quite eloquently. *"The difference between the right word, and the almost right word, is the difference between lightning, and a lightning bug."* The same goes for positioning pieces for a sculpture.

Playing with the pliers, I held up a hunk of copper pipe for a head and a large cotter pin for an arm. Suddenly, a huge piece of this puzzle was apparent. There was a strong feeling of accusation in the abstract figure, standing on my welding table.

We were in a courtroom of sorts, the inquisitor standing on a raised platform pointing at the accused. A mute armless judge stands behind, ringed with a crown-like piece of bronze, which used to house ball bearings. On the lower platform, two robot-like figures stand at attention, one tall and slender, the other shorter and thicker. They are flanked by two court assistants, whose construction resembles that of the accuser. On a third, lower level, the scene becomes a story—two small figures leaning to each other… plotting. Very Shakespearean. The goal was to create a story and an atmosphere with the minimum of fuss and filigree. I like it and consequently it was a success…at least for me. That it was purchased by an art collector was nice as well.

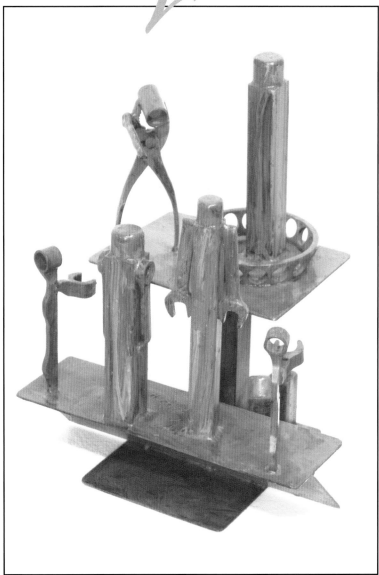

Inquisitor, courtesy of Robert Wiseman. Mr. Wiseman is an experienced art collector who purchased this piece from me more than a decade ago. He has a superb eye for abstracts and some day maybe I'll attempt to buy this one back. It's a deceptively complex piece. There is a judge, a jury, conspirators, witnesses, and the inquisitor.

125

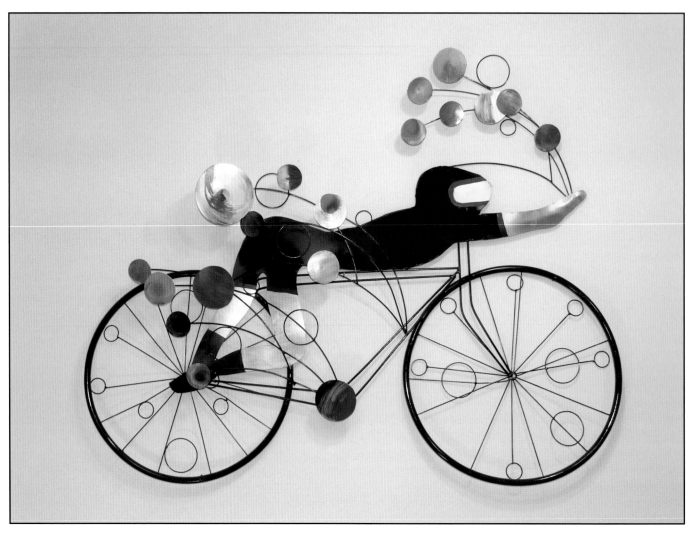

Tour de France. This one is pure fantasy. Note that the rider is almost functioning as the frame. The balloons are reminiscent of an old Renault commercial from the 60s.

NUDES

One day we were sculpting away when the door of our gallery flew open and a cheerful older couple sauntered up to the counter. I turned off my torch and asked how I could help. "We want our portraits done in wire!" the woman bubbled. "Sure! No problem!" I replied. Then the man removed a Playboy magazine that had been residing under his arm and he opened it to the playmate of the month. Having a healthy pile of my own magazines, I can't say that I was shocked. But then, they began sketching how they wanted themselves depicted. It's one thing to sketch nude models in an art class. But these two were looking for some serious poses and they weren't exactly young or skinny. I finally convinced them that the impressionistic route was the way to go. When it was done, it was a beautiful and graceful collection of curves and arches. And no one but the three of us knew exactly what they all stood for.

PROJECT VIII
MAKING A SIMPLE FOUNTAIN

(Intermediate Project)

Supplies You'll Need:
Sheet of 16 oz. soft copper
1/2" O.D. copper tubing
5/8" O.D. copper tubing
3/16" brazing rod.
Submersible pump
Restrictor clamp.
1/2 inch O.D. vinyl tubing

Before we begin making a fountain, there are some ground rules that must be laid. Unlike a typical abstract where there are almost no rules, other than those of taste, a fountain has an additional set of rules to obey. They are called, *The Laws of Physics* and if you think you're going to bend them...good luck.

First Rule: Stay away from iron and steel. What can pass as a delicate oxide of steel (rust) in an outdoor sculpture will become a real mess if you try to use it in a fountain. Rusty brown water, mucky brown steel, and that's only the beginning. For our purposes, copper, brass, and bronze are the metals of choice.

Second Rule: The Law of Gravity. Water *always* obeys the law of gravity. It's amazing how many students, in their zeal for stranger and stranger fountains, forget this simple point. Left to its own devices, water will always go down, not angled down, not leaping over six inches and then going down...just down.

Third Rule: The Venturi Effect. Fluids and gases will always speed when forced through a progressively smaller orifice. An excellent example of this is a garden hose. Without a nozzle attached to the end, the water will flow at a leisurely rate. But screw a nozzle on (essentially a variable Venturi) and you can shoot water all over the place. Sound obvious? It is! But almost every

budding young sculptor forgets it when making his or her first fountain.

To begin, you will need a reservoir and a number of basins. I use dead-soft 16-ounce copper, which I cut with a plasma cutter and then pound on a stump. You can use a tin snips, or cut the pieces with a torch. If you use snips, be sure to dull the edges when you're finished. A torch works best and gives a nice patina to the edges.

Forming the copper basins is easy, once you get the hang of it. You can use a sand bag or a stump to support the copper while you hammer. I use a variety of ball-peen hammers and plastic-headed hammers, depending on what effect I want. Essentially, you want a deep enough edge to the basins (1"-3") to contain fast-moving water. To do this, hold the copper at an angle against the bag or stump and hit at a point an inch or two from the edge. Do this all the way around until you have made a crude cup or basin leaving a channel at one end for the water to flow out.

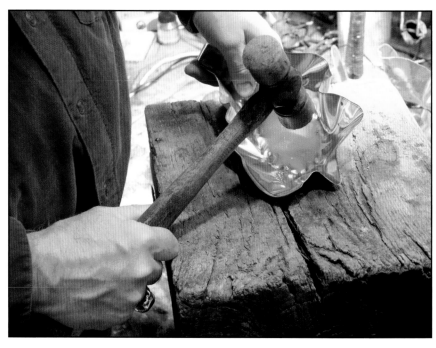

Hammering a basin. The plastic mallet I'm using to pound this copper basin is the same one I've used for 30 years. No need to throw away old friends...just because they get old or careworn.

The reservoir is hammered in the same manner. The only difference is, because the reservoir is going to contain all the water for the fountain, its sides must be higher.

Once you have everything hammered, it's time to begin the actual construction. You will need a spine for the basins to climb. It also provides the means for the water to get to the top of the fountain. Using a tubing cutter, cut a length of three or four-feet of copper refrigeration tubing. It should be 5/8" outside diameter and 1/2" inside diameter. Next, cut a two-inch length of 1/2" outside diameter copper tubing. This will be the nipple that connects the pump to the fountain. Once you have both tubes cut, you'll need to cut or drill a hole in the 5/8" tube, approximately 3" from one end. Then braze the short nipple over the hole, insuring that it is watertight.

Attaching nipple to fountain. This is where all the action takes place. It is where the work of art attaches to the pump, and if you're not careful, it is the place where a leak can easily occur. Make sure the diameter of the copper nipple matches the diameter of your pump. Then you may friction-fit a length of plastic tubing between them.

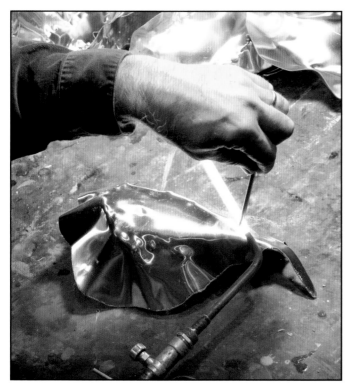

Attaching stem to basin. Here I am attaching a pre-cut 4" rod (3/16 dia.) to the undersurface of a fountain basin.

Next, braze the spine (nipple at the bottom and pointed toward the back) to the inside of the reservoir, centered, but a little toward the back. Hang in there. Once this is done, the rest is fun.

Attaching first basin. If you look closely, you will see that I create a "tongue" of sorts at the edge of the basin to steer the water flow.

Supporting first basin. Every basin is attached at the bottom to place it, and then attached above, to brace it.

You're going to be brazing 3/16" by 4" long brass stalks to the bottom of each basin. After brazing them on, we can begin our progress upward. Always work from the bottom up. It's much easier that way. At this point, you need to "flap your wings" a little as to exactly where you want the basins. Just don't forget the laws of physics. Once the first basin is installed, the second basin attaches to the upper portion of the first basin, as well as the fountain spine, and you sort of "walk-your-way" up the fountain. Try to always have every basin attached in at least two places. A zigzag pattern works well, as does a spiral pattern.

TIP

The height and angle that the water hits the basin below it is critical in determining the personality of your fountain. To take it *reductio ad absurdum*, if the basins were spaced ten-feet apart, and the water hit at ninety degrees, the *splat* that would occur would probably empty your fountain in a minute or two. Conversely, if the distance between your basins were a quarter of an inch, you'd have yourself a stealth fountain. No sound, no action, no nothing. The truth for what we're shooting for lies somewhere in between. A little trial and error in the kitchen sink will tell you what it would take me days to explain. A good kickoff point, however, would be to try about 3 to 4 inches as the spacing between the bottom of the top basin to the bottom of the bottom basin.

If you put a "tongue" on the end of your basins, you can stretch that distance to 4 to 6+ inches between basins. The tongue also allows you to steer and modulate the sound of your fountain.

As you progress, attaching one basin after another, a good thing to do is stop every so often and trickle some water into the basins, to see if the water is going where you want it…or out onto your fine Persian carpet. Chances are you'll find that some basins are fine, and once in a while, you run into one that's splashing, or overflowing the rim. There are several ways to counter this. First, you can try reducing the angle of the upper basin so that the water doesn't accelerate so fast. Failing that, you can shorten the stalk connecting the two. Failing that, you can try adjusting the tongue. Failing that, there's always the old standby of placing some pebbles or gravel into the basin, which cuts down on the splashing. If all that doesn't work…you've got yourself an outside fountain.

Attaching second basin.

You will notice as you progress to the top of your fountain, that the fountain tends to get skinnier, as the basins get closer together. This is what you want in a "regulation" fountain. In nature, things like trees, shrubs, mountains, all tend to get smaller as you go up. If you picture the overall geometry of your fountain as something like a small Christmas tree, you won't be too far off.

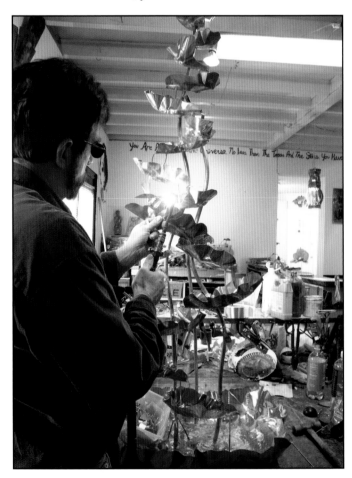

Attaching support rods. When the fountain is basically finished, go back and test each basin to assure that it is solid. Add 3/16" brass supports where necessary.

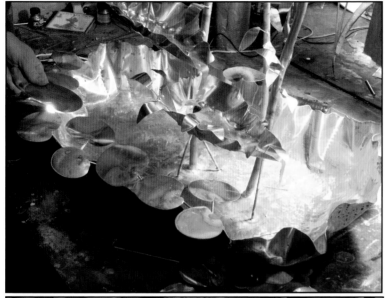

Attaching lily pads. Cut your lily pads from .015 soft copper, stem them and add them to the fountain in clusters.

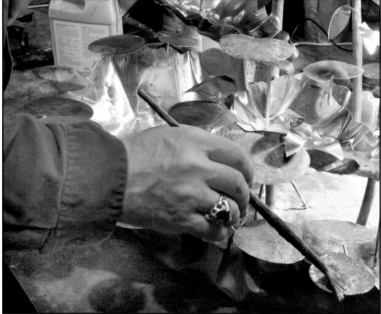

Painting lily pads.

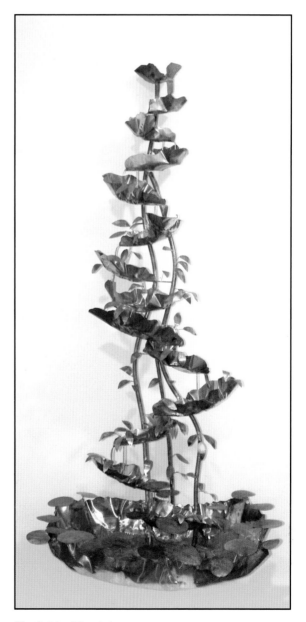

The finished fountain.

The last basin on top is treated slightly differently than all the rest. This is usually the smallest basin and it's the only basin that the spine pierces. Once you've designated the top basin, eyeball it over the spine, so that it's aligned to flow into the basin below. Then visually gauge with your eye, where the spine would come through the bottom. Crank your torch up to *high* and cut a hole the approximate diameter of the tube. This is just a little bit tricky, so once you've done this, plunge your basin into some water, and allow the spine to cool down, (a spray bottle is invaluable in cooling down specific areas). With *everything* cool to the touch, fit the top basin over the fountain's tubular spine. If you've cut it too small, a good way to spread the copper is to stick the end of a needle-nose pliers into the hole and ream it out slightly. Position the basin so that the water will flow gracefully to the basin below it, and then braze the basin all the way around the tube, being very careful not to miss a spot. It must be a watertight braze.

With the exception of the leaves, frogs, butterflies, birds, snakes, vines, and flowers that you might add to your particular basin, you have finished your first copper fountain, and you only had to wade through five pages to do it. By the time you do the next one, you'll be a pro. Just remember the laws of physics.

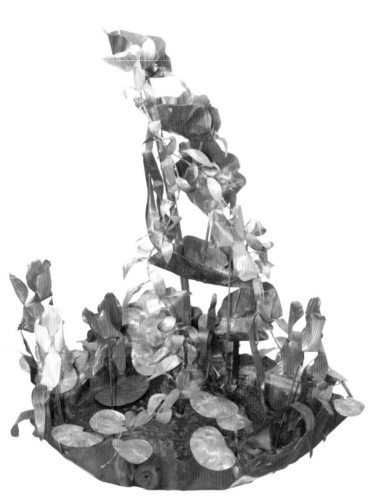

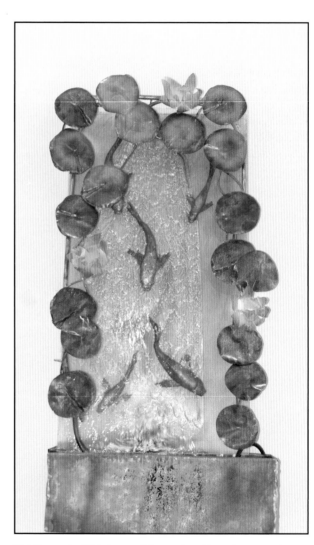

S-Curve Fountain with Iris. This copper fountain is 3' tall, 30" wide, and 16" deep.

Koi Fountain. This is a wall fountain with a glass panel upon which cast bronze koi have been attached with Epoxy. 40" tall by 18" wide.

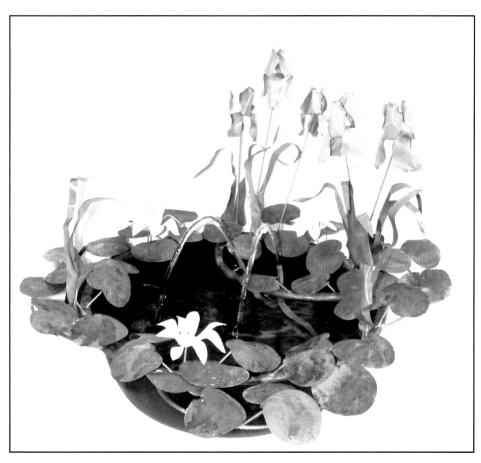

Gabrielle Fountain. This is one of our Athena series fountains. Gabby is 26" in diameter and can be buried directly in the earth.

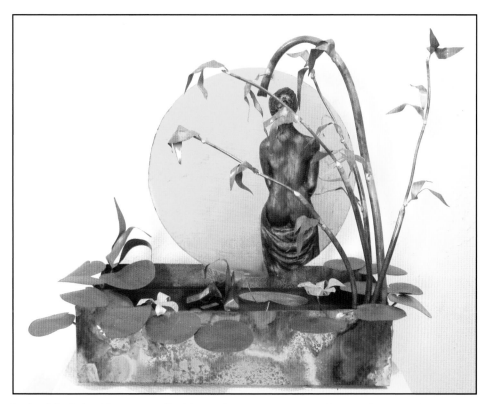

Lady of the Lake. This is a small table-top fountain consisting of a cast aluminum figure which is then electroplated, has copper bamboo, and a stained acrylic sun. approx. 20" wide by 20" tall.

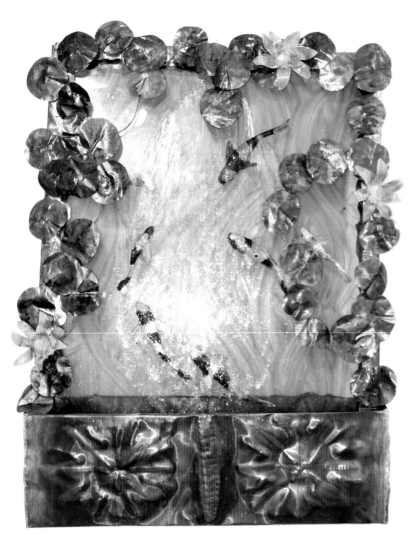

Koi and Lotus. This koi fountain is 45" tall and 33" wide.

Zen Fountain. This fountain was created by heat treating copper and then bending it into a corrugated pattern. It is 100" tall and 29" wide.

Tall Ivy Fountain. This fountain is 65" tall and 31" wide and is decorated with copper ivy.

Fountain incorporating stained-glass paint.

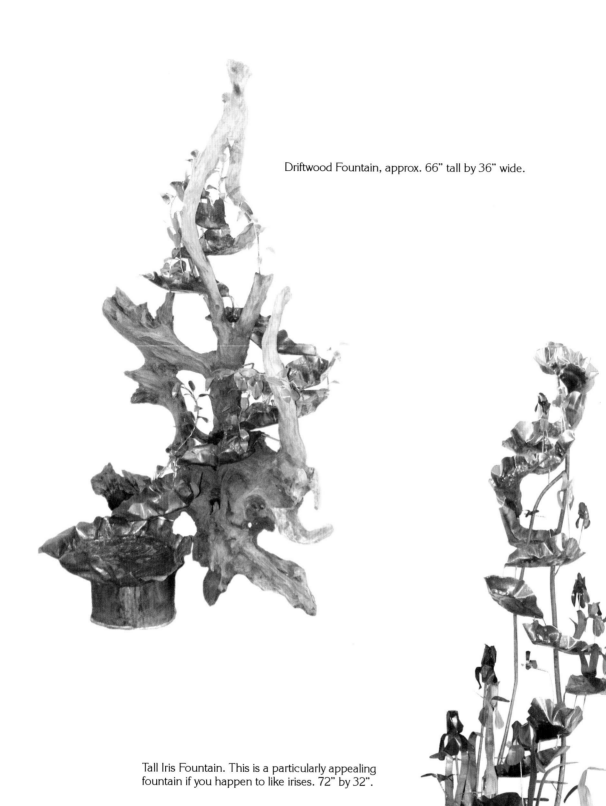

Driftwood Fountain, approx. 66" tall by 36" wide.

Tall Iris Fountain. This is a particularly appealing
fountain if you happen to like irises. 72" by 32".

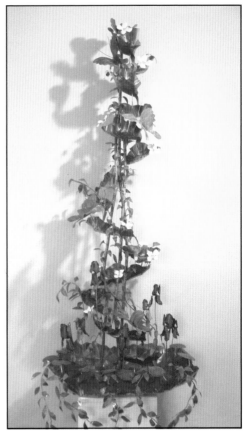

Fountain with butterflies and iris, courtesy St. Mary's Hospital.

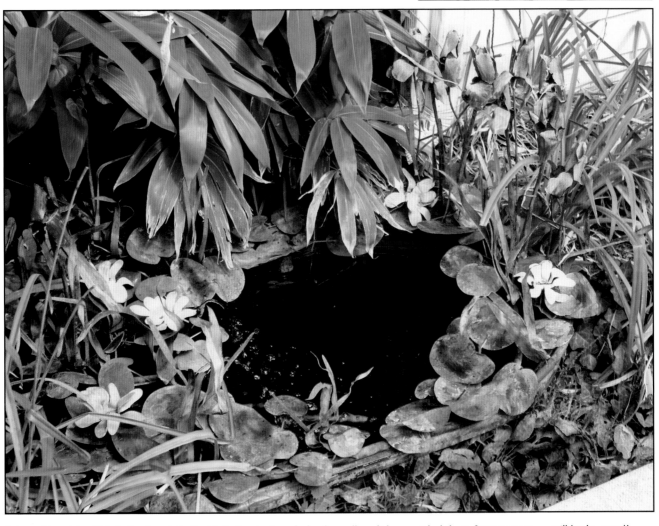

Athena Fountain. This is the fountain that is in front of our Lahaska gallery. It has resided there for ten years. ...still looks good!

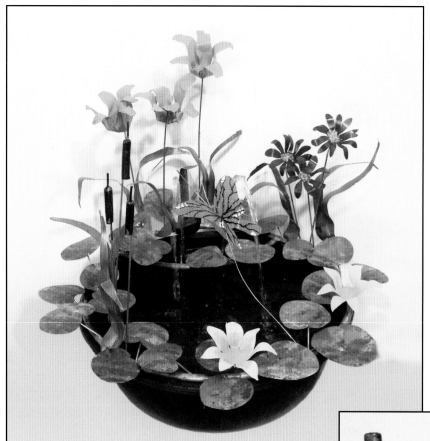

Tiger Lily Fountain. This was a commissioned fountain. I was skeptical about the color choice by the client until I saw the finished piece. It's quite cheery.

Stained Glass. One of our "stained glass" fountains. Actually, they are created with a Lexan-like acrylic, that is impervious to almost everything and will never accidentally shatter if a little one throws a baseball at it. This one is 24" wide by 36" tall.

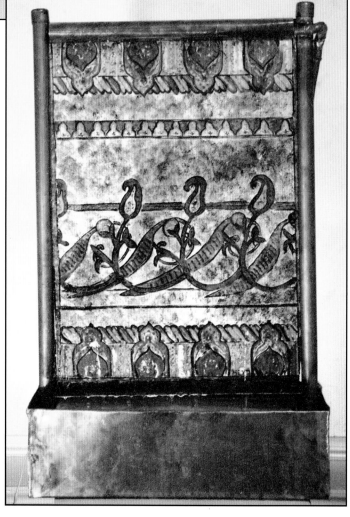

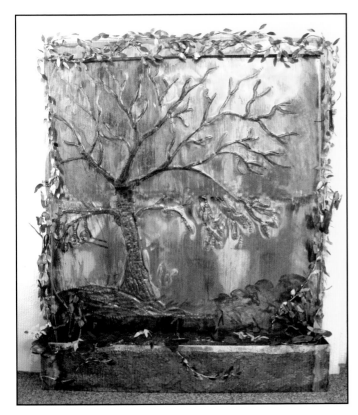

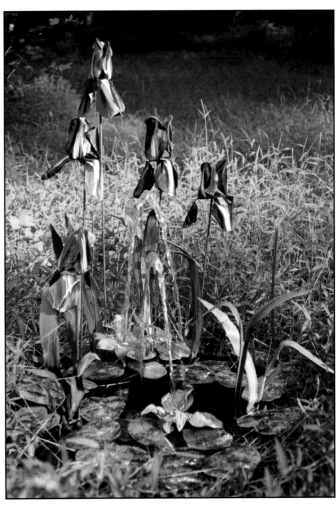

Slab Fountain. This is one of our large commercial fountains. This one resides in a medical complex in Virginia. Note the hammered tree on the façade. 8' by 6'.

Helena Fountain.

Athena Fountain. This is the flagship of our outdoor Athena series fountains. It is buried in the ground and shoots four jets of water into the two ponds.

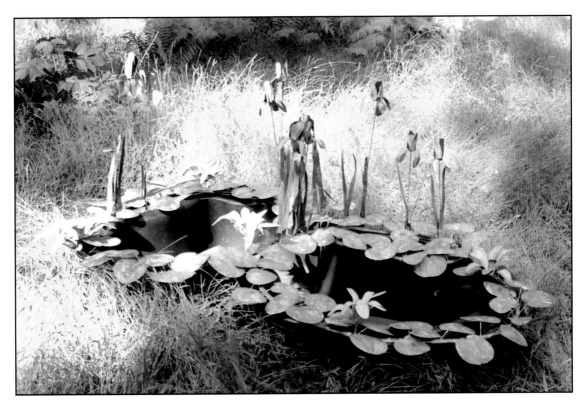

MARTIAN SAND CRUISER

If you skim through this book, you'll find a smattering of photos with the word *Martian* prefixing the titles. I've created Martian cruisers, battleships, scout ships, sand ships, destroyers, Martian warriors, and Martian princesses. I plead guilty to being a child of my time. Long before Capt. James T. Kirk took to warping through the galaxies, other intrepid young men were battling green men, and white hairless apes, and saving Martian princesses from fates worse than death. Edgar Rice Burroughs was unabashedly my mentor through his writing, creating entire worlds of magic that I could visit with the turn of a page. My son, Cameron Carter Harvey, is named partly from one of my flying buddies in pilot training and partly (the Carter part) from John Carter of Mars, Burroughs' protagonist. Mix in a bit of Ray Bradbury's Martian Chronicles with his elegant sand ships and eloquent Martians, and the spell was cast.

Martian Battleship. Yes, it could be argued that I have a love affair with the planet Mars. When you're weaned on Bradbury, Heinlein, and Edgar Rice Burroughs it's impossible not to be. This ship hovers above the sands of Mars awaiting John Carter's escape.

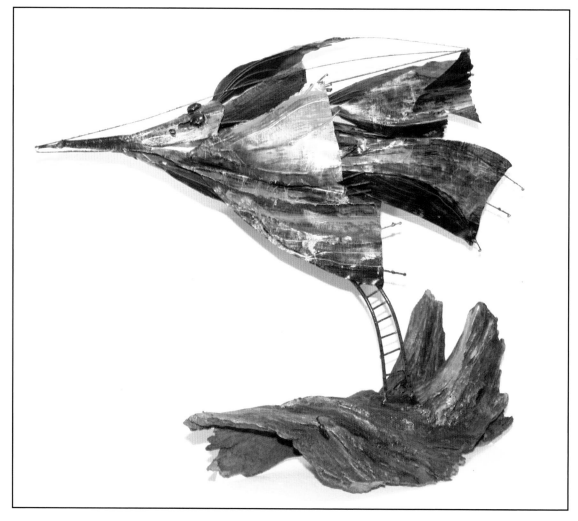

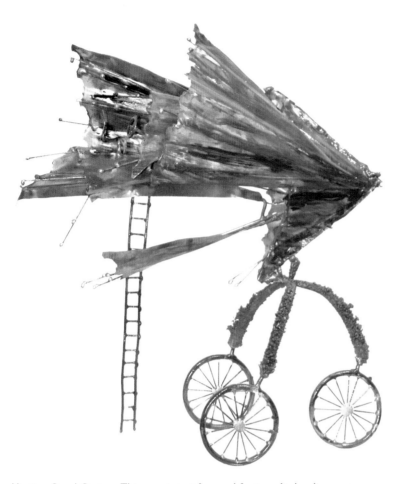

Martian Warrior Princess. This beautiful lady is comprised of copper, bronze, and glass. The iridescent patinas were accomplished by paint, heat, and metallic powders.

Martian Sand Cruiser. This one is just fun and fantasy. Its landing gear struts were formed from the electrodes in my electroplater, having plated themselves into an interesting shape.

Martian Sub. I'm telling secrets now, but I suppose that is what this book is for. Try to guess the derivation of the sub's original body. Give up? It was a plastic seltzer bottle, now encased in bronze electroplating. Don't ask where the other pieces came from.

The sculpture pictured (above) is of a Martian Sand Cruiser. The wheels are formed from copper refrigeration tubing, with welding rods for spokes. The body of the ship is reminiscent of old-fashioned ship's sails. The ladder tells you the scale, as well as the small seat and steering wheel. By my calculation, a Martian Sand Cruiser stands about two stories high and two stories long and carries no armament. Any astute observers care to guess what the tricycle landing gear is composed of? Look closely…closer. Tiny nodules of raw copper…growing out of copper tubes. They are the holders I use when I'm electroplating. It was just plain luck that I spied them and made the connection when I was working on this project.

PROJECT VIII
MAKING A BRONZE APPLE TREE

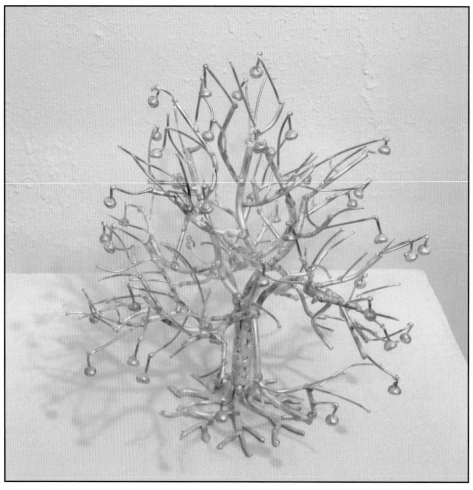

Finished Bronze Tree.

(Advanced)

This is one of those projects that looks easy…and isn't. It's not that the concept is difficult. We all know what a tree looks like: Some gnarly roots, a nice thick trunk, several main branches becoming progressively smaller, and finally becoming twigs.

The difficulty lies in the fact that bronze melts suddenly. If you're inexperienced, you'll be concentrating on brazing a small branch to a large branch, and then suddenly branches are lying on your welding table as if it had been hit by lightning. And the problem gets worse as the branches become more slender. You're putting twigs on small branches, and losing about as much as you're putting on. If you're easily discouraged, there are plenty of other things you can make. No one is

twisting your arm. Having said that, if you want to jump in and begin to really polish your timing, this project is for you. The one redeeming feature here is that even if you mess-up horribly, the only difference at the end will be that your tree will have more personality. Many trees in nature are gnarly as hell. You'll be in good company.

To create this tree, you'll need a small supply of 3/16", 1/8", 3/32", and 1/16" low fuming brazing rod. The number of rods you need will be in direct correlation to the size of the tree. I would humbly suggest that you begin with a smallish tree of perhaps 12" to 14" high and proportionally wide. Use a larger size blowpipe to begin with.

The first step will be to make the larger roots, which curve up to become the trunk and primary branches.

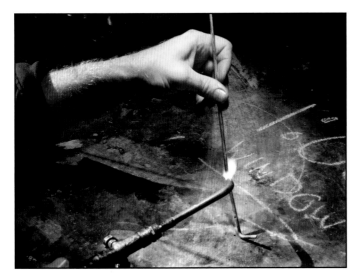

Beginning the trunk. Rods of 3/16" bronze are bent with the torch and then connected.

As you can see in the photo, we begin with five 3/16" rods of about a foot or so. (If you're going to be an artist, you don't need or want hyper-control, so the number of rods, branches, twigs, is only a kickoff point.) If you want to make a twenty-rod trunk…go for it! It'll be beautiful.

The bends are all made by heating the rod with the torch and then applying pressure. Because of the possibility of your hand slipping when applying pressure, be sure you use gloves and proper safety attire. The tendency will be for you to bend each piece in the same manner, which will give you a very boring and unrealistic tree. Fight the urge for uniformity!

The first bends are sharp angled bends at the base of the rod. This is the transition from big root to becoming part of the trunk. After you've bent five or so roots, you can begin to account for the trunk. Allow four to six-inches for this particular tree and make a bend outward, so that the roots and branches are heading in the same direction.

Lay out two of your trunk pieces on the table as indicated in the photo, and then braze them together, top and bottom. Got it? Okay, now you have a very simple and very abstract tree; the rest is just making it prettier. Using a pliers, pick up a third root/trunk piece and braze it carefully to the tree. Next take a fourth and fifth root/trunk piece and attach them in the same manner so that the roots are all radiating out from the bottom, and the branches are radiating out at the top. If you accidentally melt through the rod, don't sweat it and don't quit. Instead, refine your handling of the torch.

A word of caution, the more you work on the tree, the hotter the whole thing becomes. It's imperative that you wear gloves, preferably ones that will give you some insulation from the heat. At this point, quench the whole thing in water so that you can focus on fine-tuning one branch at a time, one root at a time. Now, we begin making the branches look like branches and not hunks of brazing rod. The word of the day is: Compound Curves. Tree limbs grow in subtle and complex angles, not left, then right, then up, then down. Think: sweeping upward and to the left, then transitioning downward and to the right. From here on in, *every* branch, root, and twig will have to bend subtly in one direction, then another.

Now that we have the basic trunk roughed-out, it's time to begin filling in the gaps between the rods comprising the trunk. This is fun, and easy. You can even, if you like, leave a small gap in the rods here and there, making a knothole, or woodpecker's nest in the trunk. Fill the gaps by dribbling bronze from an 1/8" rod. You can make the trunk as smooth or as gnarly as you like.

Now let's get back to our roots. Right now, they're thick, clunky, and boring. Make sure you put a complex curve into them. Using a pliers, prebend an 1/8" rod into complex curves, and begin by extending one or two smaller rods out from the large roots.

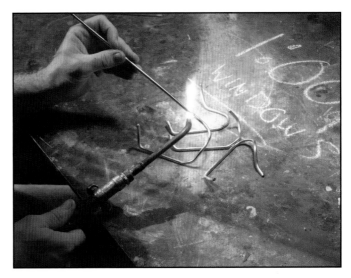

Branching out. After the trunk is formed, switch to 1/8" bronze rod, then 3/32" bronze rod, and finally 1/16" bronze rod.

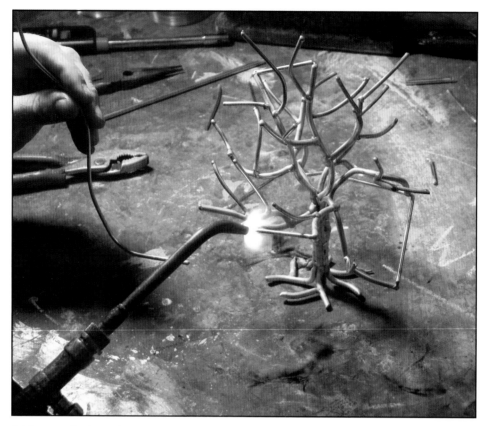

Adding smaller branches. Switch to a slightly smaller tip and use careful control over your heating area.

Adding fine branches. Switch to your smallest torch tip and keep your wits about you. The fine brass melts in the blink of an eye.

It's at this point that the project begins to take shape. Now that the trunk and roots are together, you can pre-bend the rods for your upper branches. If you're strong and prone to being macho, you can bend the 3/16" rods with your hands. I don't recommend it; it's hard on the nerves in your fingers. Use the torch. Bend several rods in each of the smaller sizes as well.

We're always working from large to small, so begin by brazing short lengths of your curvy 3/16 rod to the existing branches. Again—odd angles, complex curves! You will find that it's difficult brazing like-sized rods together, because they tend to melt at the same time. Patience and practice.

The next step is much easier (for the time being). Begin brazing hunks of your bent-up 1/8" rod to the main branches. Don't forget that branches go down as well as up.

Whenever you're putting small branches on to large, have at least two small branches emanating from the tip of the larger. It's more natural and believable.

Time to switch blowpipes. If you were using a Smith 204 for the roots, try switching to a 202 for the intermediate branches. It'll give you more control.

As your branches begin getting longer and more complicated, they're also going to get heavier. This equates to more chance that they'll melt through when heated. One way around this is to temporarily connect a brace to the end of the branch. Once you do this, you can add branches easily. After you're done, remove the braces…or slice them and turn them into even more branches!

As you get into the final stages of adding the 1/16" rod for the twigs, switch to a 201 or smaller blowpipe.

If you want a bare tree, you're just about finished. You can use a little steel wool to clean up the trunk, and place it on your desk. Or…you can braze a bolt or rod on the bottom of the tree and mount it on a marble cube or piece of wood.

If you want an apple tree, however, it's time to make apples. Drag out a length of 3/16" brazing rod and begin melting off small round pea-sized globes for the apples. Make as many as you like, and again, be careful that they don't roll off your worktable and into your shoe. After you have the apples, they need stems. The 1/16" brass rod is your source of stems; make them about ½ to ¾ of an inch long and braze them to the "apples". The last step is brazing the apples to the tree. Congratulations! Isn't it nice creating really beautiful things?

Making apples. The apples are created by melting "blobs" of molten 3/16" brass rod into a spherical puddle.

Adding apples. Stem your apples with 1/16" brass rod and then with a pliers, attach each apple to the tree.

TRADITIONAL/ LANDSCAPES

Bucks County Barns.
Painted copper over a steel
wire matrix.

Balloon Scene. Painted copper.

Lily Pond. Painted copper 4'7" by 30".

Geese Over Marshes. Painted and oxidized copper 48" by 26".

Lady in the Mist. The lady is cast from aluminum. The lilypads and flowers are painted copper.

At the Beach. A fanciful wall scene, approx. 30" by 50".

Geese in Flight. This is one of our oldest stand-bys at the gallery. It's no longer creative art so much as performing art, but it's nice making people happy. Sort of like JT singing Fire and Rain for the 10,000th time.

A Field of Geese. This is a brass hybrid of the standard Geese in Flight. The grasses are a bit more fluid, I think.

Lighthouse. Painted metal, 58" wide by 24" tall.

Pine Trees. Painted metal, 40" tall by 40" wide.

The Bather. A hybrid of our Monet Bridge Scene, this one contains a cast figure. It is 5' by 2'.

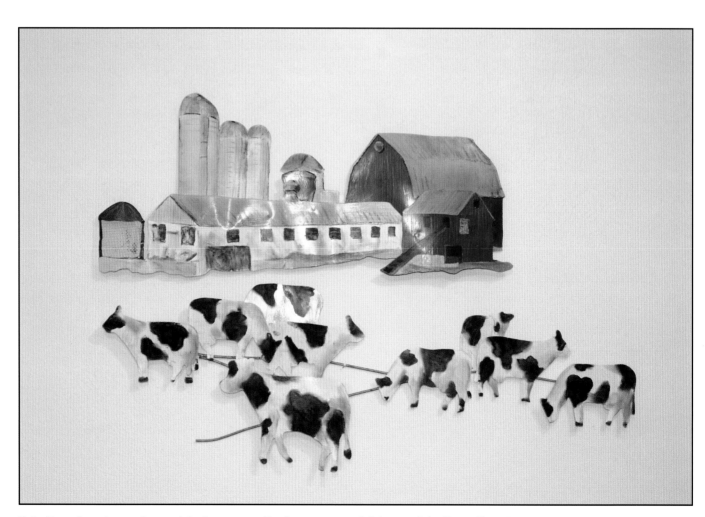

Dairy Farm. I used to work on a dairy farm, not unlike the one pictured. I drove a John Deere Tractor, loved the smell of hay, manure, silage…all of it. Happy days.

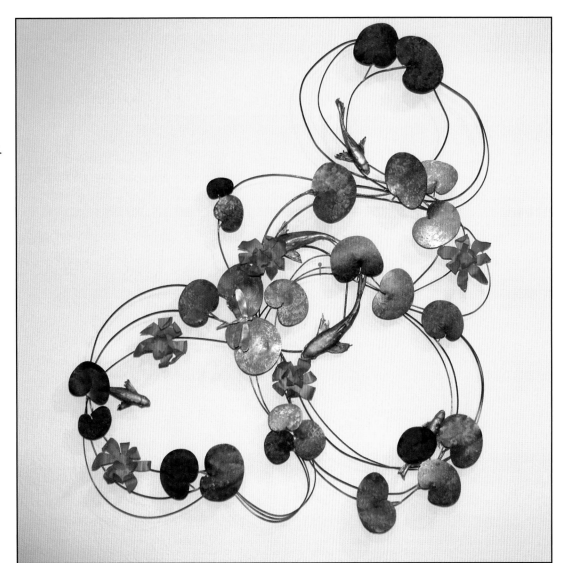

Koi Scene. This wall scene is a top view of a koi pond. It is 40" by 50".

Wild Flowers. A cheerful hedgerow of wildflowers. 36" by 18".

Amish Country. For those of you who have grown up in western PA, you understand the warm country feeling that this evokes. There is nothing cozier than a small Pennsylvania town in the autumn...and there are more covered bridges in PA than any other state.

Wine. This is one of our wine and cheese still lifes. It measures 5' by 18".

Bird on Fence. This piece reminds me of my childhood, wandering around in the backfields, eating berries, and catching frogs. It is hammered copper and painted metal.

Butterfly Bush. This wall scene is 48" by 30".

153

Pumpkins. A confession: I lived next to a 50 acre field which in the autumn contained nothing but pumpkins. Every year I'd go out with my red wagon and return loaded to overflowing with pumpkins. At the end of the season there'd be tons upon tons of pumpkins left to rot on the vine and so I thought it was okay. Eventually I got caught…by my father and had to pay for about 5 years worth of pumpkins. Never forgot the lesson I learned so early.

Pumpkins and pheasant. Still life in hammered copper and painted metal. 50" by 38".

Pheasant. Another variation on the pheasant still life.

Jamaica Floral. This one is also one of the staples at the gallery that has
paid our bills through the tough times. They've made people smile.

Wine & Grapes. Still life with grapes 39" wide by 15" tall.

Picnic. Still life with bread and wine 38" by 14".

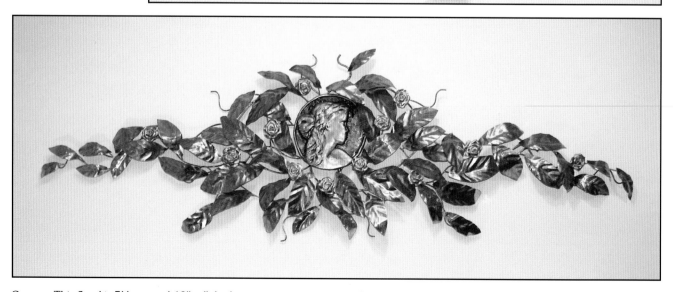

Cameo. This floral is 5' long and 18" tall. In the center is a cameo cast from aluminum, then electroplated.

Critique

KILLER TOTEMS

In the old days out in Tucson, things were a lot less politically correct, probably a lot less safe, and OSHA never paid much attention to metal sculptors. We used to go down to the Pappadeas scrap yard in the middle of Tucson and look for neat things to make into other neat things. You couldn't miss Pappadeas. From four blocks away, you could see the mountains of scrap.

For a very brief period we had gotten into buying empty Freon canisters and then making pierced lamps, totem poles, lion heads, all kinds of things. Even in my young stupidity, the process seemed slightly dangerous. I just didn't know how dangerous. To make certain the tanks were empty, I'd drill a hole top and bottom and then flush the whole thing out with water. How safe do you have to be? Then I'd draw the totem faces and lion heads and abstract patterns, and then let rip with my cutting torch.

Even with all that preparation, I was still getting a *very* pungent and annoying acrid orange gas with each cut, and I took to wearing a gas mask. Even this didn't work all that well and I took to wearing the mask, taking a huge breath inside the gallery, then stepping outside and making the cuts without breathing. Who said sculpting was easy?

Then one day we were watching a special on TV and they were talking about the properties of Freon gas. Apparently, Freon is *relatively* innocuous until heated…at which point it turns into Phosgene gas, otherwise known as mustard gas. That's what they used in the trenches in WWI. That was the end of the totem poles.

A bit of humor at the end of this anecdote—roughly a year after I stopped making the totems, I received a call from a customer who'd purchased one of the totems and placed it at the entrance of her front door. "It's broken, Henry!" she yelled into the phone. "It's broken?" I imagined my heavy plate steel and canister totem in a pile of rubble. God only knows what could have caused it. When I went out to investigate, I saw the totem standing there proudly as I drove up. As annoying as it had been to create, it looked nice and very appropriate to the desert southwest. I hadn't even made it to the front door, when the gal burst out of her house, instantly angry again. "See? It's broken!" She flipped the switch next to the door and the once glowing faces from the four 60-watt bulbs…glowed no more. I played with the switch next to the door. Then I peered inside one of the faces. "When's the last time you changed the light bulbs?" I asked. Lucille stared at me, dumbfounded. "Light bulbs? What are you talking about? You have to change the light bulbs?"

Totem Pole. These were created out in Tucson during the seventies. They are constructed from empty Freon canisters. Avoid them! There is residual Freon, which when heated turns to the equivalent of mustard gas.

Totem Pole. 8' high by 3' wide. Circa 1977.

THE LOVERS

The Lovers was cut from plates of Cor-Ten steel with a plasma cutter, welded in place with a MIG welder, primed, and then painted. The curves in the individual pieces were bent by hand, using levers, sheer willpower, and sometimes the back wheel of my car to achieve that certain *je ne c'est quoi.* The initial design was of just the two lovers, but always during construction, there is a time when you stand there and say, "What if?" In this case, it was, "What if they had a child?" Templates were cut and held up, and I wanted the child to be more abstract than literal. I'm pretty sure they had a boy, however.

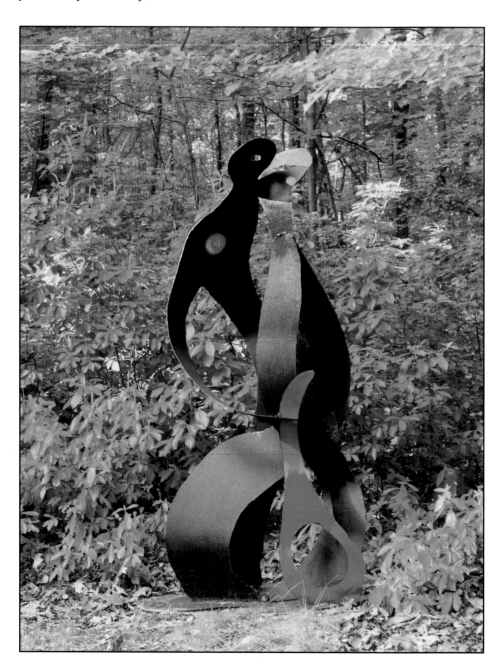

Lovers. This abstract is slightly Calderesque in its coloration, and perhaps a bit Henry Mooreish in its shape. Both artists, as well as David Smith were my inspiration in the later years. Circa 2001.

CHAPTER 11
CREATIVE MIND...INVENTIVE MIND
WHAT'S THE DIFFERENCE?

The difference between an invention and a sculpture would appear to be dramatic. One is practical; it toasts your bread faster, or makes it easier to shovel snow, or allows you to clap your hands to turn on the lights. A sculpture, however, is something to be pondered and enjoyed like a sip of brandy during a quiet walk through a gallery.

For the artist/inventor, however, the point is utterly moot. They're both ideas that have bubbled up inside the brain where they will sit in limbo for moments, days, or weeks. Will the idea be forgotten? Is it worthy of the drawing table...sketchpad? If the idea is good, or even if it is only interesting, curiosity takes over and the sketches begin, often on a corner of a yellow legal pad, a cocktail napkin, or the back of an envelope.

In this section, I'm going to show you the similarities as well as the differences between inventions and sculptures. For artwork, sketches are *de rigueur.* For inventing, however, the sketches are only the first manifestation of the idea. When inventing, sketches are quickly replaced by blueprints, technical drawings, then models and mock-ups, followed by *more* models and mock-ups, followed by...well you get the idea.

The way the adage goes, necessity is the mother of invention. Other things that are the mother of invention: a bad back, carpal tunnel syndrome, bad experiences with mechanical devices of all kinds, hearing problems, bad eyes, loss of a limb, or it could be as simple as a profound annoyance cleaning out a gutter, or taking out the trash. Anything can be the germ of an invention. Anything can be the germ of a work of art. The two are not mutually exclusive.

Look at the lowly oyster, hardly one of the more brilliant creatures on the planet. Sometimes a small grain of sand will get sucked inside the oyster's shell and immediately begin irritating it. Unlike humans, it is incapable of reaching in and removing the granule of sand, and so it does the only thing it can, it excretes a substance to coat the granule and make it less irritating. It continues to do this until eventually the oyster has created a pearl. The process can be very similar for human beings. Annoy us enough and we will take action!

Just look at what is considered the norm in automobiles now, versus 20 years ago. Virtually all of the innovations stem first from an annoyance, followed by the realization that there *has to be a better way.*

The Aardvark Shovel

The genesis behind the Aardvark snow shovel, was a terrible February blizzard, followed immediately by freezing rain, followed by snow, followed by more rain. Looking at a cross section of the accumulation, it looked like a hundred-pound white lasagna. Shoveling it was impossible as was moving it with a snowblower. And living in the woods, when the snow falls, it stays. It was overwhelming.

Aardvark. Snow Shovel patent.

Fig . 1

Fig. 5

Diagram of Snow Shovel.

The first realization of the problem was when we hiked out and purchased one of the so-called "back-saver" snow shovels. It took fifteen seconds, one scoop of heavy ice and snow to realize that it was solving only a small part of the problem. Though the makers of the shovel put an angle in the handle so you won't have to bend so low, once you've scooped a ten-pound lump of slush, it's still hanging out there in front of you. Guess what's still keeping that lump suspended in the air: It's your back.

A little self-test: Pick up a large rock or bowling ball, anything dense and heavy, and hold it close to you, cradling it against your stomach. It's not...*too* bad. But extend that rock or bowling ball out in front of you. If you're over 25, within seconds you'll feel your back muscles beginning to revolt. Put that same bowling ball in a knapsack, however, and you can walk around all day with it. That's what the Aardvark does. It brings the weight of the load in line with your torso. It's not magic, just basic physics. The difficulty was in engineering a very simple system that would allow you freedom of movement and yet put zero weight out in front of you.

Author with shovel.

Dragon Teeth

Having spent the last 30 years hanging heavy sculptures on drywall, I can tell you with some authority, that unless you're lucky enough to hit a stud at the exact point where you want to hang it, your options are limited. Drywall is essentially plaster covered on each side with paper. It is the consistency of hard cheese. Pound a nail in and watch it sag under the weight. Sure, there are a number of devices on the market to solve the problem: Toggle bolts, where you have to drill a hole and you have a permanent fixture. Ganged nails set in a bracket are expensive for what you get and very limited in their holding capacity. Hammer-in toggle bolts: Expensive, not removable.

I wanted something that was dead simple, cheap to make, utterly bulletproof, ultra-easy to install, and equally easy to remove. Plus, the arch design, cleverly lifted from those wise people who erected cathedrals hundreds of years ago, creates a device that holds wildly heavy things in thin drywall. Unfortunately, what you can't see is that this ultra simple idea took at least twenty permutations to make it simple, attractive, and easy to produce. The mating call of the successful inventor is: "Simpler—better—easier—cheaper".

Dragon Teeth. Constructed of stainless steel and guaranteed forever.

Dragon Chess

Wait! Stop! Before all you budding young chess masters take me to task…this is NOT your typical chess game. It is not played on a 64 square board. It is, instead, played on a 100 square board. It is called Dragon Chess.

"Never heard of it!" a few of you may grumble. Well, yes, that's true for the time being. That's because I came up with it, researched the patent office, and refined the game to its present state. "What makes it Dragon Chess?" Dragons, for one thing. But I'm getting ahead of myself.

Once I was showing my son how to play chess, and in the process of showing how each piece moved, I noticed something interesting. The bishop, knight, and the rook move in geometric patterns, one diagonal across the board, another, rank and file. And if you graph the kill zone of the knight, it is a circular pattern with a killing range of eight.

There was, however, no cruciform shape comparable to the knight with a kill-zone of eight. Thusly the genesis of the dragon came about…to fill the gap in the geometry.

The dragon moves like an abbreviated rook, rank or file, one or two squares in any direction. And like the knight, it can jump over a piece. I won't bore the non-chess enthusiasts, but in word, the game plays *very* smoothly; the 100-square board makes for interesting two or sometimes three-pronged attacks, and the dragons have their own personality.

Dragon. The Staunton version of our dragon in Dragon Chess. Dragon design courtesy of Edmund Golden.

I wanted a board that was equally interesting. I've accomplished it in metal (pictured) and in wood with individual cubes as squares. In the wood version, the cubes descend in height as you go toward the center, creating an arena-like effect. Lots of fun to play…a very long game, if you're adept, and an extremely short game if you're not. I've created a traditional Staunton version of the dragon for traditionalists, but the board and pieces pictured were just for fun. The board was cut from a single plate of steel, then embossed with the plasma cutter and reassembled with spacers. Rules for castling are slightly different, but other than that, a chess player can easily adapt and the dragons are intuitive.

Dragon Chess Board and Pieces. Board is 20" by 20" and created from oxidized steel. Dragon chess pieces are created from nuts and bolts.

Omega Shock

The genesis of this invention was a bicycle ride my wife and I took along a bumpy mule path along the Delaware canal. I have to say, right off the bat, that neither my wife nor I are *into* pain or long-term suffering. Over the years, I have modified many of my tools, my torch, my garden tractor, even knobs on my BMW etc. to make it more comfortable, more useful, safer or more convenient. And to whisper loudly in your ear, I think that's probably the most important trait and secret of anyone wanting to become a budding inventor—the unwillingness to quietly suffer when there's a better way. It also takes a certain degree of self-confidence (arrogance?) to assume that you might be able to improve something that's been in existence for decades…perhaps centuries. The world asks, "Who the hell are you to think you can improve a_____?" Correct answer: "I'm Me!!!!"

I am an avid bicyclist; my wife is a sometimes bicyclist, happier to watch or make the proverbial picnic lunch while I pedal over hill and dale. I never really thought very much about WHY Pamela didn't like to ride bicycles. She never said anything. But on this particular day, as we were pedaling side-by-side, my wrists were beginning to hurt from leaning on them. I know all about carpal tunnel syndrome, and I could feel the pressure numbing out my ulnar nerves. In truth, my back didn't feel all that great either, and to be honest, the very expensive high-tech racing seat was feeling particularly ridiculous. (I've learned since, that these seats can have an adverse effect on a man's … well … sexuality and so I felt extremely motivated to at least solve the problem for myself.)

Pam and I began talking, or to be more accurate, I began complaining. Red-faced from pedaling, Pam looked up and glared at me. "Just be glad you aren't a woman," she muttered.

My ears perked-up. "What? Why? What are you talking about?"

"Because bicycles were designed by men…for men. And they really stink!"

Back at the shop, I began making sketches and diagrams. I also bought four or five pounds worth of biking magazines. I noticed several things over time. First: aerodynamics is a *huge* factor in biking. Drag goes up exponentially the faster you go, thus it behooves one to maintain as low a profile as possible when pedaling. This quickly led to a second reality: In order for you to maintain that profile, you essentially have to do a sort of semi-push-up on the handlebars and therein lies the wrinkle. In order for you to remain aero-dynamic (for any length of time), you have to exert energy, holding yourself in that position…*and*…all the while, you're straining your wrists, your neck, your back, and your naughty parts.

To make an extremely long and involved story much shorter, I went from duct tape, my wife's throw pillow, and a number of pieces of electrical conduit, to a very slick, color coordinated, high-tech device whose weight was now measured in grams. And it only took a year of intensive research and development.

Lesson One: A sculpture must serve one function: to elicit a thought or emotion from the viewer. An invention, however, must often serve a score of masters. Weight is critical in the biking world. Cost to produce, Coolness factor, Safety, Reliability, Can it be retrofitted to any bike? How many body types will it fit? Will it do the job?

When the device was finished, (we came up with the name Omega Shock for it) we contacted a number of professional bicyclists and discovered that there was a grand daddy of races coming up: RAAM, Race Across America, a flat-out no-holds-barred race from Irvine, California to Savannah, Georgia that is hugely strenuous to the human body. Several teams jumped at the chance to try it. Others were skeptical. Still others thought the device looked *funny*.

In the end, Omega Shock took two gold medals, a silver medal, and a bronze. After the race, we discovered that one team member had a crash in the Rocky Mountains. She broke her tailbone completely and the judges were about to disqualify her from the race. How the heck was she going to ride all the way from the Rockies to the Atlantic Ocean with a broken tailbone? … .She did it, using our wifty weird-looking invention: Omega Shock. That was a thrill of a lifetime.

Omega Shock. Our first successful patented invention.

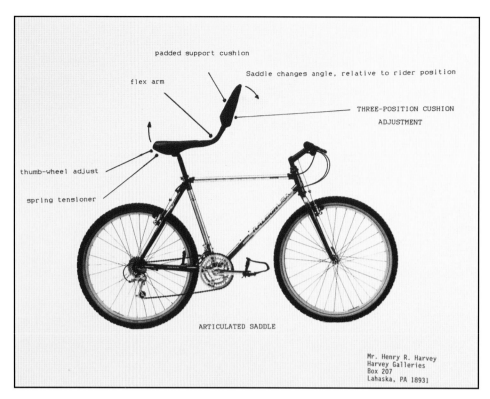

Omega Shock.

Flying Wing

This device harkens back to the sixties when I was a kid and just learning how to fly. Flying made me highly aware of the aerodynamic forces exerted on a flat surface at high speed. We experimented on an old Chevy that I had inherited from my grandmother, mounting an airfoil on the trunk that was cable-operated by a lever on the dashboard. It worked great, and I sent a letter to John DeLorean who was heading up the Pontiac Motor Division of GM. I got a nice letter back. Ole John liked the idea, but thought it was a trifle radical for passenger cars. And it was. Now it isn't. Timing is everything.

This is another idea that sprang from my early flying days. We'd fly around in old Cessna 150s at Schwanda's Airport in New Jersey. Sometimes we'd run into a shower and I'd look around on the instrument panel for the wipers. Well, there weren't any…primarily because in an airplane you're always going fast enough that the high speed of the air scoots the raindrops right off the canopy. If only we could all drive our cars at 150 mph, we wouldn't need windshield wipers. But then…what if we put little nozzles up against the windshield that pump air at a very high rate of speed along the surface of the windshield?

I bought an air emissions compressor from a Corvette and mounted it on my old Chevy, giving me an abundant supply of high velocity air. No more windshield wipers for the Chevy. No bugs either…not dust, no grit, nothing, and it was a very strange expe-rience driving around in a thunderstorm with an utterly clear windshield.

There is no difference between an inventive mind and a creative mind. The difference lies in the implementation of the idea. With notable exceptions, of course, a sculpture is the product of one mind, to create one concept. An inventor, however, must also be aware of many other factors: weight, materials, patentability, cost to build, packaging, promotion, safety, color, comfort, wearability, retrofitting, replacement parts, marketing, to name only a few. Each factor must be considered separately and then integrated into the whole.

Sketch of vectored air flow.

CHAPTER 12
TIME MACHINES

Here is how it usually goes: A family will wander into our gallery and soon after, one of the children will climb into our time machine and begin working the instruments. They're having fun. I'm having fun. And then someone throws in the monkey wrench. It's usually the father. Fathers have to be the serious ones. He'll look over at me, smirk, and ask, "Does it work?"

"Of course!" I reply instantly. This is usually followed by a moment of awkward silence. We stand there quietly listening to the fluorescent lights buzzing over our heads. The radiator creaks and gurgles against the far wall. I clear my throat. And then the father, feeling the need to clarify the situation, replies, "Well…not *really*."

To which I offer, "Well…to be more specific… it's a *linear* time machine."

The father's eyes cloud a bit and if he has a propensity toward chewing on his lower lip, the chewing begins. A moment later, "…a what?"

"Linear," I repeat. "It goes through time all right. Quite nicely, as a matter of fact. Only *linearly*. As each minute goes by in earth time, the time machine travels forward one minute in time. As an hour goes by…this particular time machine has been calibrated to progress one hour in time."

During this awkward silence, the man's child has already traveled back and talked to dinosaurs and now is speeding ahead toward some far distant future. At least someone understands. We're talking about magic here. Maybe one of these children will grow up, become an engineer, and commence work on a non-linear time machine.

The beauty of making linear time machines is that it's nearly impossible to make one that doesn't work. I have made several that plug in the wall. Lights blink a universal code of pi, 3.14159… gearboxes grind away, and headlights flash on. What is astounding is: if you pull the plug, it works just as well. I have made

time machines that operate with batteries and I'm certain that with very little effort, I can make one that will operate just by force of gravity.

There's also no size restriction in making a time machine and I would say without any arrogance whatsoever, that I could probably make a linear time machine that would fit inside a button. Such are the wonders of modern technology.

So far, I have made only a small handful of time machines. But I see a trend forming. They seem to be getting larger, more complex, and heavier, with more comfortable seating and more options. And yet, as with the automobile industry, this trend is liable to turn back on itself at any moment. And if I may be so bold as to predict…I predict that sometime in the not too distant future, there will be linear time machines, not much larger than a grain of sand. What a miraculous world we live in!

Time Machine sketch.

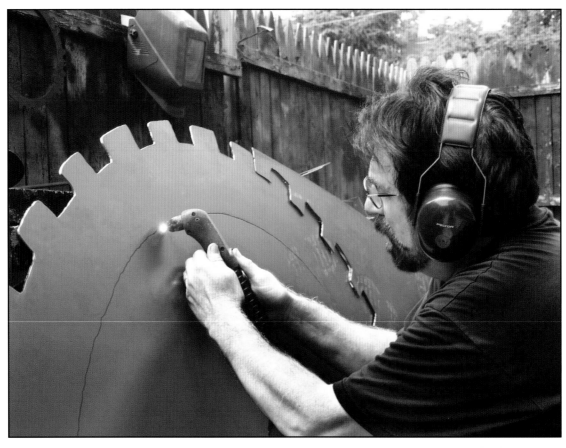

Plasma-cutting the gears. Note the sound suppressors. The hiss of the plasma cutter is dangerously loud over time.

Assembling the frame. No instruction manuals come with a time machine. You're on your own!.

Side view of initial structure.

Front view of initial structure.

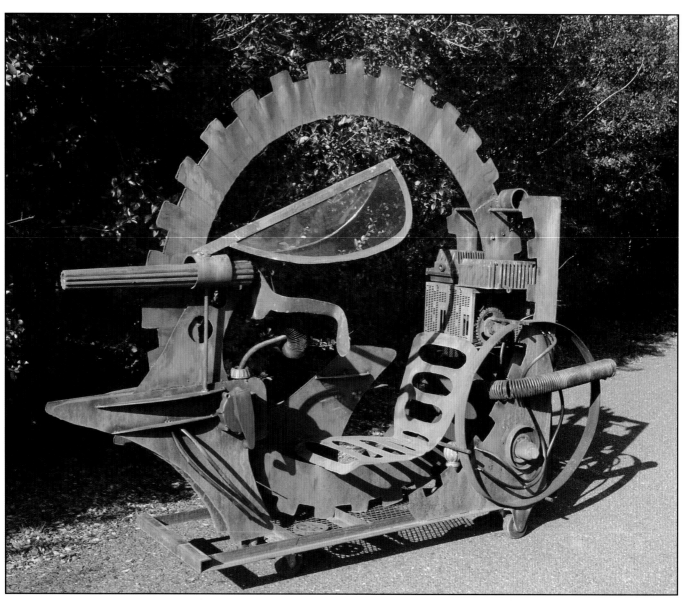

Time Machine going into final stage.

First Time Machine.

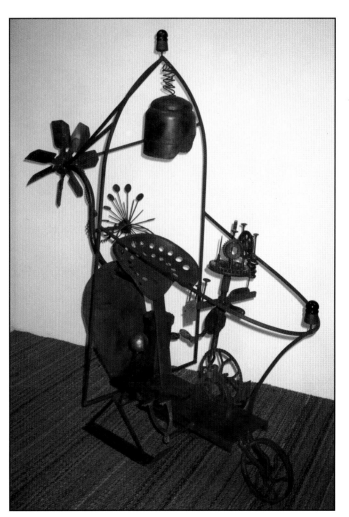

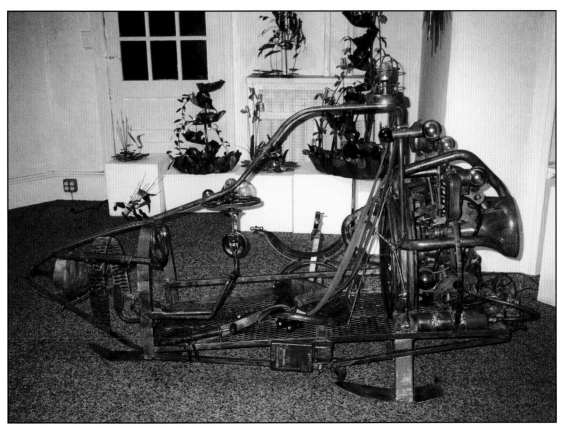

Electric Time Machine.

GEOMETRIC SCULPTURES

Voyager. Painted metal 36" by 60".

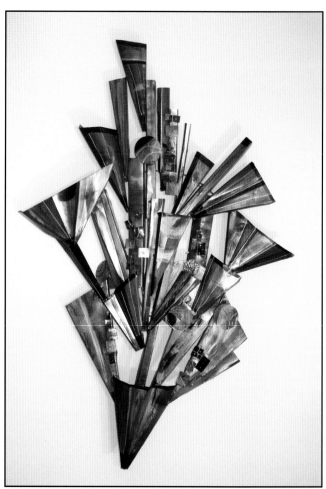

Triangulate. A big and bold abstract, brilliantly colored.

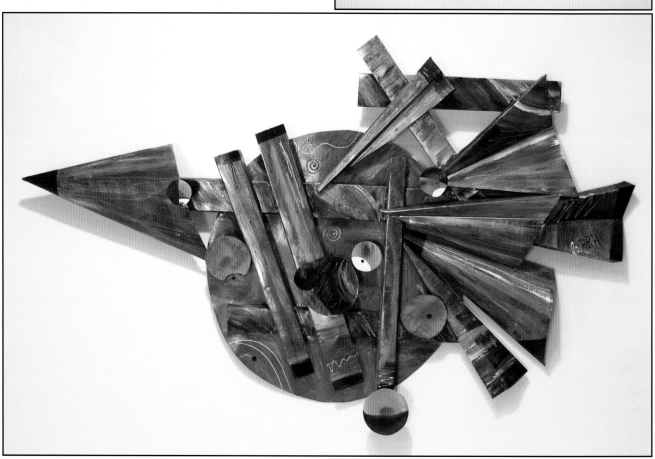

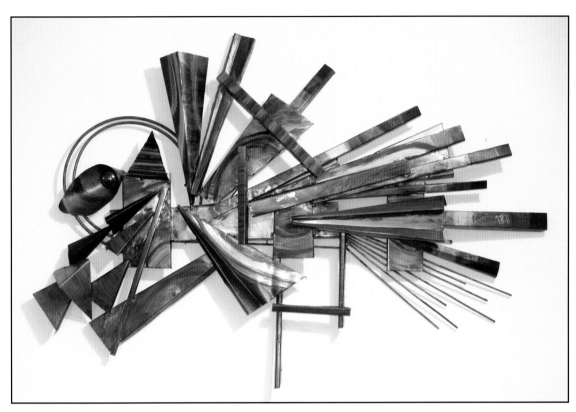

Looking to the Stars. A more delicate wall abstract. 62" by 38".

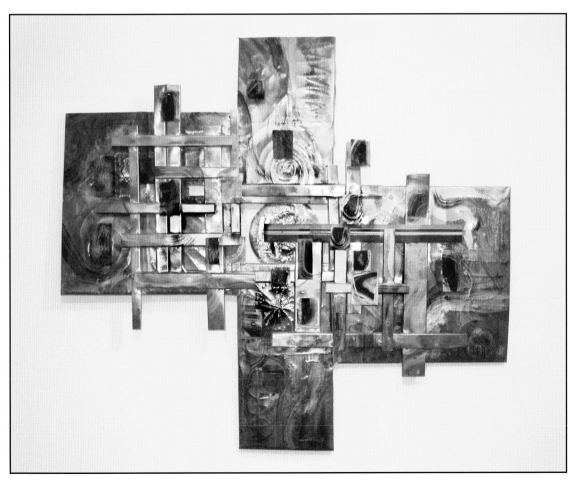

Kronos. This is one of the most powerful and masculine abstracts I've constructed. It is set with small sections of stained glass and is composed of oxidized brass. It measures 5' by 5'.

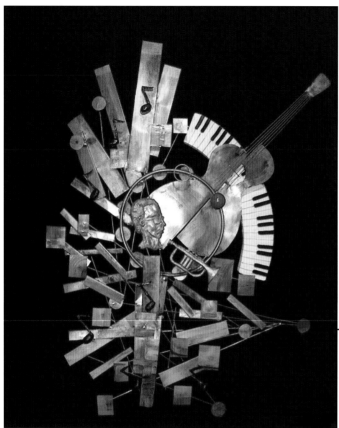

Memories of Miles. This musical abstract is 8- feet high and was constructed in two modules to facilitate shipping. The center figure of Miles' head is cast aluminum and then electroplated bronze. It is 78" by 48".

Shields. This has a slightly militaristic feel about it and a slightly oriental feel…perhaps a Samurai war shield?

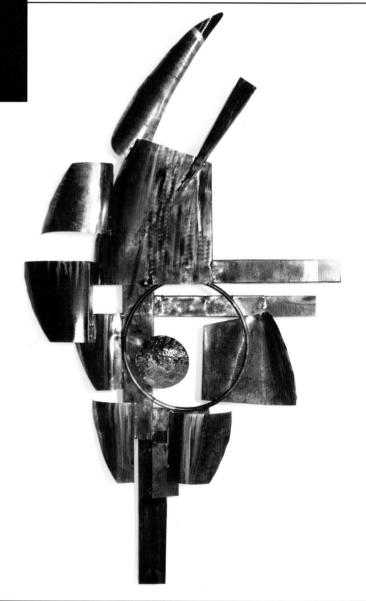

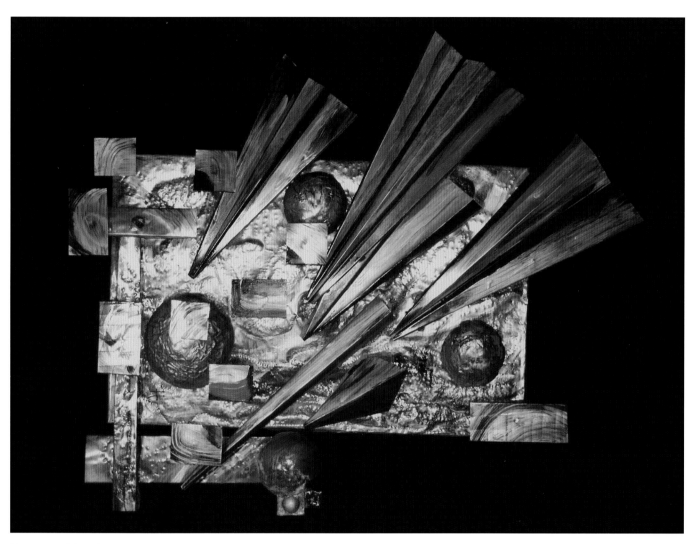

Formation. This abstract incorporates cast metal spheres, hammered copper, and formed copper triangles. It is 45" by 39".

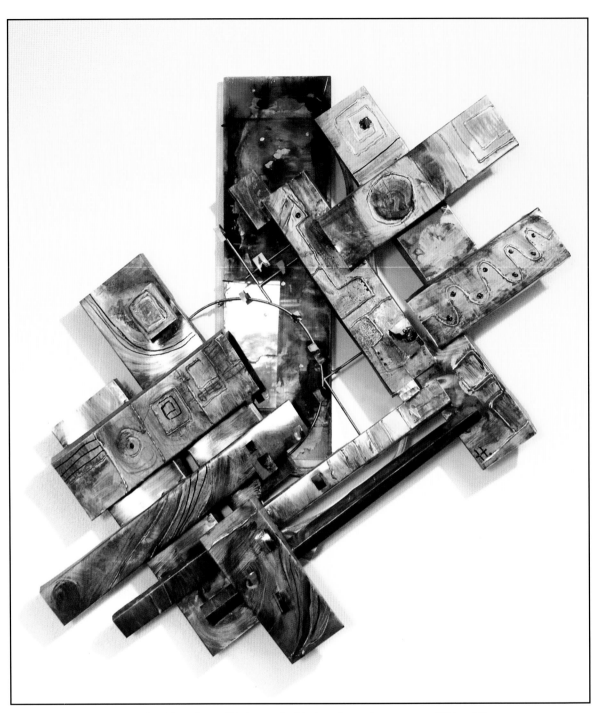

Axiomatic. This sculpture is backlit with small lights embedded in plastic. It measures 42" by 45".

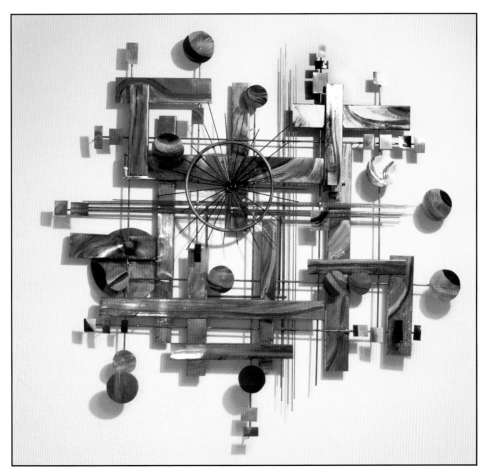

Quadrapede. This is an example of one of my more whimsical wire abstracts.
It measures 48" by 52".

Corrugated Chrome. This piece was a commission for two screenwriters who have long since become friends. It was cut with a plasma cutter, bent with a sheet metal break, and then painted. It is approx. 52" by 32". 2003.

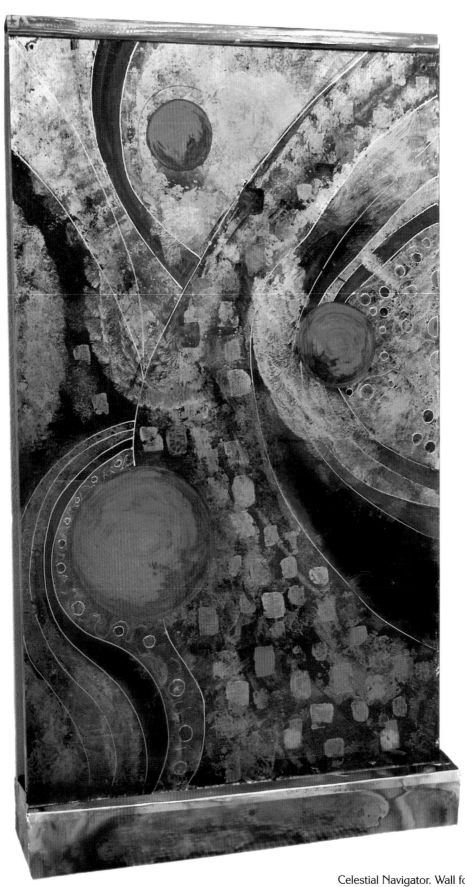

Celestial Navigator. Wall fountain, copper, bronze, and optical acrylic. 48" by 28". 2003.